MARK CATESBY'S
NATURAL HISTORY
OF AMERICA

———

THE WATERCOLORS
FROM THE ROYAL LIBRARY
WINDSOR CASTLE

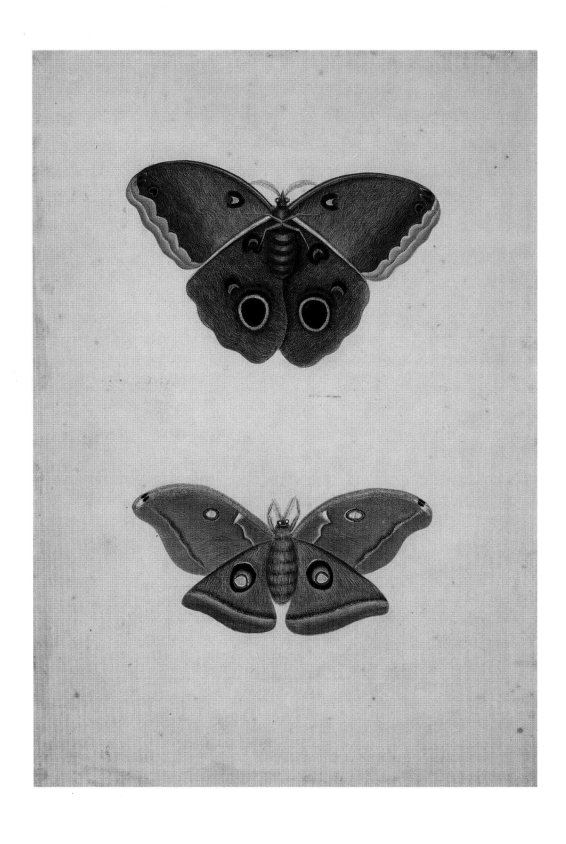

MARK CATESBY'S *NATURAL HISTORY* OF AMERICA

THE WATERCOLORS FROM THE ROYAL LIBRARY WINDSOR CASTLE

Henrietta McBurney

with an introductory essay by Amy R. W. Meyers

———

MERRELL HOLBERTON
PUBLISHERS LONDON

THE EXHIBITION

Mark Catesby's Natural History *of America:*
The Watercolors from the Royal Library, Windsor Castle
was organized by the Royal Library, Windsor Castle, in conjunction
with the Museum of Fine Arts, Houston.
National funding has been provided by British Airways.

EXHIBITION ITINERARY

The Henry E. Huntington Library, Art Collections, and Botanical Gardens, San Marino, California
May 11–July 20, 1997

The Museum of Fine Arts, Houston
August 3–November 2, 1997

The DeWitt Wallace Gallery, Colonial Williamsburg, Virginia
November 15, 1997–February 15, 1998

Telfair Museum of Art, Savannah, Georgia
March 1–May 10, 1998

The Queen's Gallery, London
October 30, 1998–January 10, 1999

LIBRARY OF CONGRESS CATALOGING-IN-PUBLICATION DATA

McBurney, Henrietta.
Mark Catesby's natural history of America: the watercolors from the Royal Library,
Windsor Castle / Henrietta McBurney: with an introductory essay by Amy R.W. Meyers.
p. cm.
Catalog of a travelling exhibition organized by the Royal Library, Windsor Castle
in conjunction with the Museum of Fine Arts, Houston. Includes bibliographical references and index.
ISBN 0 89090 081 7 (pbk.)
1. Catesby, Mark, 1683–1749. Natural history of Carolina, Florida, and the Bahama
Islands – Exhibitions. 2. Natural history – Southern States – Pictorial works – Exhibitions. 3. Natural history – Bahamas – Pictorial works – Exhibitions. 4. Catesby, Mark,
1683–1749. 5. Natural history – Southern States – Pre-Linnean works – Exhibitions. 6.
Natural history – Bahamas – Pre-Linnean works – Exhibitions. 7. Natural history illustration – Exhibitions. 8. Catesby, Mark, 1683–1749. Natural history of Carolina, Florida,
and the Bahama Islands. 9. Windsor Castle. Royal Library. I. Windsor Castle. Royal
Library. II. Museum of Fine Arts, Houston. III. Title.
QH41.C33M38 1997
578.0975 022 – dc21 97–3931 CIP

ISBN (PAPER) 0 89090 081 7

ISBN (CLOTH) 1 85894 038 9

Produced by Merrell Holberton Publishers Ltd.,
Axe & Bottle Court, 70 Newcomen Street, London SE1 1YT
Designed and typeset in Monotype Fournier by Dalrymple
Printed and bound in Italy

FRONT COVER: 'The Blue Bird and *Smilax non spinosa*' (cat. no. 10)
FRONTISPIECE: 'The Great Moth and *Phalaena Fusca*' (VI.3)

CONTENTS

SPONSOR'S STATEMENT

THIS exhibition highlights the remarkable achievement of Mark Catesby. Beginning in 1712, this English-born artist-naturalist embarked on a series of scientific expeditions to the southern colonies of British North America that would ultimately result in the first major book on New World botanical and animal life, *The Natural History of Carolina, Florida, and the Bahama Islands*. This book is recognized as one of the great achievements of eighteenth-century art and science. In Catesby's ambitious enterprise to record the extraordinary "Productions of Nature" (as he called it) inhabiting the southern colonies of North America, travel was critical. It is appropriate, therefore, that British Airways serves as the national corporate sponsor for the exhibition.

At British Airways, we are pleased to bring, for the first time, Catesby's extraordinary watercolors to American audiences from the collection of Her Majesty Queen Elizabeth II. Newly conserved and virtually unseen since King George III first acquired them in 1768, they offer Americans a unique insight into the world of eighteenth-century art and science. It is a privilege to sponsor this important exhibition and to contribute to the cultural life of this nation.

DALE MOSS
Senior Vice President, Marketing, U.S.A.
British Airways

6

PREFACE

THE Royal Library at Windsor Castle houses in its Print Room the Royal Collection of over thirty thousand drawings and watercolors. These range in date from the fifteenth to the twentieth century. One of its particular points of interest is the way in which it represents the artistic tastes of successive Kings, Queens and Princes. The collection does not comprise an even and comprehensive range of artistic work. It is more a reflection of the character and interests of its royal collectors over the centuries.

Of all the royal collectors of drawings and watercolors, King George III must rank first. About half of the present collection was acquired by him. His librarian, Richard Dalton, bought many Old Master drawings for him in Italy. However, one of the King's particular personal interests was natural history watercolors. He obtained a number even before he became King in 1760 at the age of 22. In 1768 he was able to buy from a London dealer, Thomas Cadell, the superb collection of 263 original watercolors by Mark Catesby (1682–1749), executed following expeditions to the New World in 1712 and 1726 for his book *The Natural History of Carolina, Florida and the Bahama Islands* (published from 1731 to 1747).

Catesby is commonly considered the equal of Audubon, even though predating him by a century. He became an outstanding scholar of North American natural history and these watercolors are the main surviving group of his work.

The watercolors were bound in three volumes and kept at the King's large and famous library in Buckingham House (the future Buckingham Palace) which George III had bought as a private family home in 1762. When his son, King George IV, gave that library to the British Museum in 1823, the Catesby volumes and a number of other treasures were held back and subsequently placed in the new (*i.e.*, the present) Royal Library, set up at Windsor Castle by King William IV in the early 1830s.

The Catesby watercolors remained in three volumes although it was noted a few years ago that they were in serious need of conservation. The generosity of a Japanese benefactor, Mrs. Hiroko Usami, enabled this conservation project to be started in 1994 and it has been undertaken meticulously by Mr. Michael Warnes, who was formerly Chief Paper Conservator in the Royal Library. It is therefore now possible to exhibit a selection of these watercolors for the first time.

Particular thanks are due not only to Mrs. Usami and Mr. Warnes but also to Henrietta McBurney, Deputy Curator of the Print Room in the Royal Library, and to Amy Meyers, Curator of American Art at the Huntington Library, San Marino. The knowledge and enthusiasm of these two curators has resulted in the production of this excellent exhibition catalogue. Thanks are also greatly due to Theresa-Mary Morton of the Royal Library who, in conjunction with the venues, organized all the exhibitions, and who was also instrumental in the initiation of the conservation program with Mrs. Usami.

It has been a great pleasure to work on this exhibition with colleagues in the Museum of Fine Arts, Houston; The Huntington Library, San Marino; the DeWitt Wallace Gallery, Colonial Williamsburg; and the Telfair Museum of Art, Savannah. It is particularly suitable that these superb watercolors, painted by an Englishman during his time in America, should now be shown in the United States for the first time.

OLIVER EVERETT
Librarian, Windsor Castle

DIRECTORS' FOREWORD

THE artist as explorer and scientist has a long tradition in the history of American art. The artists who immediately come to mind – Titian Ramsay Peale, George Catlin, John James Audubon, Frederic Remington and Albert Bierstadt, to name a few – represent the enthusiastic ambition of those North Americans travelling westward in the nineteenth century to capture and record different aspects of the new and unfamiliar territories of what are now the United States. To artists of earlier centuries, however, travelling westward meant something different: crossing the Atlantic Ocean from Britain and the European continent to explore what was then known as the New World, a source of constant wonder and endless opportunity to its eastern neighbors. Among the earliest and most important of these explorers was the English-born Mark Catesby (1682–1749), a budding artist and naturalist who traveled to the British colonies in North America in 1712 in order, as he wrote, to satisfy a "passionate desire of viewing as well the Animal as Vegetable Productions in their Native Countries; which were Strangers to *England*." Like many gentlemen of his era, Catesby sought to document and understand the exotic birds, fishes, mammals, reptiles and plants of this "New World," affirming the Enlightenment concept of order and classification as a means to knowledge while providing those at home with enough information about the colonies' natural resources to open up potential markets. What resulted from Catesby's travel and research was *The Natural History of Carolina, Florida, and the Bahama Islands*, the first major study of the flora and fauna of the British colonies of North America, and a source of inspiration for such subsequent American artist-naturalists as William Bartram and John James Audubon.

For the first time, the Royal Library at Windsor Castle is lending more than fifty of the original watercolors Catesby used to create his *Natural History*. Bound together since their acquisition by King George III in 1768, and protected from light for virtually their entire existence, the watercolors selected for this American tour are remarkably fresh, revealing images of scientific importance in their portrayal of environmental interplay, and delighting us with occasional unexpected whimsy. All of the images in this exhibition have undergone recent conservation – lifted from their mounts, cleaned, conserved, and remounted. Now presented in superb condition, these stunning watercolors provide new information about Catesby's workmanship, and in some cases demonstrate the presence of other artists.

This exhibition marks the sixth collaboration between the Royal Library and the Museum of Fine Arts, Houston, and the first to focus on the Royal Library's holdings that deal with American subject matter. With our colleagues at the Huntington Library, Colonial Williamsburg, and the Telfair Museum of Art, we extend our deepest thanks to Her Majesty Queen Elizabeth II for her willingness to share these extraordinary watercolors with a new, American audience. At the Royal Library we wish to thank Henrietta McBurney, Deputy Curator of the Print Room, who selected the drawings and wrote the entries for the exhibition catalogue, and her colleagues at Windsor, Oliver Everett, Librarian; Jane Roberts, Curator of the Print Room; and Theresa-Mary Morton, Curator of Exhibitions, for their unstinting co-operation and efficiency. We are also greatly indebted to Catesby specialist Amy Meyers, Curator of American Art at the Huntington, for her insightful essay.

8

Emily Ballew Neff, Associate Curator of American Painting and Sculpture at the Museum of Fine Arts, Houston, served as co-ordinating curator in organizing the American tour. Her colleagues Karen Bremer Vetter, Curatorial Administrator, and Diane P. Lovejoy, Publications Director, assumed the administrative tasks associated with touring the exhibition and publishing the exhibition catalogue. We owe our thanks to them, and to Margaret C. Skidmore, Associate Director, Development, who identified and welcomed a new national corporate sponsor, British Airways, among the museums' supporters. We also wish to thank our co-publishers, Merrell Holberton Publishers Limited, for their exceptional work and dedication in producing this catalogue.

The mounting of trans-Atlantic and transcontinental exhibitions is increasingly difficult for museums to accomplish without corporate support. Substantial financial assistance to defray the costs of this exhibition was provided by British Airways. To them, we extend our deepest appreciation for their generous support.

PETER C. MARZIO
Director, The Museum of Fine Arts, Houston

EDWARD J. NYGREN
Director of Art Collections, The Huntington Library, Art Collections, and Botanical Gardens

GRAHAM HOOD
Vice President, Collections and Museums
Carlisle H. Humelsine Curator, Colonial Williamsburg Foundation

DIANE LESKO
Director, Telfair Museum of Art, Savannah

ACKNOWLEDGMENTS

ALL students of Mark Catesby are indebted to George Frederick Frick and Raymond Phineas Stearns, whose biography *Mark Catesby: The Colonial Audubon*, published in 1961, has provided the most important study on the naturalist and his work for over thirty years. A debt is also owed to Joseph and Nesta Ewan who have supplied important information on Catesby and his community in their numerous publications on colonial American science. The present catalogue has been completed with the additional help and advice of many people on both sides of the Atlantic.

The authors would like to thank the following: in the United States, Shelley Bennett, Ann Bermingham, David Brigham, Kirstin Holms, Thomas Lange, Peter McCracken, Leo Mazow, Jack Meyers, Edward Nygren, and Ariel Presta; in England, Rex Banks, Malcolm Beasley, the Duke of Beaufort, Brenda Burgess, the Earl and Countess of Derby, Judith Diment, Gina Douglas, Antony Griffiths, Véronique Gunner, Paul Henderson, Susan Lambert, Serena Marner, Lodvina Mascarenhas, Sheila O'Connell, Jane Roberts, Christopher Ryan, Gill Saunders, Michael Snodin and Sam Whitbread. Specialist advice on Catesby's subject matter was generously given by Paul Clark *(Crustacea)*, Barry Clarke *(Reptiles and Amphibia)*, Oliver Crimmen *(Fishes)*, Alistair Culham *(Plants)*, John Edwards *(Mammals)*, Sheila Halsey *(Marine Invertebrates)*, Charlie Jervis *(Plants)*, Colin McCarthy *(Reptiles and Amphibia)*, Judith Marshall *(Insects)*, Lee Rogers *(Insects)*, Ronald Rutherford *(Plants)* and Michael Walters *(Birds)*.

Thanks go also to all colleagues in the Royal Library, in particular to Michael Warnes, who has been responsible for lifting and conserving the drawings, and to past and present volunteers including Jessica Armstrong, Leonora Clarke, Sally Korman and Richard Woodward.

HENRIETTA MCBURNEY
Deputy Curator of the Print Room
Royal Library, Windsor Castle

AMY R. W. MEYERS
Curator, American Art
The Huntington Library, Art Collections,
and Botanical Gardens

November 1996

Amy R.W. Meyers

"THE PERFECTING OF NATURAL HISTORY"

MARK CATESBY'S DRAWINGS OF AMERICAN FLORA AND FAUNA IN THE ROYAL LIBRARY, WINDSOR CASTLE

IN 1747, shortly after the English naturalist Mark Catesby (1682–1749) had completed *The Natural History of Carolina, Florida and the Bahama Islands*, Cromwell Mortimer, Secretary of the Royal Society, declared the publication to be "the most magnificent work I know

since the Art of printing has been discovered."[1] Such praise characterized the reception of Catesby's publication by English, Continental and North American naturalists, and the book's reputation as the first major study of the flora and fauna of the British colonies of North America has endured into the twentieth century.[2]

As a compendium of 220 etchings, Catesby's *Natural History* is fundamentally a visual work. Indeed, in the Preface to his publication, Catesby explicitly argued for the importance of illustration as the most effective vehicle for conveying a meaningful conception of the natural world: "The Illuminating [of] Natural History is so particularly Essential to the perfect understanding of it, that I may aver a clearer Idea may be conceiv'd from the Figures of Animals and Plants in their proper Colours, than from the most exact Description without them: Wherefore I have been less prolix in the Discription, judging it unnecessary to tire the Reader with describing every Feather, yet I hope sufficient to distinguish them without Confussion."[3] Essentially, Catesby regarded his textual passages as secondary to his prints, helping to refine an understanding of nature that was established clearly by his illustrations.

To appreciate Catesby's *Natural History* as a visual undertaking, the etchings should be examined in relation to the almost complete set of preparatory drawings that served as the basis for Catesby's work – a set of drawings that have remained undiscussed until the present time. Housed in the Royal Library since 1768,

when they were purchased by George III (1738–1818, reigned from 1760), these 263 drawings include images executed by Catesby on his expeditions to the southern colonies of North America from 1712 to 1719 and again from 1722 to 1726 (figs. 1 and 2). They also include works produced by Catesby after his final return to England, along with a number of drawings by his London colleagues (e.g. cat. nos. 16 and 47).

That Catesby prized his drawings is evident from the fact that he retained them throughout the production of his *Natural History*. In assessing his project upon its completion, he wrote: "… should any of my original Paintings have been lost, they would have been irretrievable to me, without making another voyage to *America*, since a perpetual inspection of them was so necessary towards the exhibition of truth and accuracy in my descriptions."[4] Catesby considered his drawings to be direct reflections of his empirical observations of New World flora and fauna, and in most instances he copied or traced the outlines onto the etching plate with his own hand. This ambitious project took over twenty years to complete, and it resulted in a scientific publication that Catesby's contemporaries regarded as a model of accuracy and beauty.

DEVELOPING "A GENIUS FOR NATURAL HISTORY"

Although much useful biographical information is included in Catesby's Preface, little is known of his education as a naturalist or of his training as an artist. Raised in the town of Sudbury, in Suffolk, East Anglia, he was the fourth child and youngest son of Elizabeth

Jekyll and John Catesby – a lawyer deeply involved in the political life of the town. Although Mark does not appear to have attended university or studied for the Bar, his knowledge of Latin, evident in his writings, indicates that he may have been educated at the local grammar school or by a private tutor.

Family connections probably directed the young Catesby to the study of natural history. His maternal uncle, Nicholas Jekyll, had been an associate of the renowned naturalist John Ray (1627–1705), who lived nearby in Black Notley, near Braintree, Essex. Jekyll himself lived at Castle Hedingham, Suffolk, where he developed a notable botanical garden; he may have introduced his nephew to Ray when the boy began to express an interest in the study of flora and fauna. The naturalist George Edwards (1694–1773), with whom Catesby worked closely in the 1740s, knew of his friend's early acquaintance with Ray, and believed that it had "inspired" in him "a gen[i]us for natural history."[5]

Ray not only laid the foundations for a modern system of plant classification, but through his efforts to complete and publish the writings of his deceased friend Francis Willughby (1635–1672) he significantly advanced the establishment of principles for classifying animals.[6] Ray's approach to the systematic study of flora and fauna deeply impressed Catesby, who came to rely upon Ray's and Willughby's publications as standard references for use in his field work in the colonies. He also used their books as models for organizing his own *Natural History*.

Many of Ray's and Willughby's publications are extensively illustrated, and they may have impressed upon the young Catesby the importance of visual images in helping to define species of animals and plants and to characterize natural phenomena (fig. 3). In fact, Catesby's first drawings of flora and fauna may have been modeled on prints in their books, as well as in other scientific publications. Catesby would have had access to such illustrated works through the library of Ray's colleague Samuel Dale (c. 1658–1739) of Braintree, Essex. Dale served as a collector for Ray during the great naturalist's final years and was a respected botanist in his own right.[7] He counted Nicholas Jekyll among his friends and often visited Castle Hedingham to discuss botany and examine specimens in his garden. Dale took the young Catesby under his wing and proved to be an enduring patron of his work.

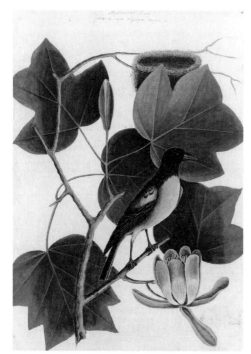

Fig. 1 Catesby, 'The Baltimore Bird' (RL 25880)

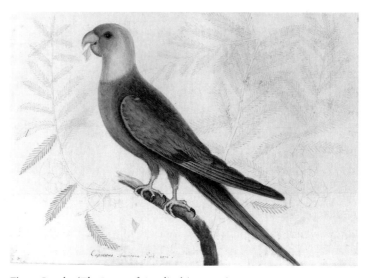

Fig. 2 Catesby, 'The Parrot of Carolina' (RL 24824)

Although their levels of professional involvement in the examination of the natural world differed, Catesby's mentors all focused more on the study of flora than on fauna or physical phenomena. It is therefore not surprising that Catesby developed a central interest in botany. Like Ray, however, Catesby was inclined to study not only plants but "other Productions of Nature," and in 1712 he extended the scope of his examinations beyond East Anglia to the continent of North America.[8] By this time a young man of small but independent means, Catesby availed himself of the base provided by his sister Elizabeth in Williamsburg, the capital of the Virginia colony, where her husband, Dr. William Cocke, had a medical practice.[9]

CATESBY'S EXPEDITION TO VIRGINIA, 1712–1719

When Catesby arrived in Williamsburg, the city was already a relatively sophisticated commercial and governmental center, and Catesby quickly came to know the wealthy and powerful associates of his brother-in-law. A close-knit group of merchants, planters and politicians, including Thomas Jones (1701–1758), John Custis (1678–1749) and William Byrd II (1674–1744), formed the heart of Catesby's horticultural and scientific community. Like many affluent landowners across the Atlantic, they developed gardens on their estates in which they experimented with plants from the wild that might be cultivated for practical purposes as well as for their beauty.[10] Custis and Byrd were particularly interested in the scientific analysis of the natural world, and welcomed Catesby as a friend with whom they might conduct horticultural experiments and make observations.[11]

As Catesby traversed the woods and fields of Virginia's Tidewater plantations and traveled up the James River toward the Appalachian Mountains, he collected seeds, plants and specimens for Samuel Dale and the experimental horticulturalist Thomas Fairchild (1667–1729), whose nursery at Hoxton, in Shoreditch on the outskirts of London, would become famous for its supply of North American species.[12] In addition, Catesby drew the plants he collected, along with birds and other animals he believed to be indi-genous to Virginia. Prompted by his reading of the first volume of *A Voyage to the islands Madera, Barbados, Nieves, St. Christophers and Jamaica*, published in 1707 by Sir Hans Sloane (1660–1753), Catesby also traveled to Jamaica in 1714 to examine the flora and fauna of the West Indies. Although he later expressed regret over his undisciplined approach to the study of natural history on this first expedition to the New World,[13] at the time he developed techniques for drawing and collecting in the field that were to benefit him greatly on his next voyage to America, when he would begin work on the *Natural History*.

PREPARATIONS FOR A SECOND EXPEDITION

The group of drawings that Catesby brought back from Virginia must have been impressive since these works helped him to secure funding for his second expedition. Soon after his return to England, Catesby showed his illustrations to Samuel Dale who, on October 15, 1719, reported to the botanist William Sherard (1658–1728): "Mr. Catesby is come from Virginia ... He intends againe to return, and will take an oppertuniity to waite upon you with some paintings of Birds &c. which he hath drawn. Its [a] pitty some

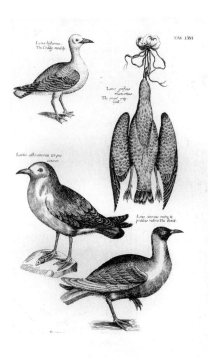

Fig. 3 Unidentified artist, 'The Great Grey Gull' (Ray 1678, Plate LXVI)

incouragement can't be found for him, he may be very usefull for the perfecting of Natural History."[14] Catesby and Dale had clearly begun to discuss a second voyage to America, and they hoped to enlist Sherard's support for the expedition.

In the Preface to his *Natural History*, Catesby described Sherard as "one of the most celebrated Botanists of the Age" – an opinion shared by most of Sherard's contemporaries.[15] Catesby's knowledge of New World plants as well as his abilities as an artist and collector impressed Sherard, who, on November 12, 1720, remarked to the gardener and horticulturalist Dr. Richard Richardson that Catesby "designs and paints in water colours to perfection."[16]

It was Catesby's good fortune to meet Sherard just as the great botanist was beginning to discuss with a group of colleagues the possibility of sending a naturalist to America. In September of 1720 Sherard informed Richardson that the artist Eleazar Albin (fl. 1713–59) had been asked to go "to Carolina to paint there in the summer months, and in the winter to paint in The Carribbe ilands."[17] Albin, however, declined the offer and Catesby was then approached.

At the meeting of the Royal Society on October 20, 1720 Colonel Francis Nicholson, who was leaving to serve as the first Royal Governor of South Carolina, declared that throughout his tenure he would grant Catesby a pension of £20 per year "to Observe the Rarities of the Country for the uses and purposes of the Society."[18] While the Royal Society itself did not offer financial support for Catesby's expedition, Nicholson's statement implies that the institution approved of the expedition, bestowing on Catesby's undertaking the prestige necessary to secure other backers.

Sherard and Nicholson were joined in their patronage by several prominent men in the world of science and collecting, including Sir Hans Sloane. Other supporters included Charles Dubois (1656–1740), a merchant who as treasurer of the East India Company amassed a large herbarium representing Asiatic species;[19] James Brydges (1673–1744; Duke of Chandos from 1719), whose interest in botany resulted in a famous garden at his estate, Cannons;[20] and Dr.

Richard Mead (1673–1754), whose eminence as a physician and supporter of scientific research as well as his renown as a collector of books and art were virtually unsurpassed in his day.[21]

For a short period at the beginning of 1722, James Brydges attempted to press Catesby to travel to Africa in the service of the Africa Company. However, Sherard and Nicholson expressed objections and by the end of the year Catesby was bound for Carolina. He embarked for Charles Town in February 1722.

THE CAROLINA EXPEDITION, 1722–1726

In the early 1720s Carolina was far less developed than Virginia. Founded in 1663, the colony still served as a British line of defense against the Spaniards, French and Indians to the south and west, with Charles Town not far from the frontier. Politically, Carolina was also in an early phase of development. In 1712 the colony's northern and southern regions had been divided, to be administered by two separate governors. A series of uprisings against the original Proprietors of the colony had ended only a year before Catesby's arrival, when his supporter Francis Nicholson was sent to govern South Carolina.[22]

As in Virginia, active land speculation was rapidly centralizing control of the Piedmont, to the west, in the hands of wealthy Tidewater planters. These powerful members of Carolina society wished to know the range of natural resources that might be exploited for profit, and Catesby's expedition would have appealed to them on practical as well as intellectual grounds. Indeed, through Nicholson, Catesby became friendly with members of the most affluent Charles Town families, on whose estates outside the city he made his first forays into the field, and whose gardens he supplemented with American plants collected on his expeditions and European plants sent by English colleagues.

To survey the broadest range of flora and fauna, Catesby recognized the need to visit each region he explored during different seasons.[23] Over the course of two years, he made three trips to the frontier garrison, Fort Moore, "140 miles up Country" on the

Savannah River, near the future site of Augusta, Georgia.[24] These trips gave him the opportunity to explore the Piedmont in every season but late autumn and winter. He also made a thorough survey of the coastal plain.

Catesby seems to have had little assistance in the field. Before beginning his first expedition to Fort Moore in 1722–23, he wrote several times to Sherard regarding the purchase of a "Negro Boy," but he never mentioned the slave again.[25] On later visits to the Piedmont he reported that he "employ'd an *Indian* to carry my Box, in which besides Paper and Materials for Painting, I put dry'd Specimens of Plants, Seeds, &c. – as I gather'd them."[26] Catesby must have greatly valued this assistance since he was burdened with the task of collecting duplicate specimens for his patrons (fig. 4) as well as supplying them with copies of his drawings. Periodically, he complained that his role as a supplier was preventing him from working on his *Natural History*.[27] This worry was compounded by the concern that his supporters would expect him to divide his own collection of drawings and specimens among them. In August 1724 Catesby complained to Sloane that dispersing his personal reference materials would reduce his ability to produce a successful publication: "My Sending Collections of plants and especially Drawings to every of My Subscribers is what I did not think would be expected from me My design was Sr... to keep my Drawings intire that I may get them Graved, in order to give A genll History of the Birds And other Animals, which to distribute Seperately would wholly frustrate that designe, And be of little value to those who would have so small fragments of the whole."[28] Since Catesby relied, at least in part, upon the support of his sponsors to keep him in the field, he was compelled to balance his own wish to assemble drawings and specimens for his *Natural History* against his backers' desires for additions to their personal collections.

As Catesby pursued his work in the field, he was also forced to prioritize his areas of study since he was faced with more species than he could draw or collect on his own.[29] His driving interest in botany caused him to pay closest attention to plants. The examination of natural resources was always foremost on his mind, and he noted that he "had principally a Regard to Forest-Trees and Shrubs" because of their use "in Building, Joynery, Agriculture ... Food and Medicine."[30]

Catesby next focused on birds, believing them to be the most numerous and beautiful of living creatures. As a botanist, he particularly valued birds because he thought that they had a closer "relation to the Plants on which they feed and frequent" than any other type of animal.[31] Since he planned to visit the Bahama Islands later in his trip, Catesby decided to postpone a full-scale examination of marine life until he reached the Caribbean. He also concluded that North American mammals differed little from those of Europe, and so drew only those which he believed had not yet been depicted by other naturalists. He attempted to illustrate as many snakes as possible, along with other reptiles and amphibians; but he resisted portraying insects because he considered that they were too numerous to illustrate comprehensively.

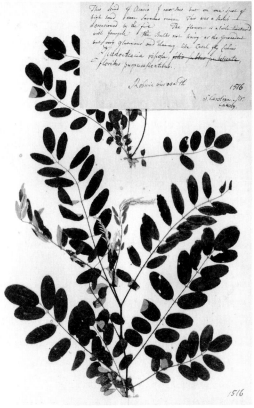

Fig. 4 One of Catesby's specimens of '*Pseudo Acacia*' (Sher. Herb., spec. no. 1514)

Catesby executed his drawings in watercolor and gouache to capture the colors of live animals and plants as accurately as possible.[32] He claimed that he produced his botanical studies from freshly gathered specimens, attempting to illustrate the leaf structure of each plant, along with its fruits and flowers, so that his images could be used to identify individual species at different times of the year. He wrote little regarding his techniques for depicting birds and mammals, but he noted that he produced his drawings of animals *ad vivum* whenever possible to illustrate their characteristic "gestures." He reported that in making ichthyological studies he found it necessary to have a series of specimens procured in rapid succession because fish quickly change color when taken from the water. He also remarked on the ease of drawing reptiles since they can be kept alive for long periods of time without food.

In August 1724, Catesby reported to Sherard that although he was willing to remain in Carolina or travel to the Bahama Islands, he wished to join the Charles Town physician Thomas Cooper in exploring "the remoter parts of this Continent perticularly Mexico in order to improve Natural knowledge."[33] Catesby hoped that if he received "a Moderate encouragement" and the help of a painter from London, Paris or Amsterdam, that "in a very few Years" he would be able to produce "No Mean Collection of Unknown Productions."[34] He received no response to his request and in 1725 traveled to the Bahamas as the guest of Governor George Phenney.[35] While exploring the islands of New Providence, Eleuthera, Andros and Abaco he executed drawings of fishes and crustacea as well as plants. He then considered himself ready to return to "the Center of all Science" to publish his *Natural History*.[36]

GENERATING SUPPORT FOR THE NATURAL HISTORY

Resettling in London in 1726, Catesby immediately sought the means to produce his publication. He financed his project in part by his work as a horticulturalist at Thomas Fairchild's nursery. After Fairchild's death in 1729, Catesby continued in his position under Stephen Bacon until soon after Bacon's death in 1733.

He then worked for Christopher Gray's nursery in Fulham, where he may have cultivated his own botanic garden.

Catesby's prominence as an importer of American species helped him with his work on the *Natural History*.[37] Through his colleagues' gardens and specimen collections he gained access to examples of American flora (and occasionally fauna) that he had not encountered on his expeditions to the New World, and he incorporated drawings and descriptions of these species into his publication.[38] Catesby's contact with gardeners, and with the landowners for whom they worked, also supplied him with a significant number of subscribers for the *Natural History*. These subscribers valued Catesby's publication as the first illustrated catalogue of North American plants, enabling them to visualize the products of the seeds available through nurseries dealing in exotics or more directly through American collectors.[39] Toward the end of his life, Catesby reported on the successful introduction of American plants to the English garden in his *Hortus Britanno-Americanus*. This book, illustrated with reworked details of botanical illustrations from the *Natural History*, was not, however, published until 1763, fourteen years after Catesby's death.

Catesby generated additional support for the *Natural History* through his association with the Royal Society.[40] He not only attended meetings and delivered papers, which were published in the Society's *Philosophical Transactions*, but he was also commissioned to draw for the Society's *Register Book*.[41] At meetings he was often the guest of Peter Collinson (1693/94–1768), a wealthy wholesale linen draper whose passion for natural history led him to become the most important conduit of scientific information back and forth across the Atlantic.[42] Collinson became the prime backer of Catesby's publication, and it was in Collinson's company, on February 1, 1732/33, that Catesby was nominated a Fellow of the Royal Society, in recognition of the completion of the first volume of the *Natural History*.

Collinson lent Catesby "considerable Sums of Money ... without Interest" to see the *Natural History*

into print,[43] and he acted as a liaison, putting Catesby in touch with colonial naturalists such as John Bartram who supplied him with new specimens for inclusion in his work.[44] Several of the sponsors of Catesby's Carolina expedition also helped to support the publication of the *Natural History* and promote its sale. Sir Hans Sloane, who was elected President of the Royal Society the year after Catesby's return to London, was an important ally, lending his imprimatur to Catesby's work through his patronage and friendship. Perhaps in return for his aid, Sloane asked Catesby to depict specimens from his ever-growing collection of natural curiosities.[45] Undertaking this task, Catesby gained access to Sloane's extensive collection of natural history illustrations, enabling him to copy drawings of American flora and fauna by other naturalists for inclusion in the *Natural History* (see cat. nos. 23, 26, 36, 38, 39).[46]

Catesby also had frequent contact with William Sherard, who, until his death in 1729, helped to supply the Latin names for the plants Catesby hoped to illustrate in his work.[47] Sherard probably made his identifications from specimens Catesby had sent from North America, as well as from Catesby's drawings.

PRODUCING THE PUBLICATION

Lacking the funds to send his drawings to Amsterdam or Paris to be copied by professional engravers, and wishing to maintain control over the printing of his images, Catesby solicited the help of the printmaker and drawing master Joseph Goupy (c. 1698–c. 1782) to teach him how to etch his own plates.[48] In the process of deciding which drawings to reproduce and the order in which the prints should appear, Catesby developed a structure for the two volumes that were to constitute the *Natural History*.[49] He determined that the first hundred etchings, for Volume I, would portray birds, frequently in association with the plants on which they feed. He grouped the next hundred plates, for Volume II, into sections illustrating fishes, crustacea, reptiles, amphibia, mammals and insects, often with plants from their natural habitats. Among the plates in the second volume, Catesby also included a

number of botanical illustrations portraying individual plants alone on the page. Late in the publication process, Catesby decided to produce an Appendix of twenty plates illustrating animals and plants he had not been able to include in the main body of the *Natural History*: many of these illustrations are of species that Catesby had not had the opportunity to observe on his travels. He executed these images from specimens sent to England by colonial naturalists and collectors and, in certain cases, after drawings by other artists (see p. 33).

Catesby chose to sell his book by subscription, stating in his *Proposals for Printing a Natural History* (fig. 5), issued in 1729, that he would sell each part, consisting of twenty uncolored plates and their accompanying descriptions, for one guinea.[50] He added that "For the Satisfaction of the CURIOUS, some copies will be printed on the finest Imperial Paper, and the Figures put in their Natural Colours from the ORIGINAL PAINTINGS; at the Price of Two Guineas." He projected optimistically that he would produce one part every four months, but he did not adhere to this schedule.

Catesby presented each part, upon its completion,

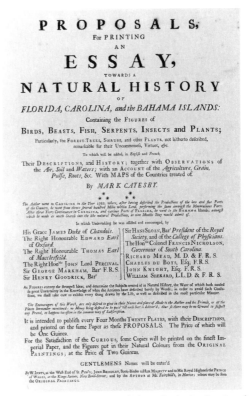

Fig. 5 Catesby's *Proposals* (Chelsea Physic Garden, London)

to the Royal Society, giving parts I–V, to make up Volume I, between 1729 and 1732 (the publication date on the title page is 1731). He then presented parts VI–X, constituting Volume II, between 1734/35 and 1743, and the Appendix in 1747. Following standard publication practices of the day, Catesby apparently included the introductory matter for Volume I with the last part issued for that volume.[51] This consisted of the title page, dedication, list of 154 subscribers and the Preface. Catesby dedicated the volume to Queen Caroline (1683–1737), whose interest in gardening was well known.[52]

As a preface to the second volume, Catesby prepared an "Account of Carolina and the Bahama Islands," in which he described the climate, soil and topography of the regions he had explored.[53] He also amplified his discussion of the animals and plants he had observed, including information on species he had not illustrated. Catesby discussed the agriculture of

Virginia and Carolina and – with the assistance of John Lawson's *The History of Carolina* (London 1714) – he described the manners and customs of the peoples native to North America.[54] In most bound sets of the *Natural History*, the Account is preceded by a map of Britain's colonial possessions in the Americas (fig. 6), which Catesby adapted from Henry Popple's "Map of the British Empire in America with the French and Spanish Settlements Adjacent Thereto" (London 1733).[55] Dedicating the second volume to Princess Augusta (1719–1772), wife of Queen Caroline's eldest son, Frederick, Prince of Wales, Catesby again sought to associate the *Natural History* with the name of a royal gardener.[56]

As Cromwell Mortimer's series of laudatory reviews for the Royal Society's *Philosophical Transactions* attest, Catesby's *Natural History* assumed immediate importance as a visual and descriptive

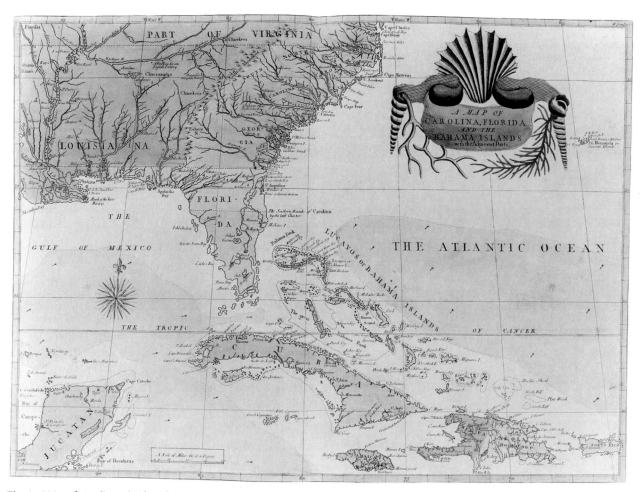

Fig. 6 *A Map of Carolina, Florida and the Bahama Islands* (after H. Popple), included in the *Natural History*

introduction to the flora and fauna of North America and the Caribbean.[57] The publication retained its significance over the course of the century even though much of Catesby's work predated the innovations introduced by the Swedish naturalist Carl Linnaeus (1707–1778) for the classification of flora according to sexual characteristics and for the naming of animals and plants with simple binomials rather than long, descriptive appellations.[58] Since Catesby's work remained the primary illustrated publication on North American and Caribbean species, Linnaeus and other mid-eighteenth-century naturalists, including Johann Friedrich Gronovius, John Jacob Dillenius and Phillip Miller, drew heavily upon Catesby's images (and, to a certain extent, his descriptions and even designations) to complete their own identifications of American animals and plants.[59]

The importance of the *Natural History* as an illustrated guide to American species caused the work to be republished several times.[60] In 1754, five years after Catesby's death, his colleague George Edwards revised and reissued the original publication, using Catesby's plates for the illustrations.[61] In 1771, the publisher Benjamin White reissued Edwards's edition, with a catalogue of the Linnaean names of Catesby's animals and plants.[62] Pirated editions of the *Natural History* were also printed in Nuremberg, the first appearing between 1749 and 1776.[63]

THE RELATION OF CATESBY'S DRAWINGS TO HIS PRINTS

It is only by studying Catesby's drawings that we can begin to understand the technical and intellectual processes by which he created the prints for his *Natural History*. A comparison of the etchings with the drawings upon which they were based illustrates, for example, the many steps taken by Catesby to compose prints depicting the relationships that exist between animals and plants from the same habitats.

As Catesby indicated, he was not absolutely consistent in his attempt to portray environmental associations in his prints, undertaking this approach only "where it would be admitted of."[64] However, the images associating animals and plants occur with such frequency throughout the *Natural History* that the illustration of the ways in which species interact can be said to constitute the main thrust of his work.

The method by which Catesby combined drawings of individual animals and plants to create more complex compositions for his illustrations can be seen through a comparison of Plate 33 in Volume I with the drawings from which the plate was composed (figs. 7–9). Catesby drew separate studies of 'The Large Lark' and 'Little Yellow Star-Flower,' which he brought together to create his etching for the second part of the *Natural History*. He reserved the image of the 'Honeysuckle' and 'Titmouse,' which appears on the same

Fig. 7 Catesby, 'The Large Lark' (RL 24846)

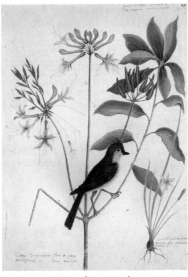

Fig. 8 Catesby, 'The Crested Titmouse, the Upright Honysuckle and the Little Yellow Star-Flower' (cat. no. 11)

Fig 9. *Natural History*, I, Plate 33

19

sheet as that of the 'Star-Flower,' for Plate 57, which he released with the fifth part. As this example makes clear, Catesby must have begun the publication process by laying out his drawings to select the combinations of flora and fauna that he wished to illustrate in each plate. He then grouped these projected plates into the parts that would constitute each volume. In order to translate most of his drawings into etchings, he may have copied or traced the images onto intermediary sheets of paper, which he then used to transfer the designs onto the plates.[65] As he transposed his drawings into etchings, he altered small details, corrected mistakes, and split images to accommodate the introduction of additional subjects into his compositions. The blossom shown in the original drawing of the 'Star-Flower,' for example, has six petals, but Catesby reconsidered the number, and the plate shows only five to correspond with the description of the plant in the accompanying text.

In combining his individual studies of animals and plants to compose his final prints, Catesby characteristically caused his subjects to reflect one another in terms of color and form. In his etching of the 'Large Lark' and the 'Star-Flower,' the vivid color of the blossom is repeated in the breast and neck feathers of the bird, and the branching roots of the plant mirror the bird's spread claws. In addition, the arching leaves follow, in reverse, the form of the lark's head and swelling breast, while the lark's tail flows into the largest leaf of the plant which rises to close a circle with the bird's beak. This harmonized composition is not only aesthetically pleasing; it suggests ties between the bird and plant that are reiterated in the naturalist's verbal description of his subjects: "This plant grows plentifully in most of the open Pasture lands in *Carolina* and *Virginia*, where these Larks most frequent and feed on the seed of it."[66] Brief statements of this kind, describing shared habitats and feeding relationships, often accompany plates that combine species from the same environment, strengthening the visual associations suggested by the compositions of individual prints.

Using reflected color and form as a rhetorical device to unify animals and plants that interact in the wild, and supporting his visual arguments with textual description, Catesby developed a new format for the illustration of flora and fauna.[67] He had few visual prototypes upon which to model his examinations of environmental interplay, because the thrust of the organic sciences since the Renaissance had tended toward the physical description of individual species for the sake of classification.

Catesby generally rejected the traditional format of the specimen drawing for his final compositions, incorporating even those images that he appropriated from other naturalists into more complex studies of organic interaction. From Hans Sloane's collection,

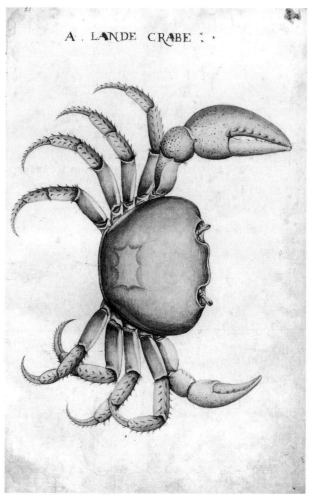

Fig. 10 After John White, 'Lande Crabe' (Sloane MS 5270, f. 16)

for example, he copied at least seven drawings of animals that were themselves copies of works by the artist John White (c. 1545–1606?), who had accompanied Sir Walter Raleigh's expeditions to Virginia in the 1580s.[68] Catesby altered these images to suit his needs, working several of them into compositions that stress the interplay of animals and plants. In his depiction of the 'Land Crab,' for example, he copied one drawing after White's work, and then added his own sketch of the *Tapia trifolia* upon which, as Catesby noted in his published text, the crab characteristically feeds (figs. 10 and 11). In composing this drawing, Catesby worked out the formal means by which to emphasize the environmental relationship of the crab and the plant. The two stems of the '*Tapia trifolia*' curve around the crab, embracing the crustacean and echoing the rounded shape of its legs. The plant's central branch points down in a 'V' toward the crab's body, and the crab's claws reach up to touch a stem of the plant on the left and a fruit on the right.

With a few minor adjustments, Catesby used this composition as the basis for his etching (fig. 12). Most of the changes involve the compression of the plant to fit the plate. One subtle alteration, however, enhances the character of the work as a study of organic interaction: Catesby opened the crab's claws to grasp the plant's stem and pluck the fruit. The naturalist thus transformed a traditional specimen drawing into a composition reflecting his own observations of the way in which two species interrelate in their shared habitat.

Images by the Dutch naturalist-artist Maria Sibylla Merian (1647–1717) were among the few that may have served as helpful models for Catesby as he developed a compositional format to portray environmental relationships. Merian was interested in the interplay she observed between insects and the plants that serve as their food, and she illustrated these associations in her work.[69] In 1699, she traveled to the Dutch colony of Surinam to illustrate tropical butterflies and moths little known to European naturalists. Returning to Amsterdam in 1701, she set about publishing her drawings, which appeared as *Metamorphosis Insectorum Surinamensium* in 1705. This work, which shows South American butterflies and moths as well as other insects and reptiles in relation to the plants upon which they feed, was a first of its kind, and it came to be regarded highly by the circle of English naturalists of which Catesby was a part.[70] Merian was an active correspondent of the London apothecary and collector James Petiver, who seems to have been interested in publishing an English edition of the *Metamorphosis*; and Richard Mead and Hans Sloane both acquired large collections of her watercolors, including full sets of the drawings that correspond to the plates of the Surinam publication.[71] That Catesby knew and respected the *Metamorphosis* is clear from his reference in the *Natural History* to Merian's depiction of the cashew.[72] He may also have had access to Merian's original drawings through the collections of Sloane and Mead.

The comparison of a drawing from Mead's collection

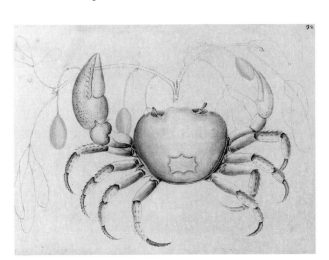

Fig. 11 Catesby, 'The Land Crab' (RL 25977)

Fig. 12 *Natural History*, II, Plate 32

of Merian's work for the *Metamorphosis* (now in the Royal Library)[73] with a drawing by Catesby for the *Natural History* demonstrates the affinity between Merian's dramatic compositions combining lepidoptera and flora and Catesby's unusual illustrations of environmental interchange. Merian's drawing for Plate 5 of her publication illustrates the life-cycle of a moth that characteristically feeds on the leaves of the *Cassava* plant (fig. 13).[74] Merian not only shows the moth at various stages of development in association with the *Cassava*, but also includes the depiction of a pregnant snake, twining around the plant's stalk. The snake is reaching down to catch an insect on the root of the *Cassava*, having deposited a clutch of eggs on another root on the opposite side of the plant. Through the repetition of oval forms, Merian draws parallels concerning gestation and maturation between the pregnant snake and her eggs and the moth as a chrysalis, caterpillar and fully formed insect. The well developed roots of the *Cassava* serve as the support for the composition, echoing the oval shapes of the animals depicted.

Catesby's finished drawing of 'the Bead Snake and the Virginian Potato' for Plate 60 in Volume II of the *Natural History* is far simpler in form and conception than Merian's work (fig. 14). He does not include insects of any kind in his image, focusing entirely upon the relation between the snake and plant. And yet, the way in which Catesby weaves the snake around the stem of the root vegetable is reminiscent of Merian's work, suggesting that he may have been looking at her illustrations for compositional solutions to the problem of how to depict animals and plants in environmental relationships. While Merian had included the snake in her composition only "to complete the decoration," Catesby showed the 'Bead Snake' with the 'Virginian Potato' to illustrate a real relationship he had observed in the field: as he explained in the text accompanying his published plate, the snake lives underground and is often dug up with the potatoes when they are harvested.[75]

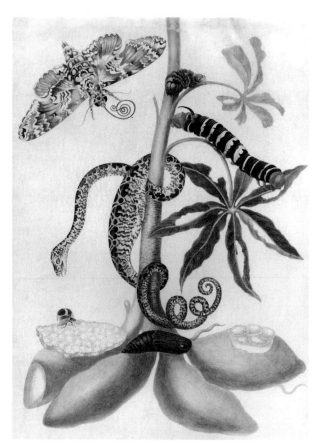

Fig. 13 Maria Sibylla Merian, *Cassava*, *Manduca rustica* and *Corallus enhydris* (RL 21159)

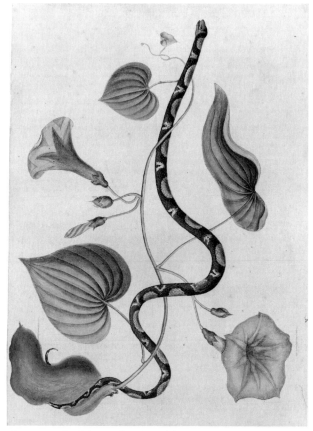

Fig. 14 Catesby, 'The Bead Snake and the Virginian Potato' (RL 26011)

Although in the final plates of the *Metamorphosis* Merian began to depict her subjects in landscape settings, Catesby rejected landscape almost entirely in his prints for the *Natural History*, favoring a more abstract approach to the depiction of environmental interplay. A few of the published plates illustrating aquatic birds show their subjects against bodies of water containing islands with palm trees or ships sailing in the distance; but generally Catesby's etchings combine environmentally related animals and plants in compositional arrangements that do not include more extensive vistas.

That Catesby consciously chose to omit landscape settings from his published prints becomes clear through an examination of his preparatory drawings for the *Natural History*. Two of Catesby's finished studies, along with one drawing by George Edwards, include larger views which Catesby pointedly eliminated when he copied the works to make his etchings.[76] Comparing the finished drawing for the first plate of the *Natural History* with the print itself indicates that Catesby reached his decision to exclude landscapes from his prints at the very beginning of the publication process (cat. no. 1 and 1.1). After arranging his many drawings to make his etchings, Catesby may have realized that he would not have time to develop a full-scale landscape in every print, and that he would have to adopt a simpler approach to the portrayal of organic interaction.

It might at first seem surprising that in seeking an efficient way to depict interchanges between species Catesby chose to use the traditional conventions of the specimen drawing, isolating his subjects from the larger environmental contexts in which he had observed those interchanges taking place. And yet, by combining individual animals and plants in clever compositional arrangements, Catesby developed an innovative approach to the portrayal of flora and fauna, illustrating a world of organic interplay that had rarely been examined by his predecessors. The elimination of landscape settings from Catesby's final compositions for his prints lends them an emblematic quality that seems to stress the timeless nature of the associations depicted. This sense of timelessness is enhanced by the flatness of Catesby's images – a flatness he attributed to his lack of training as an artist, but which he also considered advantageous to his work, removing it from the arena of art and placing it in the realm of pure description.[77]

At heart, however, Catesby understood his drawings and prints not as objective reflections of the natural world, but as human constructs. His belief in his illustrations as the products of human invention is suggested by the way in which he signed his works. While Catesby did not attach his name to any of the drawings now at Windsor, he often credited himself as the maker of his published prints.[78] He began to sign his prints with some consistency when he etched the plates for the third part of his publication.[79] At this time, he also began to integrate his monogram, MC, into the structure of his images. In Plate 57, illustrating the 'Crested Titmouse' and 'Upright Honysuckle,' for example, his signature hangs from the end of a broken twig like a spider dangling from a filament of web (11.1). Catesby clearly took pleasure in presenting his name in the form of this small, but slightly menacing creature, repeating the image in Plate 6 of his Appendix (48.1), and in his final print of the *'Bison Americanus'* and *'Pseudo Acacia'* (38.1). He also playfully made his initials peel off the bark of a broken branch (Volume I, Plate 62), serve as food in the mouth of a fish (Volume II, Plate 2) and resemble the buried seeds of the *'Meadia'* (Appendix, Plate 1). By incorporating his signature so completely into the design of his images, Catesby implied that his own persona was inseparably enmeshed in his representations.

THE COLLABORATION OF GEORG DIONYSIUS EHRET (1708–1770)

The only signature other than Catesby's to appear on the plates of the *Natural History* is that of Georg Dionysius Ehret, the German botanical illustrator who, by the middle decades of the eighteenth century, was appreciated as the finest practitioner of the art in England. Although Catesby claimed in his text to be the sole creator of his images, when he came in contact

with Ehret in the mid-1730s he decided to take advantage of Ehret's skilled hand – in both drawing and etching – to produce illustrations for the second volume of his publication.[80]

Ehret arrived in London in 1735 from the Jardin des Plantes in Paris with letters of introduction from the great French horticulturalist Bernard de Jussieu addressed to many of Catesby's colleagues, including Peter Collinson and Hans Sloane.[81] Catesby became the first English naturalist to publish Ehret's work, inviting (or perhaps employing) him to contribute illustrations to the *Natural History* from 1736 on.[82]

Ehret allowed Catesby to use his spectacular image of the *'Magnolia altissima'* as Plate 61 of Volume II (fig. 15), and he etched Catesby's own drawing of the 'Mangrove Grape Tree' as Plate 96 of the same volume. Ehret also supplied Catesby with drawings which Catesby himself etched for other plates in Volume II. Two of Catesby's plates portraying individual plant specimens are based on drawings by Ehret, while eight

plates depicting more complex environmental relationships combine drawings by Ehret and Catesby.[83]

ILLUSTRATION AS ARTIFICE OR TRUTH

Deeply impressed by Ehret's work, Catesby began to employ his colleague's sophisticated techniques for portraying plants in three dimensions, foregoing to a certain extent the argument he himself espoused that flat images make preferable scientific illustrations because they are free from the niceties of artistic convention.[84] Catesby attempted to give life to his subjects, contouring their forms according to Ehret's method for creating highlights and shadows. The Windsor volumes include, for example, a pair of drawings by Ehret and Catesby which depict the same branch of the *'Chamaedaphne'* – a plant that bloomed in England for the first time in 1740, in Catesby's own garden (cat. nos. 46 and 47). Catesby's version, which served as the basis for Volume II, Plate 98, owes a clear debt to Ehret's work. Although Catesby depicted more leaves and portrayed a looser cluster of flowers and straighter stem, he clearly sought to emulate Ehret's technique for shading leaves to represent three-dimensional forms.

Catesby's heightened interest in mastering the artistic conventions that would allow him to create convincing representations of living plants and animals in the round is nowhere more perfectly expressed

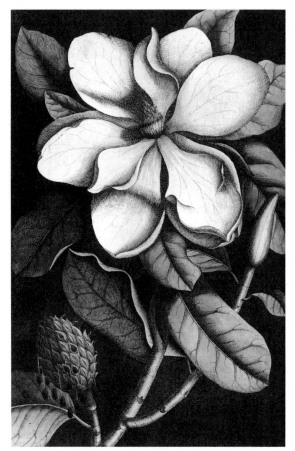

24

Fig. 15 Georg Dionysius Ehret, 'The Laurel Tree of Carolina' (*Natural History*, II, Plate 61)

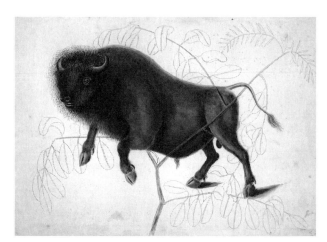

Fig. 16 Catesby, 'The *Bison Americanus* and *Pseudo Acacia*' (cat. no. 38)

than in one of his drawings of the *'Bison Americanus'* and the *'Pseudo Acacia'* – an image he rejected as the model for the print contained in the *Natural History*, but which he preserved with three other studies related to the print (fig. 16; cat. no. 38). In this work, Catesby portrays the bison rearing into the viewer's space. The creature confronts us directly with his curious, one-eyed gaze, insisting that we acknowledge his presence in our world. And yet the illusionism of the image is created almost comically, as the bison leaps over the flat form of a traditional specimen drawing of the *'Pseudo Acacia'*. The depiction of the plant is only half completed; the sketched outlines and partially colored forms emphasize the drawing process itself and consequently the work's essential character as a human creation. This notion of the work as the product of human invention is furthered by the fact that Catesby based the image of the bison not on his empirical observations of the animal in the field, but on another work of art: a drawing of a bison by the Dutch artist Everhard Kick (1636–after 1705) in the collection of Hans Sloane (V.2).[85]

The drawing Catesby chose as the final model for his print of the *'Pseudo Acacia'* and the *'Bison Americanus'* makes a less dramatic pronouncement about the nature of the image as a human construction (38.1 and 38.2). However, the tension between the flat portrayal of the branch of the plant and the more natu-ralistic depiction of the animal still conveys Catesby's belief in the artifice of illustration.

Although, on one level, Catesby may have under-stood his drawings to be the outcome of an active and sometimes amusing imagination, at the same time he believed these works to be reliable disseminators of in-formation about the natural world derived directly from empirical observation. The decades of his life that he devoted to the production of these illustrations attest to his faith that his work would, as his friend Dale had suggested, contribute to "the perfecting of Natural History."[86]

In the closing lines of the text accompanying his final print of the *'Bison Americanus'* and *'Pseudo Acacia'*, Catesby wrote: "however accurately human art may be exercised in the representation of Animals, it falls far more short of that inimitable perfection so visible in Nature itself, than when attended with the circumspection and advantages I was blessed with in the compiling of my History, and which I flatter myself are in some measure conspicuous therein."[87] Whereas all "human art" might fail at duplicating the works of Creation, Catesby believed that his own illustrations reflected the distinct advantage he had enjoyed in examining living animals and plants in their native habitats. Indeed, he believed that this experience had lent his images a small part of the "perfection so visible in Nature itself."

NOTES AND REFERENCES

1 Mortimer 1748, pp. 157–73.

2 Frick and Stearns 1961, pp. 66, 102. Unless otherwise noted, facts pertaining to Catesby's life and the publication of his *Natural History* are derived from Frick and Stearns 1961.

3 Preface, pp. xi–xii.

4 Appendix, p. 20.

5 As quoted in Frick and Stearns 1961, p. 9.

6 Stearns 1970, pp. 171–76. For a detailed account of Ray's scientific contributions see Raven 1950.

7 Dale published his *Pharmacologia* in 1693, and contributed frequently to the *Phil. Trans.*

8 Preface, p. v.

9 Catesby's sister, Elizabeth (c. 1680–1753), married the physician William Cocke. Soon after 1700 they emigrated to Williamsburg, Virginia, where Dr. Cocke prospered in his medical practice and became a successful politician. In 1712, under the patronage of Lieutenant Governor Alexander Spotswood, Cocke was sworn in as Secretary to the Colony, and the following year he became one of Her Majesty's councilors.

10 For information on colonial American horticulture see Hedrick 1950, Spongberg 1990 and O'Malley 1997.

11 In later years, although Custis did not become a subscriber to the *Natural History*, Catesby sent him prints in exchange for specimens: see, for example, Custis to Catesby, June 1730, in Swem 1948, p. 39. Byrd sought Catesby's help with the illustration of several publications and was a subscriber to Catesby's *Natural History* (Pritchard and Sites 1993, pp. 4, 27, 57, 106, 156, 159, 161, 162, 164, 165).

12 On Fairchild see Chambers 1993, pp. 141–44.

13 Preface, p. v.

14 Dale to Sherard, February 24, 1718 (RS: SH 196).

15 Preface, p. v. Unless otherwise noted, information on Sherard is derived from Clokie 1964.

16 As quoted in Frick and Stearns 1961, p. 19.

17 As quoted in Frick and Stearns 1961, p. 18.

18 As quoted in Frick and Stearns 1961, p. 18.

19 Desmond 1977, p. 198.

20 Henrey 1986, pp. 22, 25, 43–45, 112, 190.

21 On Mead see *DNB*; Mattley 1754; Calmann 1977, pp. 65, 68, 128. Support for Catesby's *Natural History* was also given by Edward Harley, Earl of Oxford; Thomas Parker, Earl of Macclesfield; John Perceval, Earl of Egmont; Sir George Markham, Bart.; and Sir Henry Goodrick, Bart. (*Proposals*, and Preface, p. v).

22 Billington and Ridge 1982, pp. 96, 126; Meinig 1986, pp. 177–78; McCrady 1901, pp. 678–80.

23 Catesby to Sherard, January 16, 1723/24 (RS: SH 174).

24 Catesby to Sherard, May 10, 1723 (RS: SH 169).

25 Catesby to Sherard, December 9, 1722 (RS: SH 165).

26 Preface, p. viii.

27 See, for example, Catesby to Sherard, April 6, 1724 (RS: SH 176).

28 Catesby to Sloane, August 15, 1724 (Sloane MS 4047, f. 212).

29 On Catesby's areas of concentration see Preface, pp. ix–x, xii.

30 Preface, p. ix.

31 Preface, p. ix. Catesby's special interest in birds continued over the course of his career. At the meeting of the RS on March 5, 1746/47, for example, he read a paper in which he gave one of the first accurate accounts of bird migration (see Catesby, 'Of Birds of Passage,' XLIV, *Phil. Trans.*, pt. 2, no. 483 (March, April, May 1747), pp. 435–44.

32 On Catesby's approach to drawing in the field see Preface, pp. xi–xii.

33 Catesby to Sherard, August 16, 1724 (RS: SH 178).

34 Catesby to Sherard, August 16, 1724 (RS: SH 178) and Catesby to Sloane, August 15, 1724 (Sloane MS 4047, f. 212).

35 Catesby to Sloane, January 5, 1724 (Sloane MS 4047, f. 307).

36 Preface, p. v.

37 In 1749 the gardener Thomas Knowlton reflected on Catesby's achievements: "The infinity of new Trees, Shrubs, &c. now of late introduced by him into the Gardens from North America fill me with the greatest Wonder & Astonishment imaginable" (as quoted in Henrey 1986, p. 209).

38 See, for example, cat. no. 50.

39 Catesby rewarded some of these subscribers with seeds and specimens of American plants when he received shipments from colonial friends (Henrey 1986, p. 169).

40 Twenty-nine subscribers were members of the RS, including James Brydges, William Byrd, Peter Collinson, Martin Folkes (Vice President, 1722/23; President, 1741–53), Richard Mead (Council member 1705, 1707–54; elected Vice President 1717), Philip Miller (Council member periodically), Cromwell Mortimer (Secretary, 1730–52), Francis Nicholson, John Perceval, Robert James Petre, Richard Richardson and Hans Sloane (Secretary, 1693–1712; President, 1727–41).

41 On Catesby's involvement with the RS, and a synopsis of his publications in the *Phil. Trans.*, see Frick and Stearns 1961, pp. 37–44, 47, 63, 87.

42 Collinson's correspondence offers the clearest picture of his important position as an encourager of the study of natural history and as a disseminator of seeds, plants and specimens throughout English and Continental gardens and scientific cabinets. See, for example, Henrey 1986, and Berkeley and Berkeley 1992. For general accounts of his activities as a naturalist, see Frick and Stearns 1961, Stearns 1970, Calmann 1977 and Pritchard and Sites 1993.

43 Collinson acknowledged this interest-free loan in a note on one of the endpapers of his own copy of the *Natural History*, which was given to him by Catesby in return for his financial assistance: "[Catesby] was at a great loss how to Introduce this valuable work to the World, untill he met with a Friend to assist and promote his views. He learned to Engrave and Coloured all himself. Yet it proved so very expensive, that he was many years in accomplishing the Work – being himself the principle Operator. So noble and so accurate a performance, began and finished by one hand, is not to be parallell'd" Collinson bound a selection of Catesby's drawings into this copy of the publication, together with works by Ehret and the young Pennsylvania naturalist William Bartram (1739–1823). Collinson's copy of the *Natural History* (along with an album of drawings including some by Catesby) is now in the collection of the Earl of Derby at Knowsley Hall.

44 Catesby's most important colonial contact was the Pennsylvania naturalist John Bartram (1699–1777), for whom see Berkeley and Berkeley 1982. John was the father of William Bartram (see preceding note). In 1740, Catesby proposed that he send John Bartram parts of his *Natural History* in exchange for American plants (Ewan 1967, pp. 319–20). Catesby used plants grown from Bartram's seeds to create images of new species (Ewan 1967, pp. 136, 141, 166, 255; *Natural History*, II, pp. 56, 71, 72–73, 98, and Appendix, pp. 1, 4–6, 15, 17).

45 For Sloane's drawings by Catesby, see p. 33.

46 For a discussion of Catesby's copies from Sloane's volume of copies of John White drawings, see Hulton and Quinn 1964, pp. 7, 27, 50–51 and note 68 below. For a discussion of Catesby's use of other artists' drawings from the Sloane Collection, see note 80 below, and p. 33.

47 Preface, p. xii.

48 Preface, p. xi. For Goupy, see Robertson 1988.

49 Catesby structured his *Natural History* as a two-volume publication, but since subscribers bound the parts as they chose, some sets vary in the order of their parts and in the number of their volumes.

50 Catesby presented his *Proposals* and the first part of his *Natural History* to the RS on May 22, 1729 (Frick and Stearns 1961, p. 37).

51 On June 28, 1733 Thomas Knowlton reported to Samuel Brewer: "Mr. Catesby has published his fifth part with a preaface" (as quoted in Henrey 1986, pp. 135–36). Since "The List of Encouragers" bound into most sets before the Preface

bears the line "Preface" at the bottom of the verso, both the List and the Preface must have been issued together with the last set of plates for Volume I. Regarding the map and the Account that are generally bound into Volume II, Knowlton again wrote to Brewer, on December 15, 1741: "Mr. Catesby will very soon publish his Last part to compleat ye 2 vollm. wharein youl have a map of Caralina with a Long Disertation one [on] Birds of ye East & West Indies &c with severall of ye most curious plants in America" (as quoted in Henrey 1986, p. 199).

52 See below, p. 32, note 17.

53 For a synopsis of this text and discussion of Catesby's sources, see Frick and Stearns 1961, pp. 71–76.

54 Catesby acknowledged that he based the section "Of the Indians of Carolina and Florida" on Lawson's work (Account, p. viii).

55 Catesby and Popple were probably acquainted, and may have shared information on the southern colonies. Popple was a subscriber to the *Natural History* and both men were Fellows of the RS (Frick and Stearns 1961, pp. 71–72).

56 Queen Caroline's death in 1737 caused Catesby to seek another dedicatee for the second volume (see below, p. 30).

57 See Mortimer 1748 and his earlier contributions to *Phil. Trans.* between 1730 and 1747. For a historical account of the scientific utility of Catesby's publication see Frick and Stearns 1961, pp. 55–108.

58 For discussions of Linnaeus's contributions to scientific classification and nomenclature see Mayr 1982, pp. 171–80 and Feduccia 1985, p. 9.

In December 1735, Catesby was asked by the RS to review the first edition of Linnaeus's *Systema naturae*, but he declined. He may not have believed himself competent to undertake the task since he was not a taxonomist and did not follow one system consistently in his own work (Frick and Stearns 1961, pp. 39–40).

59 For a discussion of naturalists who relied upon Catesby's *Natural History* for information concerning American species see Frick and Stearns 1961, pp. 56, 58, 60–61, 65, 67–68, 76–77, 80, 81, 94, 97, 99–108.

60 Frick and Stearns 1961, pp. 100–03, 109–11.

61 *The Natural History of Carolina … By the Late Mark Catesby … Revis'd by Mr. Edwards*, 2nd edn., London 1754.

62 *The Natural History of Carolina … By the Late Mark Catesby … Revised by Mr. Edwards*, 3rd edn., London 1771.

63 *Sammlung vershiedener ausländischer und seltener Vögel*, Nuremberg 1749–76.

64 Preface, p. xi.

65 A systematic comparison of Catesby's drawings

with his prints for evidence of tracing remains to be undertaken, but even a casual comparison suggests that Catesby may sometimes have traced his drawings to make his prints. Catesby may have known William Salmon's *Polygraphice* (1672) since Salmon also published on botany (see *Botanologia. The English herbal*, 1710). In *Polygraphice*, Salmon discussed a technique for tracing without damage to the original image (p. 55, 1685 edn.) – the method Catesby probably employed since his drawings show no physical evidence of tracing.

66 *Natural History*, I, Plate 33.

67 Only in creating prints of aquatic organisms did Catesby tend to employ a more traditional approach. Of the first forty prints of Volume II, focusing on fishes, crustacea and sea turtles, twenty-seven show their subjects as isolated from their environments. Catesby's lack of knowledge of aquatic flora probably accounts for this more conventional mode of presentation.

68 Sloane acquired copies of White's drawings (which he believed to be the originals) from a descendant of White's family some time after examining the works in 1709. Catesby copied several of these drawings to make prints for Volume II of the *Natural History*: see Hulton and Quinn 1964, I, pp. 27, 50–51.

69 Merian 1679–83.

70 Davis 1995, pp. 180–81.

71 Rücker and Stearn 1982, pp. 33–34, 41–43, 56–57.

72 In his text for Volume II, Appendix, Plate 9, Catesby politely corrected Merian's portrayal of the plant in which she reversed the positions of the fruit and nut (*Metamorphosis*, Plate 5). Catesby's knowledge of Merian's work is noted by Pritchard and Sites 1993, pp. 161–63.

73 Mead's collection of drawings by Merian was purchased by George III when Prince of Wales, in 1755; it is now in the Royal Library (see below, p. 30, and Rücker and Stearn 1982).

74 Although Merian did not name the moths and butterflies she portrayed, her representations are so accurate that clear identifications can be made from her images today (Stearn 1978, p. 16).

75 *Natural History*, II, Plate 60.

76 The two drawings by Catesby are cat. nos. 1 and 6, for *Natural History*, I, Plates 1 and 23 respectively. The drawing by Edwards is cat. no. 16 for Appendix, Plate 3.

77 Preface, p. xi.

78 Since Catesby retained his preparatory drawings during his lifetime, he probably did not see the need to sign them. He did occasionally sign drawings executed for his colleagues. Examples can be found in Collinson's collection at Knowsley Hall (see note 43).

79 *Natural History*, I, Plates 21 and 23 were the first

that Catesby signed but he did not attach his signature with regularity until he issued the prints for the third part, beginning with Plate 41.

80 In addition to works by Ehret, Catesby used drawings by several other artists in preparing his etchings. He not only based prints on copies after White's drawings (note 68), and included Edwards's image of the 'Razor-billed Black bird of Jamaica' (cat. no. 16), but he based a number of prints on drawings by the Dutch artist Everhard Kick (1636–after 1705) (for example, RL 26034 and RL 26036 for Volume II, Plates 76 and 77 respectively). Catesby also etched Volume II, Plate 92 and Appendix, Plates 6, 7 and 9 from drawings by an unknown hand (RL 26055, RL 26072: cat. no. 48, RL 26073: cat. no. 49, RL 26076).

81 Ehret Memoir, p. 50; Calmann 1977, pp. 36, 61.

82 Calmann 1977, p. 67.

83 Five drawings of the *'Magnolia altissima'* by Ehret at the Gilcrease Institute and RL 26047 representing the *'Anona'* served as Catesby's models for Plates 61 and 85 respectively. The drawings by Ehret which Catesby combined with his own to compose other plates include:

i. RL 26065, combined with an unlocated drawing probably by Catesby for Appendix, Plate 1

ii. RL 26066, combined with Catesby's RL 26067 for Appendix, Plate 2

iii. RL 26071, combined with insect in RL 26069 for Appendix, Plate 4

iv. RL 26079 (cat. no. 50), combined with insects from Catesby's RL 26077 (cat. no. 40) for Appendix, Plate 11

v. RL 26082, combined with elements from Catesby's RL 26077 and RL 26081 for Appendix, Plate 13

vi. RL 26084 (cat. no. 51), combined with insect in RL 26077 (also found in RL 26081) for Appendix, Plate 15

vii. RL 26085 (cat. no. 17) – plant by Ehret and bird by Catesby for Appendix, Plate 16

viii. RL 26086 (cat. no. 52) – composite drawing by Ehret and Catesby for Appendix, Plate 17

RL 26062 (cat. no. 47) is a drawing by Ehret closely associated with a drawing by Catesby (RL 26061: cat. no. 46); the latter served as the basis for Plate 98.

84 Preface, p. xi.

85 Catesby's failure to include both eyes in his frontal view of the bison may be a misunderstanding based on the single eye shown in Kick's profile view. Catesby's oversight may also have been intentional, enhancing the humor of his portrayal.

86 Dale to Sherard, February 24, 1718 (RS: SH 196).

87 Appendix, p. 20.

Fig. 17 Bindings of the Windsor *Natural History* volumes

Fig. 18 Title page of Volume III of the Windsor *Natural History*

Henrietta McBurney

THE WINDSOR VOLUMES

IN 1768 George III purchased the three volumes now in the Royal Library from the London bookseller and publisher Thomas Cadell.[1] The large folio volumes are bound in red morocco, each cover featuring a gilt border made up of several tools, including suns,

moons and stars, and a large central diamond-shaped lozenge of floral and other ornaments (fig. 17); the spines are similarly gilt, with labels in the upper two compartments – one bearing George III's cypher – and lettering in gold.[2] The text is that of the two-volume first edition of the work, the only difference being that Volume III has the Volume II title page (dated 1743) with an extra 'I' added after the 'II' (fig. 18).[3]

Apart from the fact that the Windsor volumes are in three rather than the normal two volumes, their most distinctive feature is that in place of the 220 etched plates which accompany the text in the usual printed editions of the work, they were bound up with 263 preparatory drawings, the majority executed in watercolor and gouache, although a few are in pen and

ink only.[4] Some of the drawings are composite: individual studies – these are mainly of insects – have been cut from other sheets and collaged onto the main composition.[5] The drawing sheets, which show signs of having been mounted at several different times,[6] were laid down onto blank folios.[7] These folios were then bound in between the folios of text.[8] In cases where there is more than one study for a single illustration, the different studies were mounted on consecutive folios and bound in before or after the relevant text folio.[9] After binding, each drawing sheet was framed by a strip of paper bearing a printed border composed of flowers, fruits and ribbons. These etched borders were hand-colored in watercolor after being pasted around the edge of the drawings (fig. 19).[10]

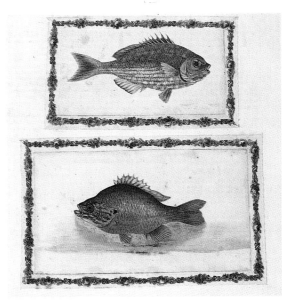

Fig. 19 Eighteenth-century floral borders in the Windsor *Natural History* volumes

Catesby continued to work on his book until 1747 when the Appendix of twenty additional plates appeared.[11] Although there is no specific mention of the drawings at the time of Catesby's death in 1749, it seems likely that they were still in his possession; however, their history between that time and their purchase in 1768 by George III is still unclear. In the announcement of Catesby's death (on December 23, 1749) in *The Gentleman's Magazine*, we are told that he "[left] behind him two children and a widow, who has a few copies of this noble work, undisposed of."[12] An inscription by Peter Collinson in his copy of the *Natural History* records that Catesby's "Widow subsisted on the sale of [the work] for about 2 years [after his death]. Then the Work, Plates etc. sold for 400£ and about 200£ more left by the Widow was divided between the two Children – a son and a daughter."[13] Whether Collinson's reference to "the Work, Plates etc." refers also to the drawings is not certain, but it would seem probable that it does. If so, it would appear that Catesby's widow, Elizabeth (who died in 1753), sold the drawings, probably to a bookseller; and it is possible that in preparing them for sale she, or perhaps her daughter, assembled and mounted them and pasted on the floral borders.[14] However, we do not know to whom the drawings were sold nor whose hands they passed through before reaching Thomas Cadell.[15] It is unlikely that Catesby's widow would have been able to afford the expense of more than the most rudimentary bindings. Therefore, who was responsible for the expensive bindings in which George III purchased the drawings is also unknown, but a likely candidate is Cadell who, recognizing the importance of the drawings, and intent on attracting a prospective buyer, could well have had the folios bound in the gilt morocco bindings in which they have come down to us.[16]

ROYAL INTEREST IN CATESBY'S WORK

In 1729 Catesby had shown a selection of his preparatory drawings for the plates of the *Natural History* to Queen Caroline (1683–1737), wife of George II and grandmother of George III, in the hope of obtaining her patronage for his work. In the Dedication to Volume II of his publication he noted that Queen Caroline had "condescended to over-look and approve my Drawings of the most extraordinary Curiosities of Nature observable in *Carolina* ... and was pleased to take the first Volume of this Work Under her own *Royal Patronage*." Which drawings Catesby showed the Queen we do not know, but they were presumably selected from among the finished drawings for the first sections of the book. In the Dedication to Queen Caroline printed in Volume I, Catesby is eloquent on the appropriateness of his royal patron, who not only had given her name to the colony whose natural history was the subject of his book, but was herself a keen horticulturalist.[17] Queen Caroline died in 1737 and Catesby found a royal patron for the second volume of his work in Augusta, Princess of Wales (1719–1772), who, like her mother-in-law Queen Caroline, also had botanical and horticultural interests.[18]

The acquisition by Augusta's son, George III, of the three-volume set of the *Natural History* containing the original drawings was thus made in the context of two generations of royal interest in Catesby's work. It is likely that the King was already familiar with the printed work, whether from one of the copies presented to Queen Caroline or Princess Augusta which may have been absorbed into one of his own libraries, or from a copy which he acquired independently.[19] The circumstances surrounding his purchase of the three-volume set are sparsely documented: we know of the price he paid and the vendor's name only through an inscription in the first of the three volumes.[20] The large amount of money paid by the King – £120[21] – surely indicates either a real interest in the drawings themselves or a more general interest in the building up of a collection of natural history drawings and books. We know that John Stuart, 3rd Earl of Bute (1713–1792) – who had been a friend and mentor of the Prince, later King, since the early 1750s,[22] and who himself had one of the finest natural history libraries of the time – was instrumental in acquiring

drawings and books on behalf of the King.[23] In 1763 Bute had purchased all the "materials" of George Edwards – "upward of 900 Original finished drawings and Sketches from life" – for £300, and according to Edwards these were destined for the "Kings new liberary now fitting up at Buckingham house."[24] Bute clearly knew Catesby and his work: he is listed among the subscribers to the *Natural History* and was honored by the naturalist in having a plant – the 'Stewartia' – named after him.[25]

On their arrival in the Royal Collection in 1768, the three Catesby volumes were shelved in the natural history section of George III's library at Buckingham House, which already contained two volumes of drawings by Maria Sibylla Merian and many albums of natural history drawings from the *Paper Museum* of Cassiano dal Pozzo.[26] When in 1823 much of the content of George III's library was given to the nation by George IV, the collection of drawings was held back, and in 1833 it was moved to the new Royal Library being created by William IV at Windsor. At some stage after that date the Catesby volumes were separated from the other albums of natural history drawings and shelved with the volumes of printed books in the Royal Library. There they remained until 1994 when, thanks to a generous gift from a Japanese benefactor, the conservation of the drawings preserved within their covers began. Once this process has been completed, the volumes themselves will be conserved, facsimiles inserted in the place of the original drawings, and the volumes replaced on the shelves of the Royal Library. The mounted drawings will be housed in the Print Room designed in 1859 by Prince Albert.

NOTES AND REFERENCES

1 On the page facing the title page in Volume I is the inscription "purchased in 1768 of Mr Thomas Cadell for £120 pounds [sic]." Cadell (1742–1802) was a successful London bookseller and publisher and a generous patron of authors, who ran his business in the Strand from 1767 to 1793 (see *DNB*, *s.v.*; obituary in *Gent. Mag.*, LXXII, 1802, p. 1173; Plomer 1932, pp. 41–42; Nichols 1812–15, VI, pp. 441–43 and numerous refs.).

2 The lettering on the spines reads: "CATESBY'S / NAT. HIST. OF/ CAROLINA/ ORIGINALS/VOL I [II/III]." The bindings measure 21 1/16 × 14 3/16 in (535 × 360 mm). Each volume contains Queen Victoria's bookplate.

3 The normal two-volume printed edition of the work contains one hundred text pages (and plates) in each volume, although the order in which the Appendix and the pages of prefatory and end matter are bound into the volumes varies from copy to copy. The Windsor volumes, however, are made up as follows: Volume I: title page (1731); [missing Dedication page]; Preface; text pp. 1–100; Volume II: title page (1743); text pp. 1–72; Volume III: title page (1743); text pp. 73–100; Appendix pp. 1–20; 'Index Rerum'; 'Map of Carolina ...'; 'An Account of Carolina ...'; Index.

4 In three cases, where the preparatory drawings appear not to have survived, the appropriate etched plates were bound in: Volume I, Plate 77; Volume II, Plates 21 and 24. The watermarks so far found on the drawing sheets are chiefly the 'Strasburg lily' type, with fleur-de-lys in shield, surmounted by a crown, usually with the figure '4,' and letters ('LVG,' 'VI,' 'W' or 'WR') below. A few are the 'IHS I. VILLEDARY' mark.

5 See, for example, cat. no. 40.

6 The lifting of the drawings during the recent conservation campaign undertaken by the Royal Library has revealed that most of them were mounted at least once before the present arrangement. Some show earlier signs of being pasted along the edges, while others were formerly tagged with white or colored paper at the four corners.

7 Two drawings were inlaid rather than laid down: cat. no. 16 (by George Edwards) and RL 26093, both of which bear inscriptions on the versos.

8 The watermarks on the blank pages to which the drawings are stuck are the same two types found on the majority of the drawings themselves, namely (a) the 'Strasburg Lily' type, with 'LVG' below, and occasionally with '4' between the 'LVG' and the shield, and (b) the 'IHS I. VILLEDARY' mark. These two watermarks are also those found on the text and plate pages of first edition copies of the *Natural History*. This evidence would seem to indicate that the mounting of the drawings was carried out soon after the publication of the completed work in 1747.

9 A few drawings were mounted incorrectly alongside text to which they do not belong: for example, the order of the drawings corresponding to Appendix Plates 4 and 5 was reversed.

10 It is clear from the previous positioning of the strips on cat. no. 50 (by Ehret) that these were added after the binding process: the right edge of the drawing sheet is so close to the gutter that the paper strip was applied to that side entirely over the drawing sheet, thus unbalancing the actual symmetry of the plant on the drawing sheet. Indications that the hand-coloring was done after the strips were pasted can be seen, for instance, where the borders have been mitred at the corners of the drawing sheets, and in the occasional splash of watercolor on the drawing or mounting sheets. The borders belong to the genre for decorative paperwork which flourished during the second half of the eighteenth century. Borders of this type were being sold by printsellers for decorative work including the framing of prints for Print Rooms (see, for example, Sayer and Bennett's *Enlarged Catalogue of New and Valuable Prints, in Sets or Single ...*, London 1775, p. 110 under 'Books of Ornaments, &c.,' no. 1, 'Decorations for *Print Rooms*, viz. bordering in an infinite variety ...').

11 Twelve of the twenty illustrations used in the Appendix were the work of artists other than Catesby: eight by Ehret, three possibly by a pupil of Ehret, and one by Edwards.

12 *Gent. Mag.*, XX, 1750, pp. 30–31.

13 The inscription is on the blank folio preceding the title page. Collinson's copy is in the collection of the Earl of Derby at Knowsley. For Collinson's relationship with Catesby see p. 18 above and cat. no. 43 below.

14 Responsibility for the somewhat incongruous and unskilled application of the borders points to an amateur rather than, for example, one of

Catesby's professional colleagues (see note 15 below regarding the suggestion that George Edwards might have assembled the set). An alternative suggestion that the borders might have been applied after the volumes had entered the Royal Collection – by, for example, one of George III's daughters – seems unlikely on the grounds that no examples of similar work by them exist, and the work is not skilled enough for Princess Elizabeth, the most likely candidate for executing decorative work of this type.

15 It has been suggested that George Edwards assembled the set. Edwards was evidently in close contact with Catesby at the end of Catesby's life: Thomas Knowlton informed Richard Richardson on July 18, 1749 that "I saw ... Messrs Catesby and Edwards, who has materials for a third volume of Birds, Flies and Animals etc., but poor Mr Catesby's legs swell, and he looks badly. Drs Mead and Stack said there were little hopes of him long on this side of the grave" (Turner 1835, p. 400). Annotations on a number of the drawings, including the versos, may be in Edwards's hand (see cat. nos. 33 and 47). However, although Edwards may have helped Catesby's widow to put the drawings in order, it would seem unlikely that he was responsible for the final arrangement (see note 14 above).

16 The absence of George III's coat-of-arms or cypher on the bindings, and the fact that the tools do not match those identified as being used in the Royal Bindery, seem to preclude the possibility of the drawings having been rebound after their acquisition by the King. The inscription recording the purchase (see note 1) was probably added to Volume I at the time of the acquisition.

17 Queen Caroline had extensive gardens at Richmond designed for her by Charles Bridgeman (see Desmond 1995, Chap. 1). A copy of Volume I of the *Natural History*, presumably that which Catesby presented to the Queen, is included in the manuscript *Catalogue of The Library of Her Late Majesty Queen Caroline*, under the category 'History of America' (see p. 74 of that MS, dated 1743, now housed in the Royal Library). An inscription in a later hand reads: "T[ome].1. The same in 4 Volumes," indicating that sections of the second part of the work were added as they were published. The contents of Queen Caroline's library were dispersed after her death.

18 Princess Augusta, together with her husband, Frederick, Prince of Wales (1717–1751), shared interests in gardening and exotic plants (interests that were encouraged by John Stuart, Earl of Bute, see p. 30 and notes 22 and 23 below). Together they developed gardens in the grounds of the White House at Kew which were to form the foundations of the Royal Botanic Gardens (see Desmond 1995, Chaps. 2 and 3).

19 Two ex-Royal Library copies are known: one, a first edition, is in the British Library (King's Library: pressmark 44.k.7,8). This is the copy listed in the *Bibliothecae Regiae Catalogus* (London 1824), the catalogue of the books from George III's library produced at the time of their transfer to the British Museum; it is bound in red leather with gold tooling, has a border of crowns, the Prince of Wales's feathers blocked in gold in the center, and George III's cypher on the spine. The other, which contains George III's bookplate, is also a first edition and was included in a sale in 1837 of duplicates from the Royal Library; it is now in a private collection in South Carolina. At the time of the sale the Royal Librarian considered this printed set to be a 'duplicate' of the set with the drawings.

20 The inscription is on the first endpaper of Volume I. Although the Privy Purse accounts in the Royal Archives record payments by the King to Cadell, there appears to be no record of this particular purchase.

21 The price in 1747 of the full printed work, with colors, was 21 guineas.

22 Bute's initial link with the Royal Family was with Frederick, Prince of Wales, whom he met in 1747, and whose interest in plants he encouraged. Bute retained the friendship of Princess Augusta after the Prince's death.

23 Francis Russell describes Bute as having "an insatiable appetite for scientific and botanical material" (Russell 1997).

24 Information from a letter dated London, May 7, 1763, from George Edwards to Lord Cardross (transcribed in full in Stuart Mason 1992, p. 46 and note 50). The Edwards drawings appear never to have reached the Royal Collection.

25 *Natural History*, II, Appendix, Plate 13. Catesby ends his description of the plant by saying, "The Right Honourable and ingenious Earl of *Bute* will, I hope, excuse my calling this new Genus of Plants after his name." Two drawings attributed to Catesby (subjects not identified) are included in the *Catalogue of the Botanical and Natural History Part of the Library of the late John, Earl of Bute, including His Lordship's Noble Collection of Coloured Drawings in Natural History*, sale catalogue, Leigh & Sotheby, Covent Garden, London, May 8, 1794, lot 1072*.

26 Inventories A and B (the early nineteenth-century inventories of drawings in George III's collection) indicate that the Catesby volumes were shelved alongside the Merian and Dal Pozzo albums of drawings rather than with the printed Catesby volumes. Inventory A, subtitled 'A Catalogue of the Drawings and Prints as they are arranged in the Book Cases,' notes on page 3 that the Catesby volumes were housed on 'Shelf D'; this information is corroborated on p. 4 of Inventory B where the volumes are recorded as being in 'Press D' of the section 'Historia Naturalis.'

NOTE ON THE NATURAL HISTORY ALBUMS
OF SIR HANS SLOANE

THE physician and naturalist Sir Hans Sloane (1660–1753) was one of the most important patrons of Catesby's second expedition to the New World. Catesby sent him animal and plant specimens (see cat. no. 5 and p. 89) as well as duplicates of his drawings, especially his illustrations of birds (see I.1–3). Given that one of Catesby's drawings in the Windsor *Natural History* set, of which he made a duplicate for Sloane, is inscribed "Orig.," it would seem that Catesby endeavored to keep his 'originals' in his own possession (see cat. no. 19). Sloane himself identified many of the drawings Catesby did for him by inscribing "Mr. Catesby" on the sheet (normally in the lower right corner).

Sloane made his collection of natural history albums available to his fellow naturalists. This collection contained a large number of albums of drawings and prints of natural history subjects, in addition to live and preserved plant and animal specimens. The list of the collection made at the time of Sloane's death notes that he owned 136 "Books in Miniature or Colours, with/ fine Drawings of Plants, Insects,/ Birds, Fishes, Quadrupeds, and all/ sorts of natural and artificial/ Curiosities" (MacGregor 1994, pp. 28–29). After his return from America, Catesby appears to have used the collection as a source of images for his own work. The illustrations in Sloane's albums were especially useful to Catesby when he found his own field drawings or preliminary sketches inadequate for preparing finished watercolors (see cat. no. 38). In other cases, Catesby apparently selected illustrations in Sloane's collection in preference to his own, even when he seems to have had adequate opportunity to describe (and presumably illustrate) the particular specimen himself. Catesby appears to have copied only images of fauna from Sloane's collection; his botanical illustrations were all done from actual specimens. In one instance only did Catesby acknowledge the source of his copy: in the text to his illustration of the tiger swallowtail butterfly he states that the image is from "the sketch of the 'Mamankanois' in the manuscript of Sir Walter Raleigh belonging to Sir Hans Sloane" ("*Mamankanois* in MS. Dni. Gualteri Raleigh penes D. Hans Sloane"), that is, from a drawing in Sloane's so called John White volume (see cat. no. 39).

The surviving albums from Sir Hans Sloane's collection are now divided between the British Library (Department of Manuscripts) and the British Museum (Department of Prints and Drawings); they are listed in a manuscript inventory, dated 1832, which is housed in the British Library (MSS). The albums, divided according to their subject matter, contain drawings commissioned by Sloane from contemporary artists including Everhard Kick, Mark Catesby and George Edwards; earlier drawings collected by Sloane (see cat. no. 36); drawings sent to him by other collectors and naturalists; and miscellaneous prints. Among the earlier drawings Sloane acquired is a volume of drawings which he believed to be by the artist John White (c. 1545–1606), who accompanied Sir Walter Raleigh on his expedition to the New World in 1585. The drawings in this volume (Sloane MS 5270) are, in fact, by an early-seventeenth-century copyist of White, possibly his son. Before Sloane managed to acquire this volume, he commissioned copies of the drawings for his own natural history albums; these early-eighteenth-century copies (by an unidentified draftsman) of the so called John White drawings were mounted into different albums in Sloane's collection according to their subject matter (see Hulton and Quinn 1964, pp. 27 and 50; Croft-Murray and Hulton 1960, pp. 59–60).

HENRIETTA McBURNEY 33

A NOTE TO THE READER

I. QUOTATIONS MADE FROM CATESBY'S TEXT IN THE NATURAL HISTORY

Quotations are made from the Windsor first edition set of the *Natural History*. (It should be noted that the text of first editions varies from copy to copy in terms of spelling, punctuation and capitalization.)

II. FORMAT OF THE CATALOGUE ENTRIES

Artist's Name — This is provided only when an artist other than Catesby created the work.

Titles of Drawings — Catesby's English names, as published in the *Natural History*, are used wherever possible; where Catesby does not provide an English name, his Latin synonym is given in italics; where Catesby does not identify a plant or animal in the drawing, the modern common or scientific name is given in square brackets.

Where Catesby's names are used in the catalogue entry they appear in single inverted commas.

Modern Common and Scientific Names — These are given in square brackets beneath the title.
Common names: lower case is used for the first letter of both zoological and botanical common names (the normal zoological practise of using upper case is not followed here).

Scientific names: the scientific name (genus and species) is given in italics. This is followed by the name of the author (describer), which is often abbreviated. Parentheses around the author's name indicate that the current generic name is different from the one given in the original description.

For the compiler of the present catalogue, Joseph Ewan's Notes in Ewan and Frick 1974 were used as the starting point for providing modern names for Catesby's plants and animals. Howard and Staples 1983 was used for the botanical drawings. As both these publications refer only to the published images, a number of plant and animal species in Catesby's drawings had still to be identified. For the zoological drawings, experts at the Natural History Museum and the Zoological Society in London provided specialist knowledge; for the botanical drawings, Alistair Culham and Ronald Rutherford of the Botany Department of the University of Reading shared their expertise.

Numbering and Locations References — Each drawing is identified by the Royal Library inventory number (prefaced by 'RL'). This number is followed by the volume number (of the Windsor three-volume *Natural History* set) and the text page number opposite which the drawing was mounted; the suffix 'a' or 'b' to the page numbers indicates that several drawings were bound between the text pages.

CATALOGUE

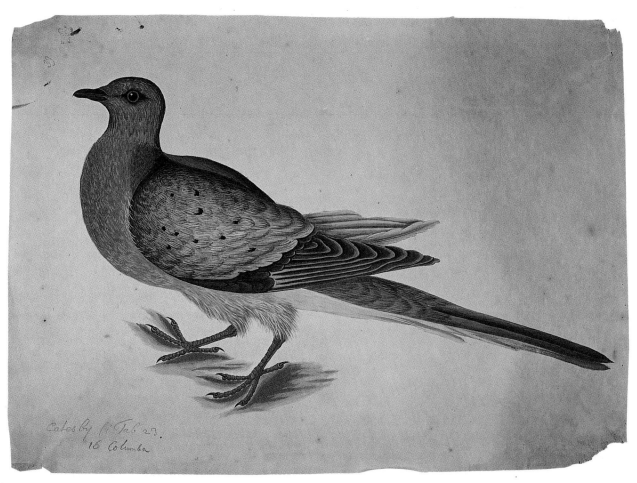

I.1 Catesby, 'The Pigeon of Passage' (Sloane MS 5264, no. 39)

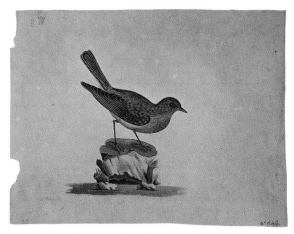

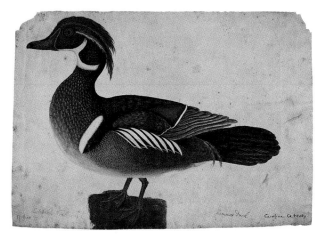

I.2 Catesby, 'The Blue Bird' (Sloane MS 5264, no. 126)

I.3 Catesby, 'The Summer Duck' (Sloane MS 5265, no. 31)

SECTION I: BIRDS

Cat. Nos. 1–17

THE first volume of the *Natural History* is devoted primarily to birds. Catesby explains the reason for this in his Preface: "There being a greater variety of the feather'd kind than of any other Animals (at least to be come at) and excelling in the Beauty of their Colours,

besides having oftenest relation to the Plants on which they feed and frequent; I was induced chiefly (so far as I could) to compleat an Account of them, rather than describe promiscuously Insects and other Animals; by which I must have omitted many of the Birds, for I had not time to do all, by which method I believe very few Birds have escaped my Knowledge, except some Water Fowl and some of those which frequent the Sea" (Preface, p. ix). In addition to the hundred plates which constitute Volume I, nine more birds are included in the Appendix. Allowing for the fact that a few species are depicted more than once, and that several plates illustrate two different species each, a total of 109 species are represented.

Catesby's *Natural History* was the first published work which both illustrated and described the birds of North America. He summarized the main difference between American and European species by saying that "The Birds of *America* generally excell those of *Europe* in the Beauty of their Plumage, but are much inferior to them in melodious Notes" ('Some Remarks on American Birds,' in Account, p. xxxv).

Catesby's birds are grouped roughly according to the order employed by Ray and Willughby in their *Ornithology* of 1678. He noted that as "very few of the Birds [had] Names assign'd to them in the Country, except some which had *Indian* names, I have call'd them after *European* Birds of the same Genus, with an additional Epithet to distinguish them" (Preface, p. xi). He appears to have invented his Latin designations himself, basing many of them on those used by Ray. (Although most of these designations were superseded in 1758 by those of Linnaeus, Linnaeus based seventy-five of his classifications of North American birds on Catesby's work.)

Catesby writes of his depictions of birds that he "painted them while alive (except a very few) and gave them their Gestures peculiar to every kind of Bird, and where it would admit of, I have adapted the Birds to those Plants on which they fed or have any Relation to" (Preface, p. xi). On the whole his illustrations fulfil these claims. Although many of Catesby's birds are in stationary poses, few are in stiff profile (as was the case with many earlier illustrations) and he often manages to convey a sense of motion.

After the first eight illustrations, Catesby broke with the tradition of positioning his birds on stumps or decorative foliage and combined them with his studies of plants. To begin with, he attempted to combine plants and birds that had a particular relationship with each other (in terms of the plant providing the bird's food supply or habitat), relationships that he sometimes endorsed by visual means, for instance matching colors or forms (see cat. nos. 3 and 4 and p. 21 above). This combination of plants and animals also had economic implications, for it saved the cost of extra plates (he could not have afforded to depict each of his plant and animal specimens on separate plates). Toward the end of the publication, plants and animals were combined where there was no environmental relationship and where the matching appears to have been done on aesthetic grounds (see cat. nos. 8, 16 and 17).

As the publication progressed, the balance between the bird and plant shifted, with the plant becoming the dominant subject-matter and the bird apparently added as an afterthought (see cat. no. 12). Plants were Catesby's primary interest and a number of those described and illustrated in the *Natural History* were later included in his *Hortus Britanno-Americanus*, published posthumously in 1763 (see below, p. 131).

1 The Bald Eagle

[Bald eagle *Haliaeetus leucocephalus* (L.)]
RL 24814 (I, p. 1)

Watercolor and gouache heightened with gum arabic, over pen and
brown ink and traces of graphite
Inscribed in pen and ink, upper right corner: *1*
10 1/16 × 14 3/4 in.; 271 × 375 mm

Catesby begins his *Natural History* with birds of prey,
following the pattern set by John Ray in his *Ornith-
ology*. This is the first of the seven birds of prey he in-
cludes, and the most dramatic of the illustrations.
Above the eagle the 'Fishing Hawk' (the subject of
Plate 2) is shown hovering, having dropped its prey,
which the bald eagle is about to catch. This narrative
is recounted in the text accompanying Plate 2; here,
Catesby notes that the eagle is "of a small size, yet has
great strength and spirit, preying on Pigs, Lambs and
Fawns."

He depicts the bald eagle against a river landscape,
observing that "they always make their Nests near the
sea, or great rivers." The illustration is, however, one
of only two in which Catesby includes landscape
backgrounds (see also cat. no. 6); he appears to have
realized early on that the task of providing suitable
landscapes for all his animal subjects would take too
long, and he therefore abandoned the attempt after
two plates. In the six plates following this he depicted
birds on their own without backgrounds (see cat. no.
2), and thereafter he combined them with plant studies
(see cat. nos. 3–12).

In the etched version of this illustration (1.1) Cates-
by omits the landscape, including instead an outline of
the bird's head and bill depicted actual size.

1.1 *Natural History*, I, Plate 1

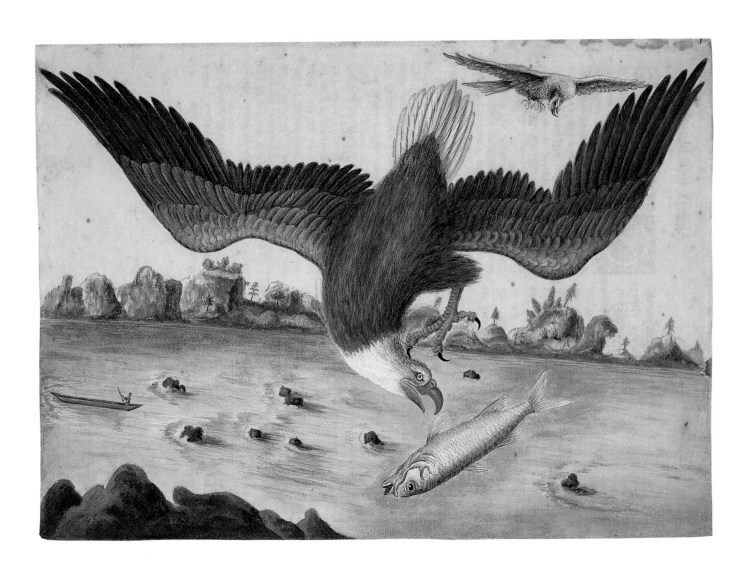

2 The Little Hawk

[Sparrow hawk *Falco sparverius* L.]
RL 24818 (I, p. 5)

Watercolor and gouache heightened with gum arabic, over graphite
Inscribed in pen and ink, upper right corner: *5*
10⅝ × 14⅞ in.; 270 × 378 mm

By contrast with his 'Bald Eagle' (cat. no. 1), Catesby's 'Little Hawk' is depicted in a traditional stationary profile pose standing on a perch. Catesby wrote that the hawk "abide[s] all year in *Virginia* and *Carolina*, preying not only on small birds, but Mice, Lizards, Beetles &c."

The watercolor is striking for the vivid colors and markings of the bird's plumage. As these details are not entirely accurate, it may be that Catesby executed the drawing from memory or from a skin in his collection. His written description is, however, closer to the true appearance of the bird: "The Basis of the upper Mandible is cover'd with a yellow Sear: the Iris of the Eye Yellow; the Head lead-colour, with a large red spot on its Crown: round the back of its Head are seven black spots regularly placed: the Throat and Cheeks are white, with a tincture of red; marked with transverse black lines: the Quill-feathers of the Wing dark-brown; the rest of the Wing blue, marked, as on the Back, with black: the Tail red, except an inch of the end, which is black; the Breast and Belly of a blueish red; the Legs and Feet yellow."

The watercolor is close to the final etching (2.1); the outlines may well have been traced onto the plate as they accord almost exactly with those of the print.

2.1 *Natural History*, I, Plate 5

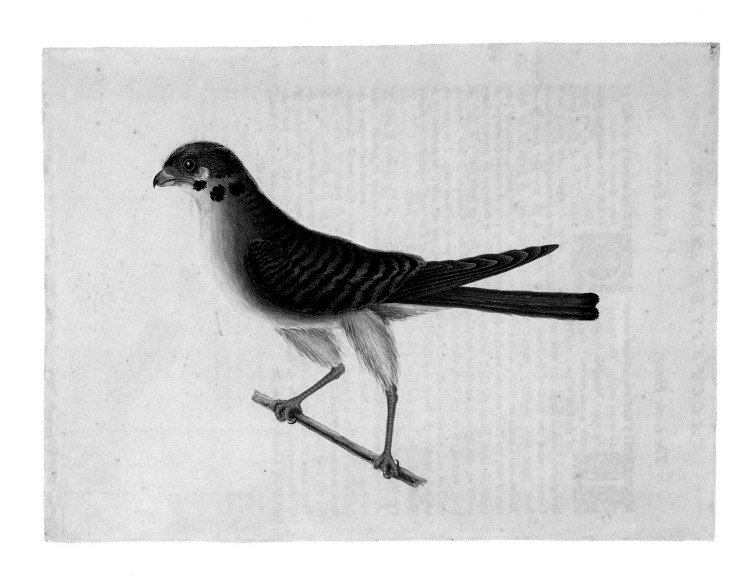

3 The Cuckow of Carolina and the Chinkapin

[Yellow-billed cuckoo *Coccyzus americanus* (L.), and chinkapin *Castanea pumila* Mill.]

RL 24822 (I, p. 9)

Watercolor and gouache heightened with gum arabic, over graphite
Inscribed in pen and brown ink in Catesby's hand, upper center:
Cuckow of Carolina. Cuculus Caroliniensis; lower right: *Castanea, pumila
Virginiana, rasemoso fructu / parvo in Singulis capsulis echinatis unico –
/ D. Banister The Chinquapin*; in graphite, lower right: *44*; in pen and
ink, upper right corner: *9*
10⅝₁₆ × 14½ in.; 262 × 368 mm

After the first seven plates of the *Natural History*, Catesby starts to combine his illustrations of birds with studies of plants, wherever possible chosen for their significance as the bird's food supply or habitat. Here, noting that the 'Cuckow of Carolina' is "a solitary Bird, frequenting the darkest recesses of woods and shady thickets," he sets it against a branch of a woodland shrub. The relationship between bird and plant is further emphasized by the matching of the "greenish white" color of the underside of the chinkapin leaf with the greyish-white of parts of the bird's plumage. The visual link between the two is made again in the matching of the featherlike treatment of the plumage on the bird's neck with that of the "spikes of whitish flowers" on the plant stems.

Catesby remarks of the cuckoo that it "is about the size of a Black-bird" and that its "Note is very different from ours, and not so remarkable as to be taken notice of."

In his drawing of the chinkapin, Catesby illustrates not only the flowers and the white underside of the leaves, but the "prickly burr" and an example of the nut, details which he also describes in the accompanying text.

He includes an illustration and description of the shrub in his *Hortus Britanno-Americanus* (3.2), but notes that "When sent from America they frequently disappoint our expectations, and will not come up." He suggests that one of the reasons for this is that "being kept too long out of the ground, they lose their germinating power by the length of their passage: if therefore some of them be put up in moist earth, and others in dry sand, a better chance may be expected than when they are all sent together packed up in the same manner."

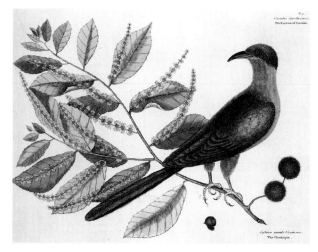

3.1 *Natural History*, I, Plate 9

3.2 *Hortus Britanno-Americanus*, Figure 22

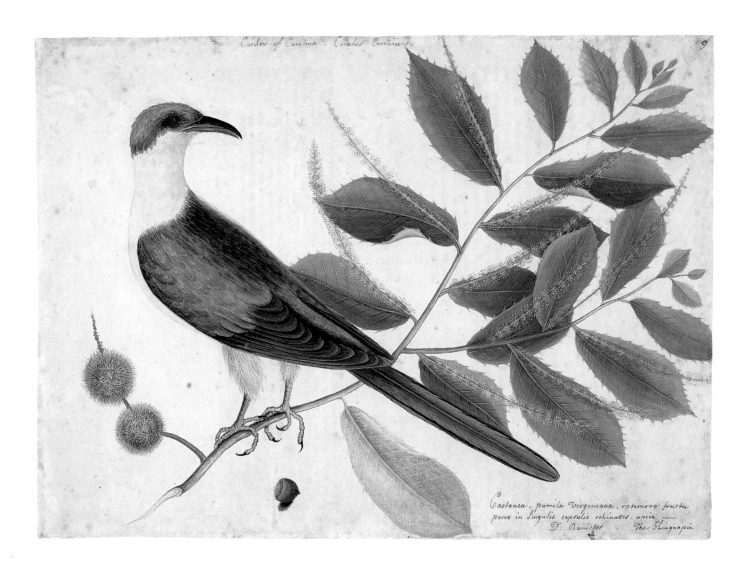

"... the Leaves are serrated, and grow alternately, of a dark
green, their back-sides being of a greenish white: at the joints
of the leaves shoot forth long spikes of whitish flowers, like
those of the common Chestnut, which are succeeded by Nuts
of a conick shape, and the size of a Hasel-nut; the Shell,
which incloses the Kernel, is of the colour and consistence of
that of a Chestnut, inclosed in a prickly burr, usually five or
six hanging in a cluster. They are ripe in September."

4 The Blue Jay and Bay-leaved Smilax

[Blue jay *Cyanocitta cristata* (L.), and bay-leaved smilax *Smilax laurifolia* L.]

RL 24828 (I, p. 15)

Watercolor and gouache heightened with gum arabic (on berries), over pen and brown ink
Inscribed in pen and brown ink in Catesby's hand, top left: *The crested Jay Pica glandaria caerulea cristata*; bottom right: *Smilax laevis, Salicis folio non / Serrato, baccis Nigris –*; top right corner: *15*
10¹³⁄₁₆ × 14½ in.; 274 × 368 mm

In this striking composition Catesby manages to capture the characteristic movement of the jay, observing that the American species has "the like jetting motion of our Jay; their Cry is more tuneful."

He positions the bird on a branch of the smilax, the berries of which, he notes, are "food for some sort of Birds, particularly this Jay." The connection between plant and bird is further emphasized in the matching of the deep blue-black color of the plant berries with the coloring of the bird plumage, the shades and markings of which Catesby depicts in detail (although not entirely accurately).

The bay-leaved smilax is another of the shrubs Catesby introduced to England, later including it in his *Hortus Britanno-Americanus* (4.2).

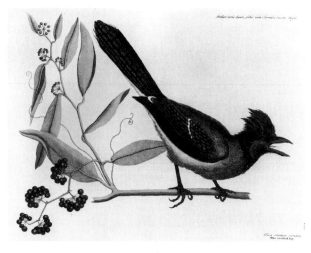

44

4.1 *Natural History*, I, Plate 15

4.2 *Hortus Britanno-Americanus*, Figure 31

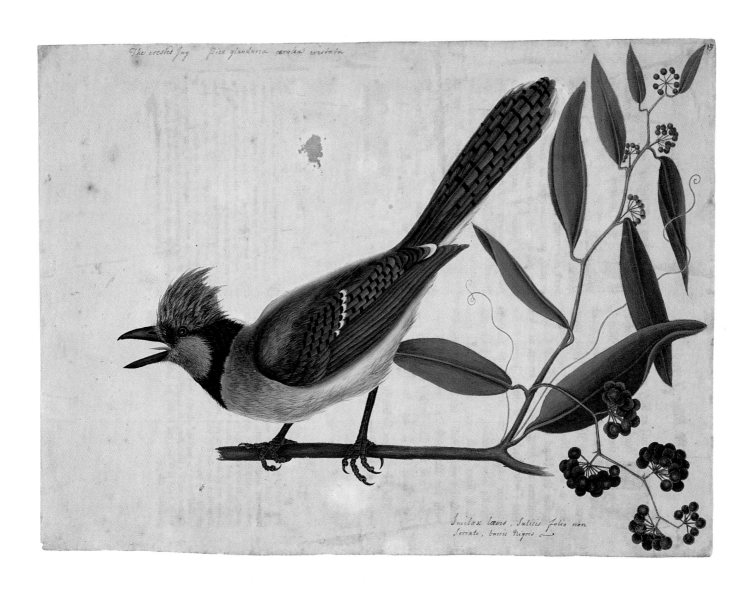

The crested Jay Pica glandaria cærulea cristata

15

Smilax lævis, Salicis folio non
serrato, baccis Nigris

"... the Back [is] of a dusky purple: the interior vanes
of the larger Quill-feathers black; the exterior, blue,
with transverse black lines cross every feather, and their
ends tipt with white: the Tail blue, mark'd with the like
cross-lines as on the Wings ... The Hen is not so bright
in colour; except which, there appears no difference."

5 The Largest White-Bill Wood-Pecker and the Willow-Oak

[Ivory-billed woodpecker *Campephilus principalis* L., and willow oak *Quercus phellos* L.]
RL 24829 (I, p. 16)

Watercolor and gouache heightened with gum arabic, over pen and brown ink and traces of graphite
Inscribed in pen and brown ink in Catesby's hand, upper left: *Largest — white bill woodpecker. Picus maximus rostro albo.*; upper right: indecipherable inscription crossed out; lower left: *Quercus Anpotius Ilex Marilandica folio longo / Angusto Salicis R: Hist: — Willow Oak.*; upper right corner: *16*; in graphite, upper right corner: *16*
14¾ × 10¹¹⁄₁₆ in.; 375 × 271 mm

Catesby writes that he identified eight different species of woodpecker while he was in America. On March 12, 1723, he sent dried specimens of seven of these from Carolina to Sir Hans Sloane in London, writing in his accompanying letter: "I hope you have ere this received from Capt Rave (who sailed from hence the 10 of May last) a Box of dryed Birds, shels, and insects ... Concluding you have recd. those by Capt: Rave I doe not repeat sending any of ye same again, with one I sent before I now send seven kinds of woodpecker which is all the kinds except one I have discovered in this Country ..." (Sloane MS 4047, f. 90).

Catesby executed watercolors of all eight species of woodpecker, incorporating them into six plates of Volume I of the *Natural History*; duplicates of several of these (but not of the present drawing) can be found in

Hans Sloane's natural history albums in the British Library (see p. 33). All except one are shown on the trunks of different species of oak tree; the exception is his Gold-winged Wood-pecker (yellow-shafted flicker, *Colaptes auratus*, Plate 18), which Catesby depicts perching on a branch because, he observes, "it [does not] alight on the bodies of trees in an erect posture as woodpeckers usually do, but like other birds."

In this bold composition Catesby fills the sheet with a life-size depiction of the woodpecker in the "erect posture," perching uneasily on a trunk of the willow oak with a branch of the foliage arranged behind.

In the accompanying text he describes an interesting feature of the beak of this bird: "The Bills of these Birds are much valued by the *Canada Indians*, who make Coronets of 'em for their Princes and great warriors, by fixing them round a Wreath, with their points outward. The *Northern Indians*, having none of these Birds in their cold country, purchase them of the Southern People at the price of two, and sometimes three Buck-skins a Bill."

In the etching Catesby alters his depiction of the sawn-off tree stump to show it as a continuous trunk, and omits the detail of the acorn included here in pen and ink. He includes the willow oak among the nine species of oak he describes and illustrates in the *Hortus Britanno-Americanus* (5.2).

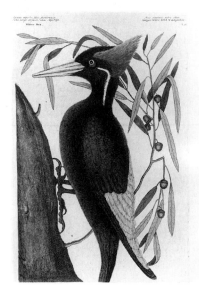

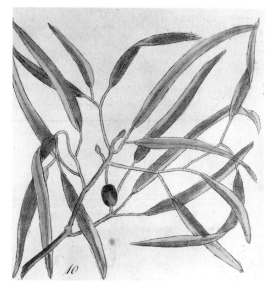

46

5.1 *Natural History*, I, Plate 16

5.2 *Hortus Britanno-Americanus*, Figure 10

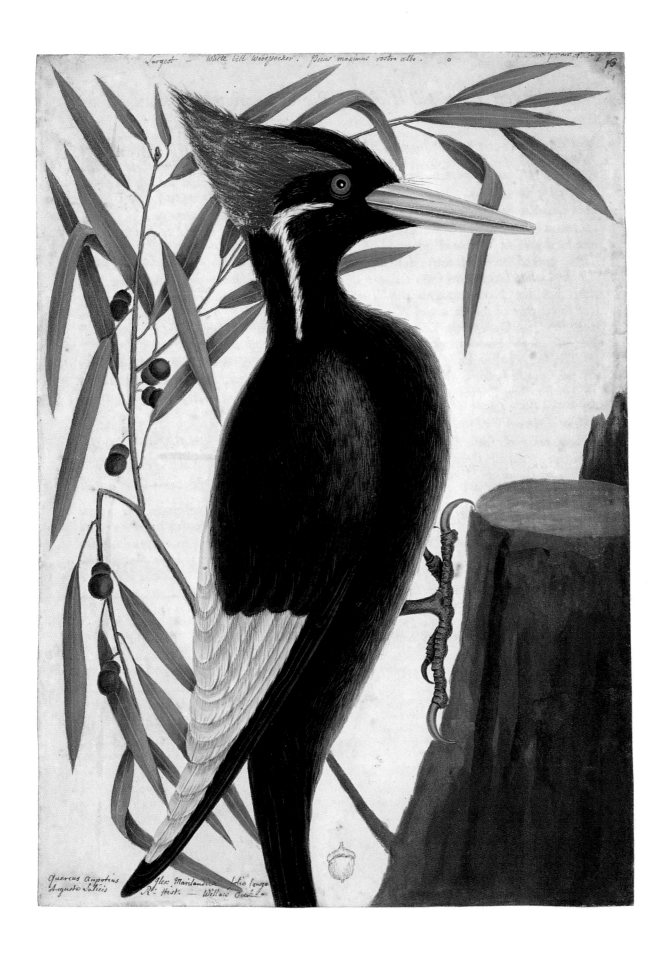

Largest — White bill Woodpecker. Picus maximus rostro albo.

Quercus Cupulus
Angusto Salicis
R: Hist: — Willow Oak

6 The Pigeon of Passage and the Red Oak

[Passenger pigeon *Ectopistes migratoria* (L.),
and turkey oak *Quercus laevis* Walter]
RL 24836 (I, p. 23)

Watercolor and gouache heightened with gum arabic, over pen and
brown ink
Inscribed in pen and brown ink in Catesby's hand, upper left: *Wood
pigeon Quercus Esculi divisara foliis amplioribus. Aculeatis. Pluk: Hist —
— Red Oak.*; lower right, painted over, partially legible: *Quercus Esculi
divisara foliis amplioribus aculeatis*
Verso: inscribed in pen and brown ink, not in Catesby's hand:
A Virginia Wood Pidgeon comes in / Winter Seazon
10⅝ × 14⁵⁄₁₆ in.; 269 × 363 mm

This is one of the two drawings in which Catesby sets
his subject against a landscape background (see also
cat. no. 1). Here, the distant view of snowy mountains
appears to represent the breeding place of the passen-
ger pigeon, Catesby noting: "The only information I
have had from whence they come, and their places of
breeding, was from a *Canada Indian*, who told me he
had seen them make their nests in rocks by the sides of
rivers and lakes far north of the river *St. Lawrence*,
where he said he had shot them."

The "information" Catesby was given, however,
conflicts with the fact that the typical nesting place of
the passenger pigeon was forests rather than rocks.

The foreground setting for the bird is a stem of the
turkey oak, together with its acorns – one of the plants
off which Catesby observed the pigeons feeding. He
writes that these birds "come in Winter to *Virginia* and
Carolina, from the North; [in] incredible numbers; ...
In their passage the People of *New-York* and *Philadel-
phia* shoot many of them as they fly, from their balco-
nies and tops of houses; and in *New-England* there are
such numbers, that with long poles they knock them
down from their roosts in the night in great numbers."

The bird, in fact, became extinct around 1914.

Catesby executed another drawing of the passenger
pigeon for Hans Sloane (I.1). As the proportions of the
Sloane version differ slightly from those of the present
drawing, it would seem that one version was copied
rather than traced from the other.

The 'Red Oak' is included as Figure 9 in the section
on oaks in the *Hortus Britanno-Americanus*, where

Catesby notes: "The leaves of this oak retain no cer-
tain form, but sport into various shapes more than
other oaks do" (p. 6). A specimen of the leaves that
Catesby sent William Sherard, and which is now pre-
served in the Sherard Herbarium in Oxford (VII.1), is
remarkably similar to the specimen shown in this
drawing.

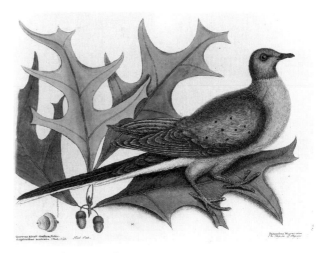

6.1 *Natural History*, I, Plate 23

48

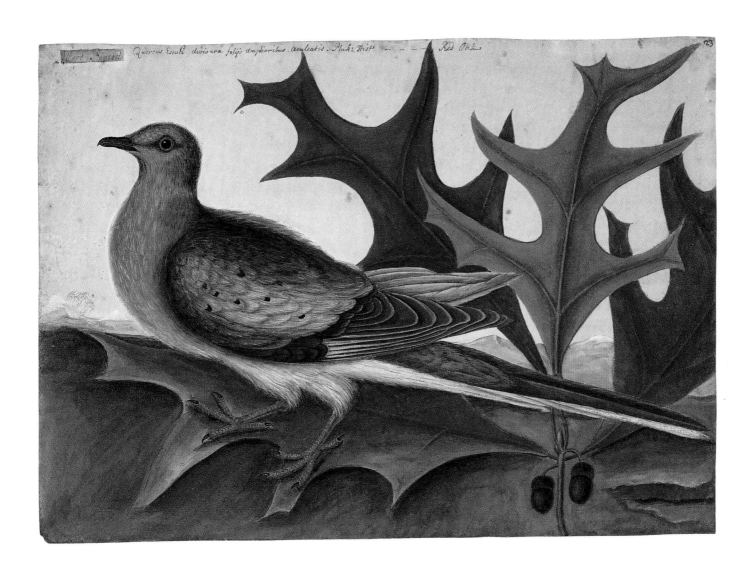

7 The Blue Gross-beak and the Sweet Flowering Bay

[Blue grosbeak *Passerina caerulea* (L.), and sweet bay
Magnolia virginiana L.]

RL 24853 (I, p. 39)

Watercolor and gouache heightened with gum arabic, over graphite;
some rubbing to gouache (on seeds)
Inscribed in pen and brown ink in Catesby's hand: *Coccothraustes
caerulea Tulipfera virginiana, laurinis foliis aversa / parte rore caeruleo
tinctis, Coni baccifera – / Pluk Phytogr. Tab. 68 fig 4*; top right corner:
39; in graphite (to right of plant stem): *11*
14¾ × 10½ in.; 375 × 267 mm

Catesby combines his image of the blue grosbeak with the study of the sweet bay to produce a pleasing composition in which the colors and shapes complement each other. Although in his text he does not make any comment on the bird's feeding habits, he indicates these by showing it reaching for a seed of the plant. He observes that "It is a very uncommon and solitary bird, seen only in Pairs. They have one single Note only, and appear not in Winter. I have not seen any of these Birds in any parts of *America* but *Carolina*."

The illustration of the sweet bay is one of a number of studies Catesby made of different species of magnolia, a tree recently introduced into England and which was much prized by gardeners (see also cat. nos. 9 and 51). It is the first tree to be included in the *Hortus Britanno-Americanus*, where Catesby describes and illustrates four different species. He writes in the *Natural History*: "This beautiful flowring Tree is a Native both of *Virginia* and *Carolina*, and is growing at Mr. *Fairchild*'s in *Hoxton*, and at Mr. *Collinson*'s at *Peckham* where it has for some years past produced its fragrant Blossoms, requiring no protection from the Cold of our severest Winters."

His illustration of the strange, exotic fruit-heads and seeds is complemented by a detailed description: "[the flowers] are white, made up of six *Petala*, having a rough conic *Stylus*, or rudiment of the Fruit: which, when the *Petala* fall, increases to the bigness and shape of a large Walnut, thick set with knobs or risings; from every of which, when the Fruit is ripe, is discharged flat Seeds of the bigness of *French* Beans, having a kernel within a thin Shell, covered with a red Skin. These red Seeds, when discharged from their cells, fall not to the ground, but are supported by small white threads of about two Inches long."

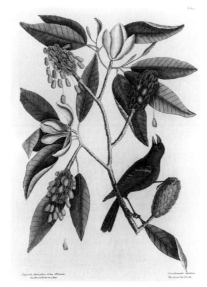

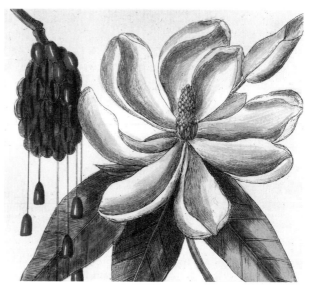

7.1 *Natural History*, I, Plate 39

7.2 *Hortus Britanno-Americanus*, Figure 3

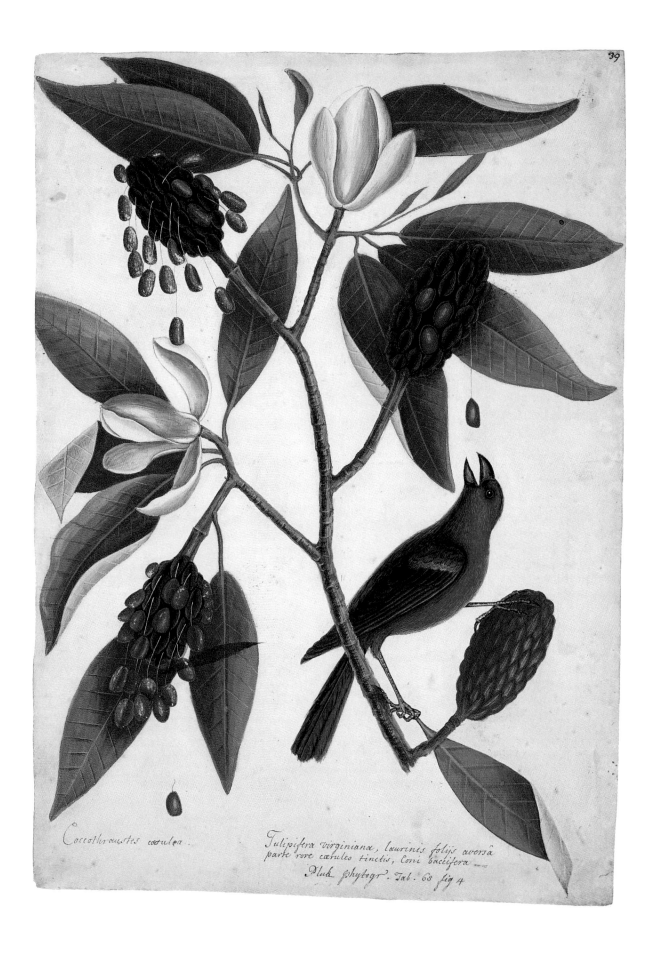

39

Coccothraustes cærulea.

*Tulipifera virginiana, laurinis folijs aversâ
parte rore cæruleo tinctis, Coni baccifera —
Pluk. phytogr. Tab. 68 fig 4*

8 The American Goldfinch and Acacia

[Eastern goldfinch *Carduelis tristis* (L.), water locust
Gleditisia aquatica Marsh. (fruit), and honey locust
Gleditisia triacanthos Sarg. (leaves)]
RL 24857 (I, p. 43)
Watercolor and gouache heightened with gum arabic, over pen and
brown ink
Inscribed in pen and brown ink in Catesby's hand, top center:
Carduelis; bottom left: *Acacia abruae foliis triacanthos Capsula / Ovali
unicum semen clandente.*; top right corner: *43*
14⅞ × 10⁹⁄₁₆ in.; 378 × 268 mm

In this composition the relationship between bird and
plant is less obvious. The Eastern goldfinch was often
kept as a caged bird, presumably on account of its
spectacular color, particularly the summer plumage of
the male, as shown here. Catesby does not comment
on its natural habitat apart from noting that "These
Birds are not common in *Carolina*; in *Virginia* they are
more frequent; and at *New-York* they are most numer-
ous; and are there commonly kept in cages." He says
that "They feed on Lettuce and Thistle Seed."

Catesby writes of the 'Acacia' that he "never saw
[any] but at the Plantation of Mr. *Waring* on *Ashley*
River, growing in shallow water." He seems, however,
to have confused the fruit and leaves of two different
species of locust tree, depicting the fruit of the water
locust with the leaves of the honey locust.

In common with a number of his botanical studies,
the etched version of the composition is rather thinner
than its drawn counterpart. In several of his etchings
Catesby reduces the amount of plant foliage shown in
the drawings, possibly because of shortage of time.
The striking effect of the present sheet, achieved by the
arrangement of the leaves to form a dense backdrop
for the bird, is lacking in the etching.

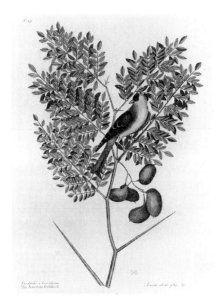

8.1 *Natural History*, I, Plate 43

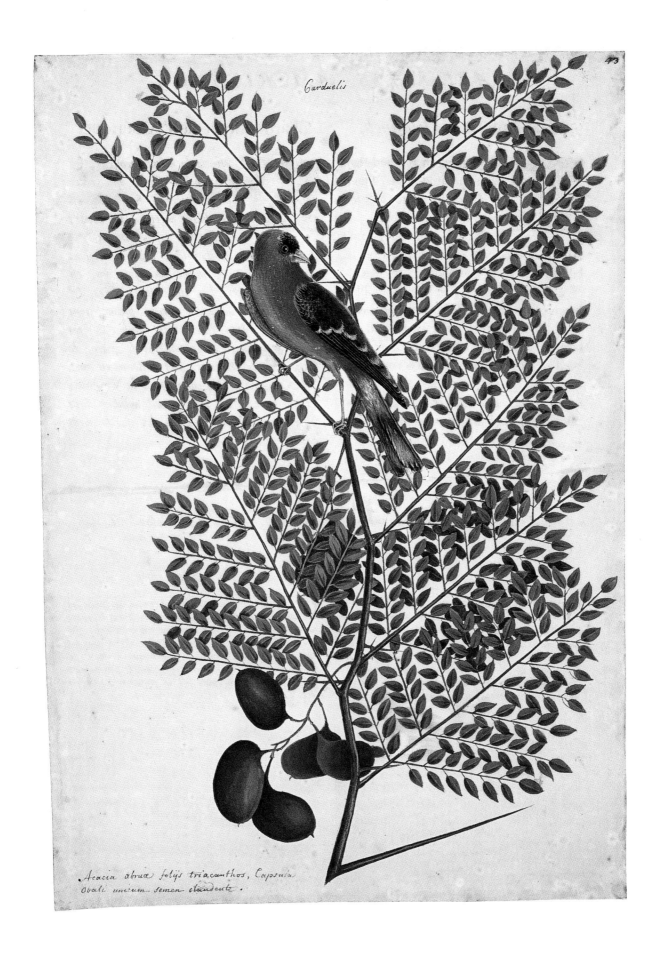

Carduelis

Acacia abruæ folijs triacanthos, Capsula
ovali unicum semen claudente.

9 The Painted Finch, the Blue Linnet and the Sweet Flowering Bay

[Painted bunting *Passerina ciris* (L.),
indigo bunting *Passerina cyanea* (L.), and sweet bay
Magnolia virginiana L.]
RL 25875 (I, p. 44)

Watercolor and gouache heightened with gum arabic, over graphite
Inscribed in pen and brown ink in Catesby's hand, upper right: *Tricolor.*
Ligurinus; lower right: *Linaria Caerulea*; upper right corner: *44*
Verso: sketch in pen and brown ink over graphite of 'Swallow-Tail
Hawk'
14¾ × 10⁹⁄₁₆ in.; 374 × 268 mm

In this sheet Catesby uses the sweet bay again as a background for his illustrations of birds (see also cat. no. 7). Although he places the 'Painted Finch' and 'Blue Linnet' together in this watercolor, presumably on account of their similarity, he later separated them, reproducing them in consecutive plates with different plants: Plate 44 showed the 'Painted Finch' perched unconvincingly on a petal of the loblolly bay flower, while Plate 45 showed the 'Blue Linnet,' perched equally unconvincingly on a leaf of the solanum (9.2). The preparatory drawing for the latter plant (RL 25876) bears a faint sketch in graphite of the 'Blue Linnet,' presumably added at the stage at which Catesby decided to rearrange his images of the birds. The present watercolor thus represents an early stage in his arrangement of his subject matter.

George Edwards, believing the two different species of bird were the same, appears to have based his illustration of the 'Painted Finch' on the present watercolor (Edwards, 1743–51, Figure 130). He writes: "Mr. *Catesby* has figured these two Birds as different Species distinct from each other, not having then discover'd their Identity: See his *Painted Finch*, and his *Blue Linnet*, Vol. I, p. 44 and 45 of his *Natural History of Carolina*, &c."

Like the 'American Goldfinch' (cat. no. 8), the 'Painted Finch' was kept as a caged bird on account of its spectacular coloring. Catesby was able to observe specimens belonging to the former Governor of South Carolina, Robert Johnson, and noted that it took several years for the cocks to reach their full color. He also observed that "When they are brought into this cold Climate, they lose much of their lustre as appear'd by some I brought along with me."

The verso of this sheet bears a preparatory drawing in pen and ink of the 'Swallow-Tail Hawk,' used by Catesby as the basis of his watercolor (RL 24817); the illustration was reproduced as Plate 4 of the *Natural History*.

9.1 *Natural History*, I, Plate 44

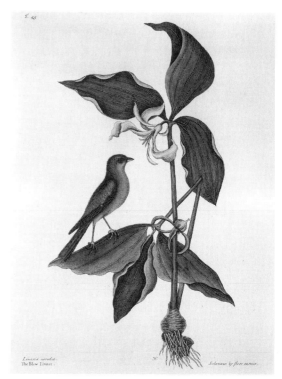

9.2 *Natural History*, I, Plate 45

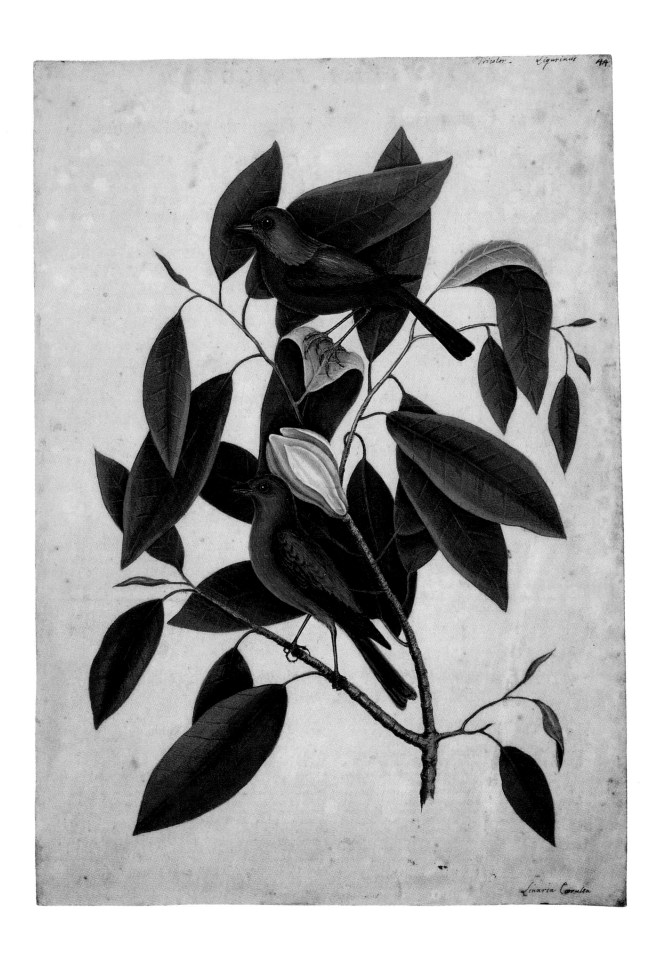

Linaria Coerulea

10 The Blue Bird and *Smilax non spinosa*

[Eastern bluebird *Sialia sialis* (L.), and carrion flower
Smilax pumila Walter]

RL 25879 (I, p. 47)

Watercolor and gouache heightened with gum arabic, over pen and
brown ink and graphite
Inscribed in pen and brown ink in Catesby's hand, upper center: *Blew
bird* / *The common blew Bird* / *Rubecula Americana caerulia*; lower
right: *Smilax non Spinosa humilis, folio* [partly erased] / *Aristolochie,
baccis rubris*; upper right corner: *47*; in graphite, lower edge: *40*
Verso: inscribed in pen and brown ink: *JC* [crossed out]; *N* [crossed
out]; *J:C*
10⁹⁄₁₆ × 14⁹⁄₁₆ in.; 268 × 370 mm

This drawing is one of Catesby's more elegant and
whimsical compositions. Noting that the bluebird
nests in "holes and trees," he shows it perched on a tree
stump with the plant, which "sometimes trails on the
Ground," shown springing up to form an arbor of
leaves and berries around the bird. The dried specimen
of the '*Smilax*' that Catesby sent William Sherard, and
which is now preserved in the Sherard Herbarium in
Oxford, is similar to the specimen of the plant that
Catesby depicts here (10.2).

Catesby executed a duplicate drawing of the East-
ern bluebird – without the plant – for Hans Sloane
(1.2) (see p. 33 above).

This distinctive composition appears to have in-
spired John James Audubon's watercolor of a 'Brown
Thrasher' (*Toxostoma rufum* (L.)), executed in 1815
(10.3).

10.2 Catesby's specimen of '*Smilax*' (Sher. Herb.,
spec. no. 2223.2)

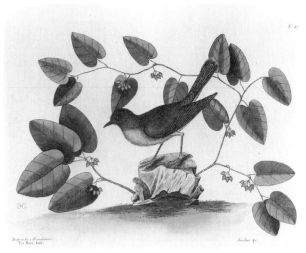

10.1 *Natural History*, I, Plate 47

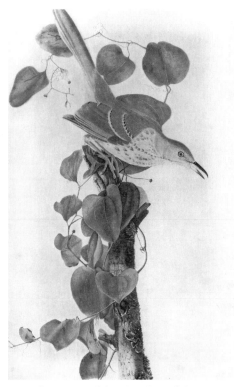

10.3 John James Audubon, '*Turdus Rufus*'
(sold Sotheby's, London, July 11, 1996, lot 51)

The common blew Bird *Louis dens*

Rubecula Americana cærulea

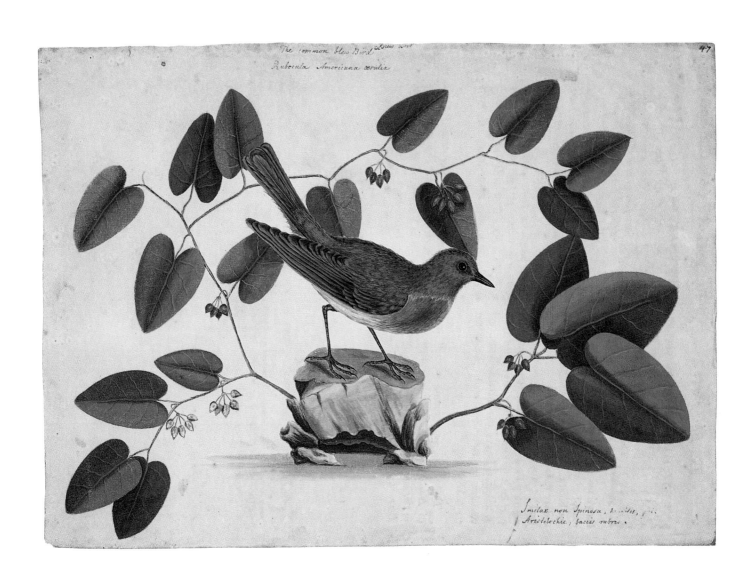

Smilax non Spinosa, humilis, f...
Aristolochie, baccis rubris.

11 The Crested Titmouse, the Upright Honysuckle and the Little Yellow Star-Flower

[Tufted titmouse *Parus bicolor* (L.), pinxter flower *Rhododendron nudiflorum* (L.) J. Torr, and yellow star-grass *Hypoxis hirsuta* (L.) Cov.]

RL 25892 (I, p. 57)

Watercolor and gouache heightened with gum arabic, over pen and brown ink and graphite
Inscribed in pen and brown ink in Catesby's hand, upper right: *Parus cristatus Americanus / The American crested Titmous*; bottom left: *Cistus Virginiana flore & odore / periclymeni – Dom: Banister*; bottom right: *Ornithogalum luteum / parvum foliis gramineis / glabris –* ; top right corner: *57*
14¾ × 10¹¹⁄₁₆ in.; 375 × 271 mm

In this attractive watercolor Catesby combines his illustration of the tufted titmouse with two separate plant studies. He says of both bird and plants that they were common in Carolina and Virginia; it is likely that he collected the plants, both summer flowering, at the same time. However, as with cat. no. 9, the drawing represents an early stage in Catesby's arrangement of his subjects: when he etched the composition he decided to omit the 'Yellow Star-Flower,' placing it instead with his illustration of the 'Large Lark,' a bird which feeds on the 'Yellow Star-Flower' seeds (11.2).

Catesby notes of the habitat of the tufted titmouse that "They breed in and inhabit *Virginia* and *Carolina* all the Year. They do not frequent near houses, their abode being only amongst the forest-trees, from which they get their food; which is Insects."

He shows the bird with its characteristic tuft or crest erect, although somewhat inaccurately curling backward instead of forward.

He depicts the 'Upright Honysuckle' with different colored flowering stems, a feature of the plant he also describes in the text: "At the ends of the stalks are produced bunches of flowers, resembling our common honysuckle; not all of a colour, some Plants producing white, some red, and others purplish, of a very pleasant scent, tho' different from ours. The flowers are succeeded by long pointed *Capsulas*, containing innumerable very small seeds."

He further notes that "[it] will endure our Climate in the open air, having for some years past produced its beautiful and fragrant blossoms at Mr. *Bacon*'s at *Hoxton*, and at Mr. *Collinson*'s at *Peckham*."

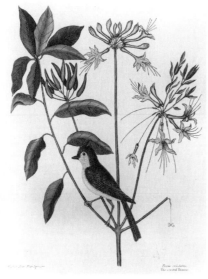

11.1 *Natural History*, I, Plate 57

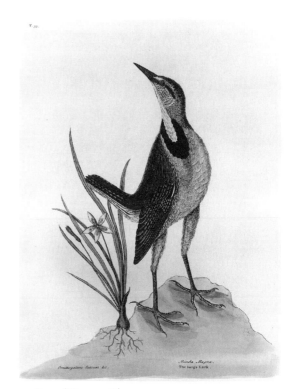

11.2 *Natural History*, I, Plate 33

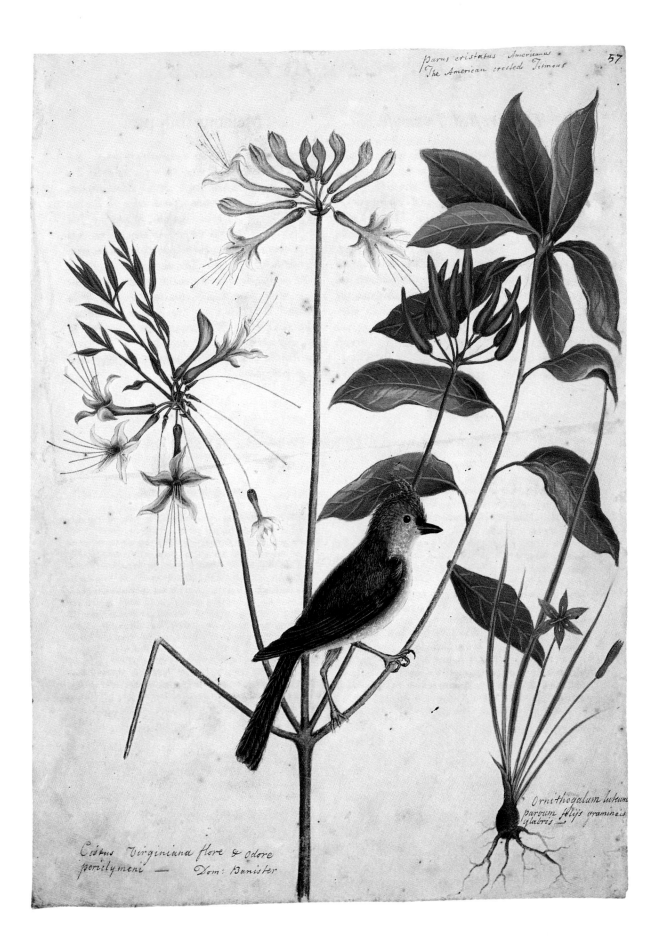

Ornithogalum luteum
parvum filijs gramineis
glabris —

Cistus Virginiana flore & odore
periclymeni — Dom: Banister

12 The Red-Start and the Black Walnut

[American redstart *Setophaga ruticilla* (L.), and black walnut *Juglans nigra* L.]

RL 25902 (I, p. 67)

Watercolor and gouache heightened with gum arabic, over outlines in
brush and watercolor and graphite
Inscribed in pen and ink, upper left: *67*
Verso: inscribed in pen and brown ink in Catesby's hand, upper right:
Ruticila Ruticilla Caroliniensis [crossed out] *Virginiensis*
10¾ × 15¹⁄₁₆ in.; 272 × 382 mm

Catesby found both bird and tree in Virginia. He noted that the American redstart was seen only in summer, "frequent[ing] the shady Woods." The black walnut he observed particularly "towards the Heads of the Rivers, where in low rich Land, they grow in great Plenty, and to a vast Size."

The composition, in which the bird appears to have been placed almost as an afterthought, is reminiscent of a number of Catesby's illustrations of birds (see, for example, the 'Bahama Titmouse': 12.2). As in that sheet, the placing of the bird next to the fruit of the tree may be an implicit indication of the bird's size. It is possible that Catesby executed the drawing of the American redstart from memory, or from an inadequate sketch, as he depicts the orange color incorrectly on the breast rather than on the wings.

He notes of the black walnut that the nut kernels are "very oily and rank tasted; yet, when laid by some Months, are eat by *Indians*, Squirrels, &c. It seems to have taken its Name from the Colour of the Wood, which approaches nearer to Black than any other Wood that affords so large Timber. Wherefore it is esteemed for making Cabinets, Tables, &c."

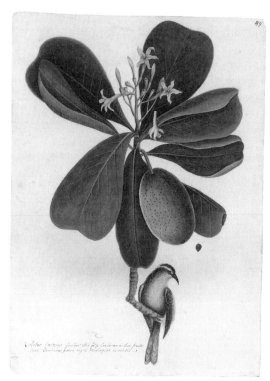

12.1 *Natural History*, I, Plate 67

12.2 Catesby, 'The Bahama Titmouse' (RL 25894)

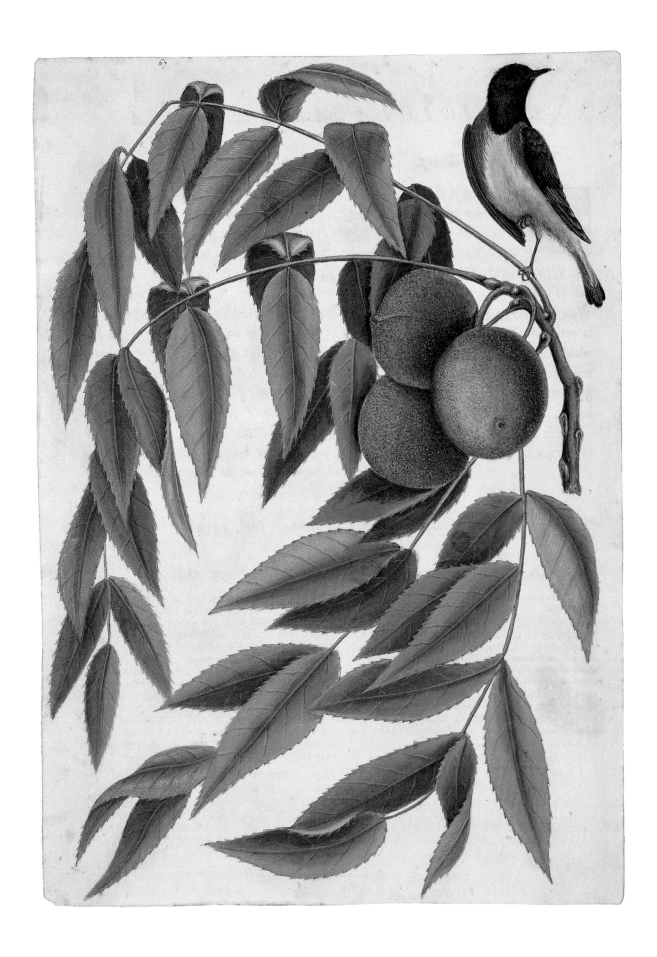

13 The Blue Heron

[Little blue heron *Egretta caerulea* (L.)]
RL 25911 (I, p. 76)

Watercolor and gouache, over pen and brown ink and touches of
graphite
Inscribed in pen and brown ink in Catesby's hand, upper left: *Blew
Heron*; top right: *Ardea caerulea purpureo capite*; top center: *76*
Verso: sketch in pen and ink, over brush and green watercolor and
graphite
Verso: inscribed in pen and brown ink in Catesby's hand, top edge:
Blew Heron Yellow Iris
10¹¹⁄₁₆ × 14¹⁵⁄₁₆ in.; 271 × 379 mm

Catesby follows Ray in placing water birds at the end
of his section on birds, that is, in Volume I of the
Natural History, although the order within this
subsection is somewhat haphazard. The present draw-
ing (together with cat. no. 14) is one of a group of
spectacular sheets depicting large waders. Most of
these birds are illustrated on their own without plants,
possibly because of their size. In the etched version of
this sheet Catesby places the bird on a river bank.

He notes that this heron "weighs Fifteen Ounces,
and in Size is somewhat less than a Crow From the
Breast hang long narrow Feathers, as there do likewise
from the Hind-part of the Head; and likewise on the
Back are such like Feathers, which are a Foot in
Length, and extend four Inches below the Tail, which
is a little shorter than the Wings. These Birds are not
numerous in *Carolina*; and are rarely seen but in the
Spring of the Year."

Catesby is inaccurate in his depiction of the color-
ing of the bird which he shows (possibly from mem-
ory) as too blue; the head and neck are in fact reddish-
brown. He made a special study of bird migration (see
note 31 on p. 26), but here comments "Whence they
come, and where they breed, is to me unknown."

Catesby's preparatory sketch in pen and ink for the
'Little White Heron' (his illustration is, in fact, of an
immature specimen of the little blue heron) on the
verso of this sheet (13.2) is particularly interesting as
the finished watercolor for this illustration (*Natural
History*, Plate 77) is missing from the Windsor vol-
umes. The subsidiary sketch of a bird on the verso of
cat. 13 is of the 'Little Thrush,' the finished watercolor
for which appears on a sheet with the 'Dahoon Holly'
(RL 24844).

13.1 *Natural History*, I, Plate 76

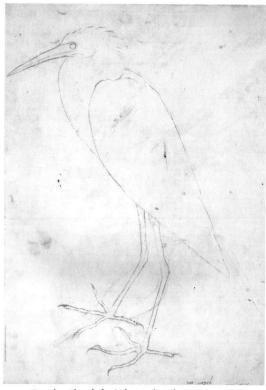

13.2 Catesby, Sketch for 'The Little White Heron'
(verso of cat. 13)

Blew Heron

Ardea cærulæ purpureæ capite

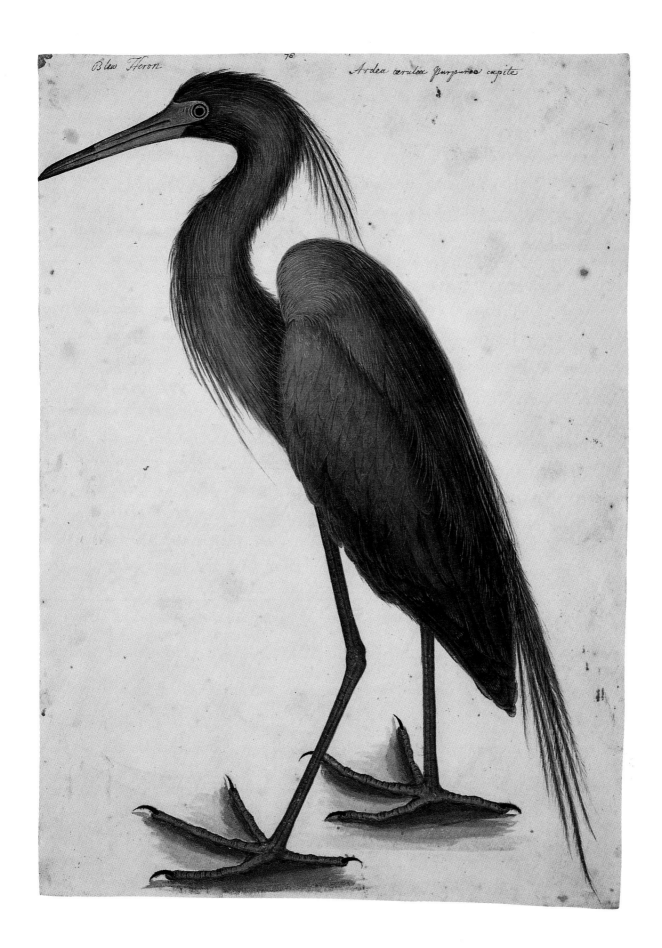

14 The Red Curlew

[Scarlet ibis *Eudocimus ruber* (L.)]
RL 25919 (I, p. 84)

Watercolor and gouache, over graphite
Inscribed in pen and brown ink in Catesby's hand, top right, *Arquata coccinea Bahamaensis*; top right corner: *84*
14⅞ × 10¹¹/₁₆ in.; 378 × 271 mm

This sheet is particularly striking for the reds of the bird's plumage, an intensity of coloring not found in the hand-coloring of the etched versions of this plate. Catesby writes of the bird's colors: "The Bill is in form like that of other Curlews, and of a pale red colour: on the fore-part of the Head, and round the Eyes, is a skin of the same colour as the Bill, and bare of feathers: the Legs are likewise of a pale red colour: about an inch of the end of the Wings are black, all the rest of the Bird is red."

He notes that it is a "larger Bird than the precedent [i.e., his 'Brown Curlew' which was, in fact, an immature white ibis], being about the bigness of a common Crow," and that it is found "frequent[ing] the Coasts of the *Bahama* Islands and other parts of *America* between the Tropicks, [but they] are seldom seen to the North or South of the Tropicks."

As in the case of cat. no. 13, the bird is not combined with a plant study, and in the etching is shown standing on a generic shore line.

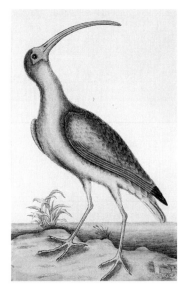

14.1 *Natural History*, I, Plate 84

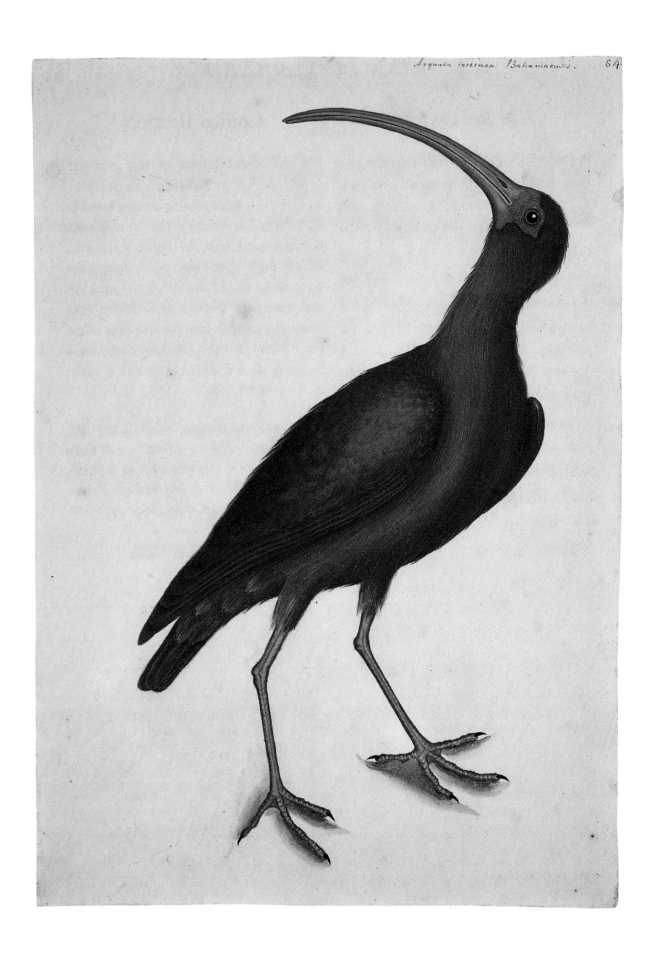

15 The Summer Duck

[Wood duck *Aix sponsa* L.]

RL 25932 (I, p. 97)

Watercolor and gouache heightened with gum arabic, over traces of
graphite
Inscribed in pen and brown ink in Catesby's hand, top right: *The*
Summer Duck Anas Americana cristata elegans; top right corner: *97*
10⁹⁄₁₆ × 14⅞ in.; 268 × 377 mm

Catesby ends Volume I of the *Natural History* with
illustrations of ten species of duck. In his Account he
observes that "Tho' the warm Parts of the World
abound most with Animals in general, Water Fowl may
be excepted, there being of them a greater Number and
variety of Species in the northern Parts of the World,
than between the Tropicks." He suggests that the rea-
son for this is that "as Nature has endowed all Creatures
with a Sagacity for their Preservation, so these Birds to
avoid the Danger of voracious Animals (to which they
are more exposed than Land Birds) choose to inhabit
where they least abound" (Account, p. xxxvi).

This is the most spectacular of his ducks; he found it
breeding in Virginia and Carolina where "[they] make
their Nests in the Holes of tall Trees (made by Wood-
peckers) growing in Water, particularly Cypress-
Trees." In the Account he puts forward a possible rea-
son for this choice of breeding-place: "there are some
Species of the Duck Kind, peculiar to these torrid Parts
of the World, which pearch and roost upon Trees for
their greater Security, of these are the Whistling Duck,

Hist. Jam. p. 324. The *Ilathera* Duck, Vol. I. p. 93, of this
Work. The Summer Duck, Vol. I. p. 97. Besides some
others observed by *Margrave* and *Hernandes* (Account,
p. xxxvi)."

However, as with the waders, most of Catesby's
ducks – including this one – are depicted on their own
without plants. Catesby executed a duplicate drawing
of this duck for Hans Sloane (1.3).

Edwards included the 'Summer Duck of Catesby' as
Figure 101 of his *Natural History of Birds*. His illustra-
tion was not, however, taken from Catesby but from a
specimen "sent me by my honour'd Friend, Sir *Robert*
Abdy, Bart. It was shot in a Pond at the Seat of *William*
Nicholas, Esq; a Relation of Sir *Robert*'s. It is a Native
of North America" (Edwards, 1743–51, II, p. 101).

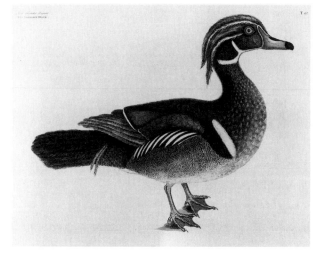

15.1 *Natural History*, I, Plate 97

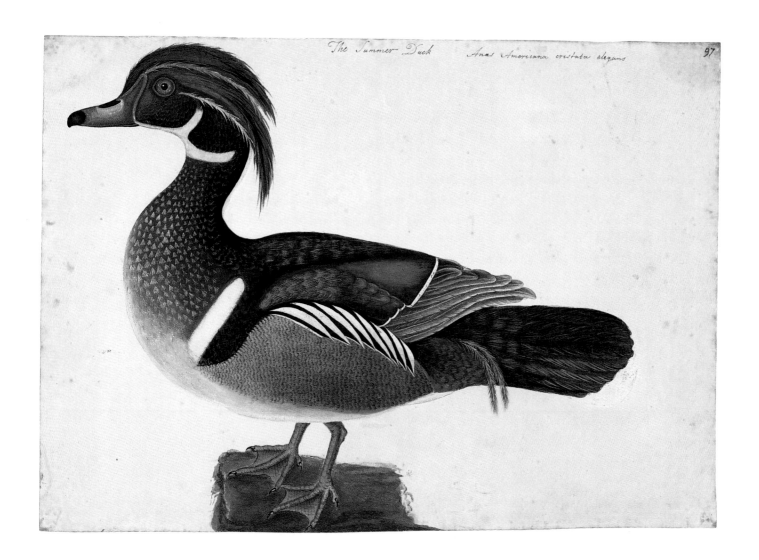

"The lower part or verge of the Wings are lapped over
and covered by the small downy side Feathers, extend-
ing from the Shoulders half way the Wings, display-
ing alternately and in a wonderful manner black and
white pointed Lines, varying in Appearance according
to the Motion of the Bird, and different Position it puts
its Feathers into, which adds much to the Beauty of it"
(*Natural History*, I, p. 97).

16 The Razor-billed Black-bird of Jamaica

[Smooth-billed ani *Crotophaga ani* L.]

RL 26068 (III, Appendix, p. 2a)

Watercolor and gouache heightened with gum arabic, over graphite
Verso: sketches of head of blackbird in grey and black watercolor
Verso: inscribed in pen and brown ink in Edwards's hand, lower center:
*these Sketches of heads are from an other bird which / I suppose was Older
the bill being a little hooked and / Sumthing biger April 1744*; lower edge:
*This bird was procur'd by T. White Esq. from Jamaico / Sir Hans Sloane
has described it by the name of the Greater black-bird / in his Natral hist:
of Jamaico. it is also discribed in Willughby Pa 120 5* [51? last digit cut]
*/ by the name of the Brasillian Ani of Kin to the parrots / it is drawn from
nature of the bignes of life Geo Edwards / Decemr 1743 / it hath 2 toes
forward and 2 backward*

13³⁄₁₆ × 10⅛ in.; 335 × 257 mm

This sheet and cat. no. 17 are from the extra twenty plates which constitute the Appendix on which Catesby worked between 1743 and 1747. In these drawings he appears to have combined fauna and flora without the same environmental concern he had shown at the outset of the publication. By the mid-1740s new plant and animal specimens were arriving in England which he had not seen or described in their natural environment.

Catesby also included in the Appendix a number of new plants and animals which had come from places other than North America. This bird was one such example. As he notes, it had been described by Hans Sloane in his *Natural History of Jamaica* where, Catesby says, "Sir *Hans Sloane* informs us, that it subsists on

Beetles and Grasshoppers. It also feeds on fruit and grain. They appear in flocks, and are querulous, and very noisy. They are numerous in *Jamaica, Hispaniola*, etc."

This is the only drawing by Edwards in the Windsor *Natural History* set. He notes on the verso of this sheet that he did the drawing of the blackbird from life in December 1743, the bird having been "procur'd by T. White Esq. from Jamaico" (16.2). His subject may well have been a caged specimen in Sloane's collection as Edwards was employed by Sloane at this time (see p. 33). As in most of his bird illustrations, Edwards depicts the bird on a tree stump against a generic landscape setting. In the etching, however, Catesby combines Edwards's bird with his own study of the calceolus orchid, executed by him three years earlier from a plant cultivated in Peter Collinson's garden in Peckham (RL 26069). He creates a whimsical and somewhat incongruous composition by positioning the bird on the delicate stem of the orchid.

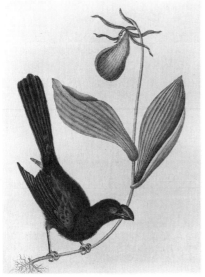

16.1 *Natural History*, II, Appendix, Plate 3

16.2 George Edwards, Studies and notes for the 'Razorbilled Black-bird of Jamaica' (verso of cat. no. 16)

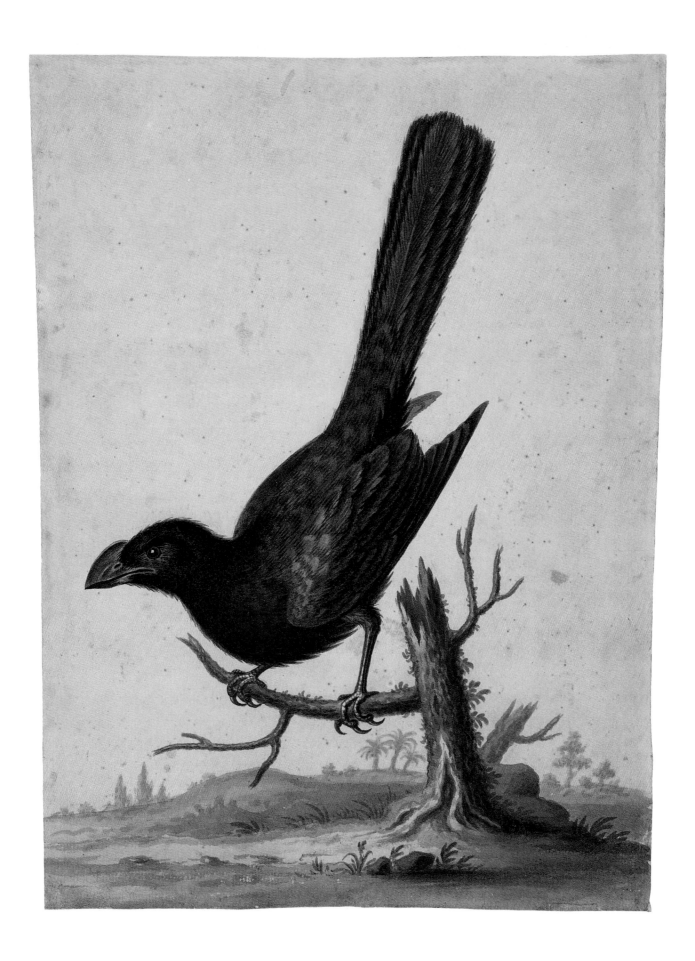

17 The Whip-poor-Will and the Ginseng or Nin-Sin of the Chinese

[Common nighthawk *Chordeiles minor* (Forster), and ginseng *Panax quinquefolium* L.]
RL 26085 (III, Appendix, p. 16)

Watercolor and gouache heightened with gum arabic, over graphite
14¾ × 10½ in.; 374 × 267 mm

Here Catesby again combines one of his own illustrations with a study by one of his colleagues. This time, however, the bird was executed by Catesby; he appears then to have given his drawing to Ehret who added the plant: it is clear that the stalk of the plant was painted after the bird rather than the other way around. As with cat. no. 16 there appears to be no environmental relationship between bird and plant.

Catesby informs us that although he stated in the Addenda to his Account (p. xliv) that he had never been able to catch sight of the 'Whip-poor-Will' while he was in America (despite the fact that "I once shot one of them, but cou'd not find it in the Dark"), he had "since received two of them from *Virginia* [which] has enabled me to exhibit the figure of it, and also to add to the description of it some remarks sent me by Mr. *Clayton* concerning it."

However, Catesby seems to have confused two birds. His illustration appears to be of the common nighthawk (*Chordeiles minor*), but the description fits the whip-poor-will (*Caprimulgus vociferus* Wilson), a completely different species. Edwards includes an illustration and description of 'The Whip-poor-Will or lesser Goat-Sucker' in his *Natural History of Birds* (I, Figure 63), noting that "Mr. *Mark Catesby* obliged me with this Bird; it was brought from *Virginia*, and there was another brought with it, which compared in all its Marks, but more obscure which I suppose to be the Female." Edwards's illustration is clearly based on Catesby's (17.2).

There is a drawing on vellum by Ehret of the ginseng plant, signed and dated 1744, at Knowsley in one of the volumes of Ehret drawings (Knowsley NH12 E5, f. 8). It is likely that the drawing Ehret executed for Catesby was copied from the Knowsley version, possibly a year or so later. Catesby notes in his accompanying text that a description and drawing of the ginseng made in 1709 by a "Father Jartoux," a Jesuit missionary in China, "published in the *Memoirs of the Academy of Sciences* at *Paris*, gave light to the discovery of the same plant in *Canada* and *Pensylvania*; from which last place it was sent to Mr. *Collinson* in whose curious garden at *Peckham* it has, the preceding two or three years, and also this year 1746, produced its blossoms and berries as it appears in the figure here exhibited." Ehret later published the Knowsley version of his drawing of the ginseng as Plate VI of Trew's *Plantae Selectae*, 1750.

17.1 *Natural History*, II, Appendix, Plate 16

17.2 G. Edwards, 'The Whip-poor-Will or Lesser Goat-Sucker' (Edwards 1743–51, I, Figure 63)

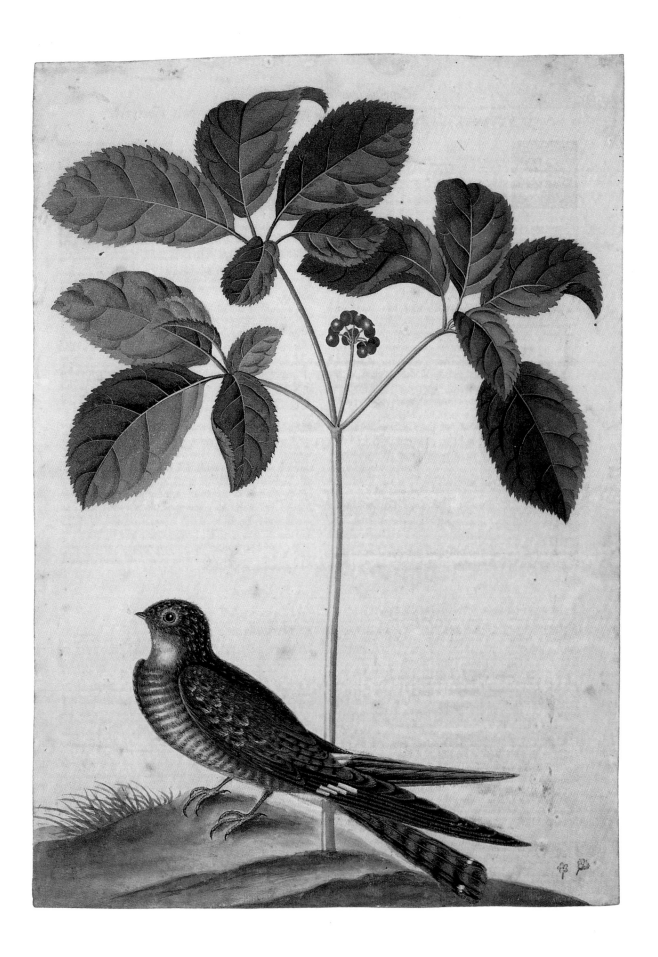

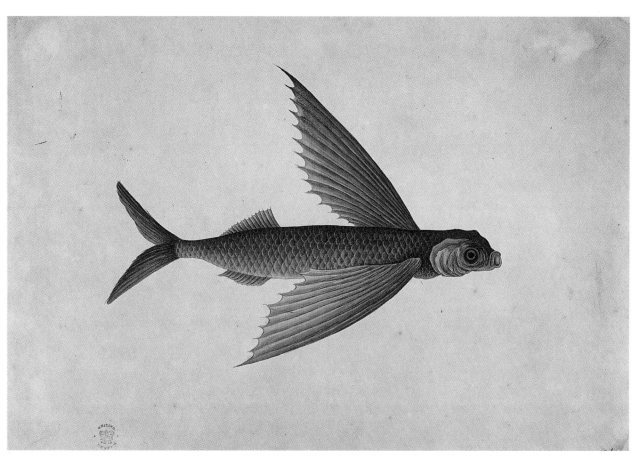

II.1 Catesby, 'The Flying Fish' (Sloane MS 5267, no. 74)

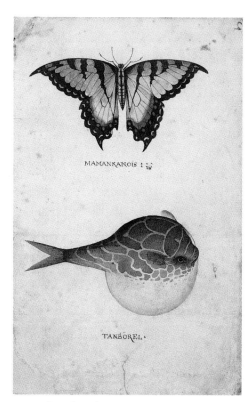

MAMANKANOIS :

TANBOREL .

II.2 After John White, 'Tanborel and Mamankanois'
(Sloane MS 5270, f. 14)

SECTION II: FISHES

Cat. Nos. 18–23

CATESBY begins the second volume of his *Natural History* with the depiction of forty-six species of fish, which he illustrates in thirty-one plates, with one plate in the Appendix (Plate 19). The Windsor set contains drawings of two further species not included in the published volume (the 'Pilchard,' RL 25942, and the 'Sawfish,' RL 26093). Fishes thus constitute the largest group of fauna which Catesby studied, apart from birds. The majority of Catesby's drawings of fishes date from his visit to the Bahamas in 1725, a visit made with the specific intention of studying the marine life. He notes: "Of Fish I have described not above Five or Six from *Carolina*, deferring that Work till my Arrival at the *Bahama* Islands; which as they afford but few Quadrupeds and Birds I had more time to describe the Fishes, and tho' I had been told they were very remarkable, yet I was surprised to find how lavishly Nature had adorn'd them with Marks and Colours most admirable" (Preface, p. x).

As a whole, in his illustrations of fishes, Catesby does not achieve the same impressive standard that he set in his illustrations of birds. Most of the portraits are rather stiff profiles, and he does not attempt to 'naturalize' his fishes, unlike his birds, by providing them with appropriate backgrounds. Where he adds plants as background, these are very often land rather than water plants. In the etchings his decision to add shadows, rather than compensating for the lack of backgrounds, tends to detract from the images. Catesby was not always accurate when it came to depicting fins, and he himself admitted the difficulty in portraying colors accurately, because fishes change color when re-moved from the water. To overcome this problem he tried to paint each fish "at different times, having a succession of them procur'd while the former lost their colors" (Preface, p. xi). However, his stay in the Bahamas was not long enough to allow him to do this in every instance; and it was possibly shortage of time that accounted for his less careful study of fishes in general. Nevertheless, many of Catesby's drawings of fishes are appealing for their simplicity and almost emblematic quality.

A number of Catesby's fish drawings were not done from life but were derived from illustrations in Hans Sloane's natural history albums (see p. 33 and II.2–3). The majority of Catesby's copies were based closely on the Sloane prototypes, even to the extent of his tracing the outlines and replicating the media of the originals – a rather thin use of watercolor compared to his usual gouache technique (see cat. no. 23); occasionally his drawing was derived rather more loosely from its prototypes. The reason for Catesby's basing some of his illustrations on secondhand images is not explained, but it may again have arisen from shortage of time – or lack of opportunity – to observe these particular specimens adequately. A duplicate of one of his own fish drawings which Catesby made for Sloane is in Sloane's album, 'Drawings of Fish in Colour' (II.1).

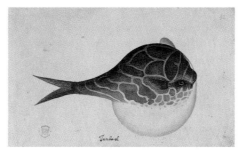

II.3 Unidentified eighteenth-century artist after II.2
(Sloane MS 5267, no. 42)

73

18 The Squirrel

[Squirrelfish *Holocentrus rufus* (Walbaum)]
RL 25940 (II, p. 3a)

Watercolor and gouache heightened with gum arabic, over graphite
Verso: inscribed in pen and brown ink in Catesby's hand, top edge:
Squirril
10⁹⁄₁₆ × 14¹⁵⁄₁₆ in.; 268 × 379 mm

Catesby describes the 'Squirrel' as a "good eating Fish." In his accompanying text, he makes unusually brief comments on the squirrel's color which are limited to the fact that the iris is yellow and the "whole Fish" red. He notes of its size, "These Fish are most commonly of the Size of this Figure, tho' some of them grow to four times the Bigness."

In the etched plate Catesby combines the squirrelfish with the 'Croker,' the preparatory drawing for which is on a separate sheet (18.2). In order to fit both fishes on the page, he has to flatten two of the fins of the squirrelfish, thus producing a somewhat less compelling image than that of his drawing.

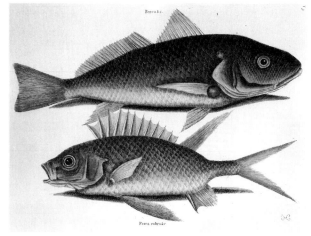

18.1 *Natural History*, II, Plate 3

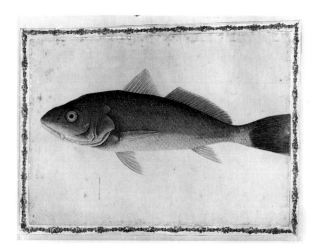

18.2 Catesby, 'The Croker' (RL 25939)

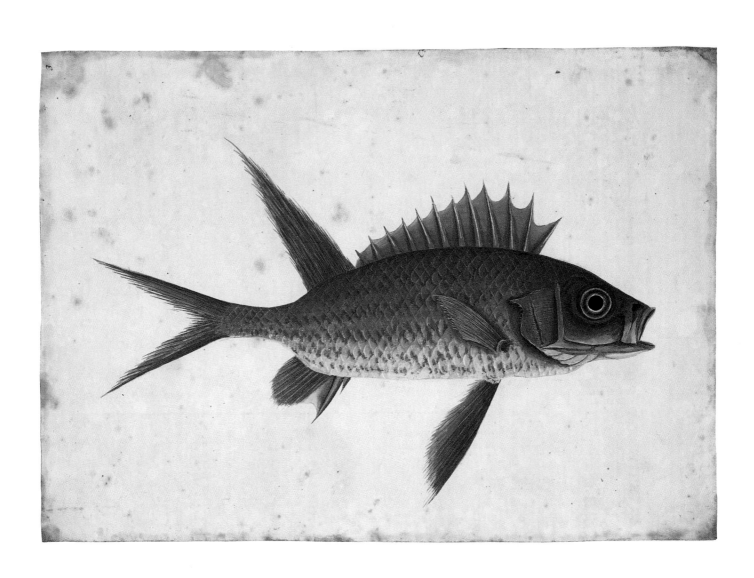

19 The Flying Fish, the Rudder Fish and the Fresh-Water Pearch

[Exocoetid flyingfish *Exocoetidi* indet.;
Bermuda chub *Kyphosus sectatrix* (L.);
Pumpkinseed *Lepomis gibbosus* (L.)]
RL 25947, 25948, 25949 (II, p. 8)

Watercolor and gouache heightened with gum arabic, over graphite
Inscribed in pen and brown ink in Catesby's hand, upper edge: *Orig:*
8⁹/₁₆ × 9¹⁵/₁₆ in.; 217 × 253 mm
Watercolor and gouache heightened with gum arabic, over graphite
3⅝ × 6⁷/₁₆ in.; 92 × 164 mm
Watercolor and gouache heightened with gum arabic, over graphite
4⅜ × 8¹/₁₆ in.; 111 × 204 mm

Catesby drew these three fishes separately but combined them in the same etching, presumably on account of their small scale. In the Windsor albums they were mounted together on a single page.

In the Preface Catesby describes how, during his journey to Carolina in 1722, he and the crew of his ship were "often diverted" with the "Pursuit of Dolphins after Flying-Fish ... the Dolphins having raised the Flying-Fish, by the swiftness of their Swimming, keep Pace with them, and pursue them so close that the Flying-Fish at length tired, and their Wings dry'd, and thereby necessitated to drop in the Water, often fall into the Jaws of their Pursuers" (Preface, p. vii).

However, "at some Times neither Element aford them Safety, for no sooner do they escape their Enemies in the Water, but they are caught in the Air by voracious Birds."

In his text accompanying Plate 8, Catesby notes: "As they are a Prey to both Fish and Fowl, Nature has given them those large Finns, which serve them not only for Swimming but likewise for Flight. They are good eating Fish, and are caught plentifully on the Coasts of *Barbados*, where at certain Seasons of the Year the Markets are supplyed with them."

Catesby produced a duplicate drawing of the 'Flying Fish' for Sloane (II.1). The fact that he inscribed the present drawing "Orig." would seem to imply that the Sloane version was a copy of this one and that he was concerned to keep his "originals" in his own possession (see p. 33).

Catesby comments on the 'Rudder Fish': "These Fish are most commonly seen in warm Climates, and in crossing the Atlantick Ocean Ships Rudders are seldom free from them: they seem to gather their Nutriment from the Slime adhering to the Rudder and Bottom of the Ships; and tho' so small a Fish, they keep Pace with Ships in their swiftest Course."

The 'Fresh-Water Pearch' was one of the few fresh-water fishes Catesby depicted. He says they were common in Virginia and Carolina, noting: "They are found mostly in Mill-Ponds and other standing fresh Waters: They are called by some Ground Pearch, from their burrowing into, and covering themselves in the Mud or Sand."

19.1 *Natural History*, II, Plate 8

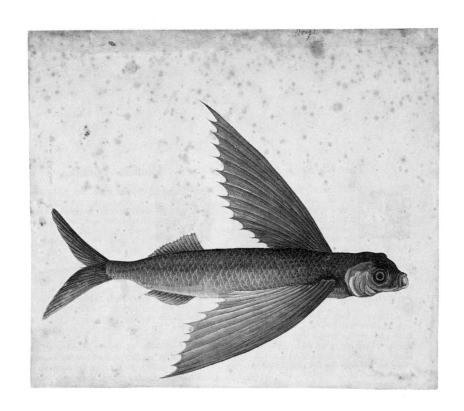

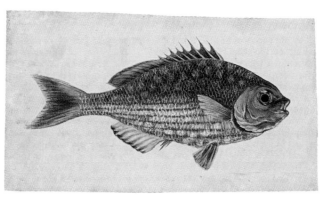

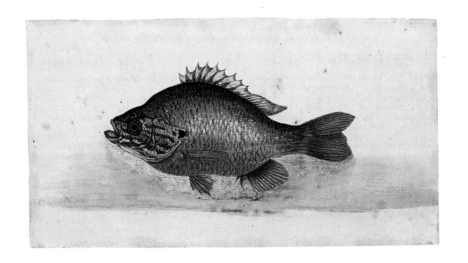

20 The Hind and the Skipjack

[Red hind *Epinephelus guttatus* (L.);
Bluefish *Pomatomus saltatrix* (L.)]

RL 25957, 25958 (II, p. 14)

Watercolor and gouache heightened with gum arabic, over pen and
brown ink and graphite
6⅝ × 14¹¹⁄₁₆ in.; 169 × 374 mm
Watercolor and gouache, over pen and brown ink and graphite
5 × 14⅞ in.; 126 × 377 mm

These two drawings of fishes, mounted together in the
Windsor *Natural History* set, were combined in a
single etching. While the spectacular 'Hind' was found
"in the shallow Seas of the Bahama Islands," the more
commonplace 'Skipjack' was found off the coasts of
Virginia and Carolina.

Catesby notes of the 'Skipjack' that "the Scales are
small of a shining Brightness; and when just taken are
green on the Back, which in *Virginia* has given them
the Name of *Green Fish*; but in *Carolina* it hath ob-
tained the other Name from its frequent Skipping out
of the Water."

He says of the 'Hind': "The whole Fish instead of
Scales was covered with a thick Skin variously col-
oured; *viz* the Head of a muddy Red, the Back of a
dark reddish Brown, the Sides green and Belly white;
the whole sprinkled very thick with red Spots."

Both fishes were considered edible and "esteemed
good."

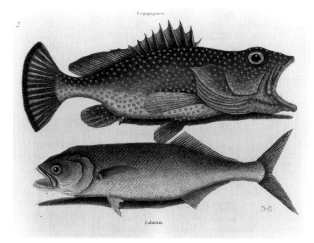

20.1 *Natural History*, II, Plate 14

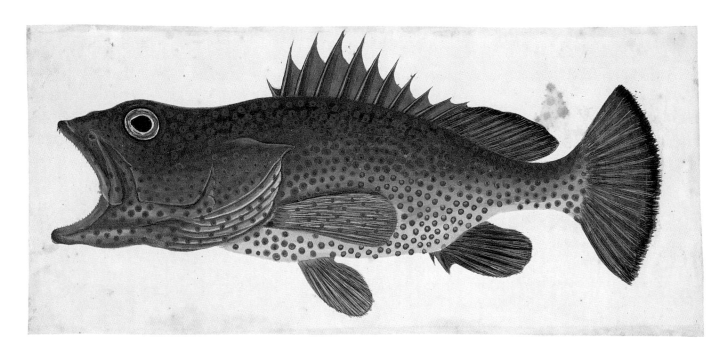

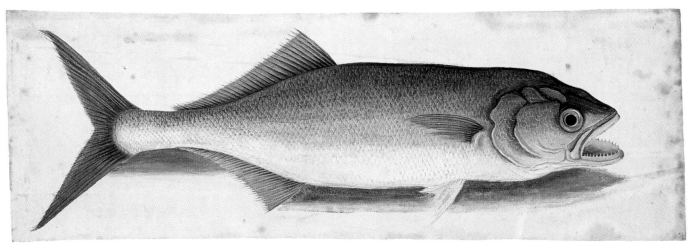

21 The Blue Fish

[Blue parrotfish *Scarus coeruleus* (Bloch)]
RL 25963 (II, p. 18)

Watercolor and gouache over graphite
Inscribed in pen and brown ink, upper right corner: *Blew fish*; top left
corner: *18* [crossed out]
Verso: outline sketch of 'Blue Fish' in graphite; inscribed in pen and
brown ink in Catesby's hand, top left:
Blew F.
10⁹⁄₁₆ × 14⁹⁄₁₆ in.; 268 × 370 mm

The drawing illustrates another of the vividly colored
fishes observed by Catesby off the Bahama Islands,
and also common "in most of the Seas between the
Tropicks." Catesby says of its coloring merely that it
is "entirely blue," but comments specifically on the
unusual shape of the head: "[it] is of an odd Structure
and like that of the Whale, which produces the Sper-
ma Ceti." He also notes that the fish varies in size,
some specimens being "twice the Bigness of this; but
I think they are seldom found much larger." He makes
a reference to Willughby's *De Historia Piscium* in
which the species is illustrated and described.

The verso of the sheet bears an outline sketch of the
fish in graphite; as the outline differs from the profile
of the fishes of both the finished watercolor and the
etching, the sketch would not appear to have been used
in the transfer of the image onto the plate.

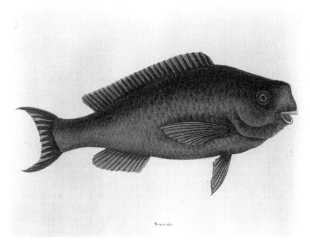

21.1 *Natural History*, II, Plate 18

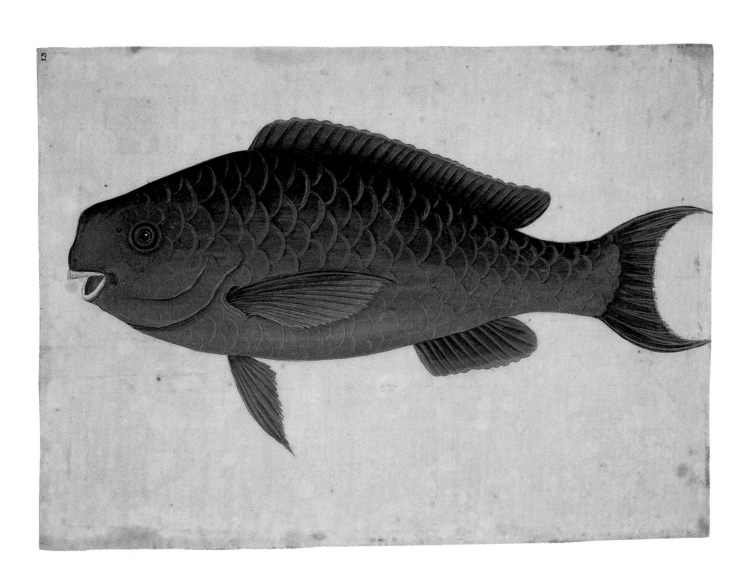

22 The Sole

[Peacock flounder *Bothus lunatus* L.]
RL 25971 (II, p. 27)

Watercolor and gouache over graphite
Inscribed in pen and ink, top right corner: *27*; in Catesby's hand, left
edge: *25*
10⅝ × 14¹¹⁄₁₆ in.; 269 × 373 mm

Catesby does not say where he found the 'Sole,' but
this apparently was "the only one of the kind I have
seen." He adds, "whether they are eatable I know not,
nor could I be informed, they being very rarely
caught," and notes: "The Tail is in Form of a Rhom-
bus or Lozenge; The Body of the Fish brown, sprin-
kled over with Figures of an oval Form, being like
semi-circles with their Ends pointing to one another,
or like Circles divided in the middle, of a bright blue
colour."

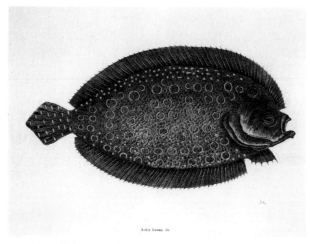

22.1 *Natural History*, II, Plate 27

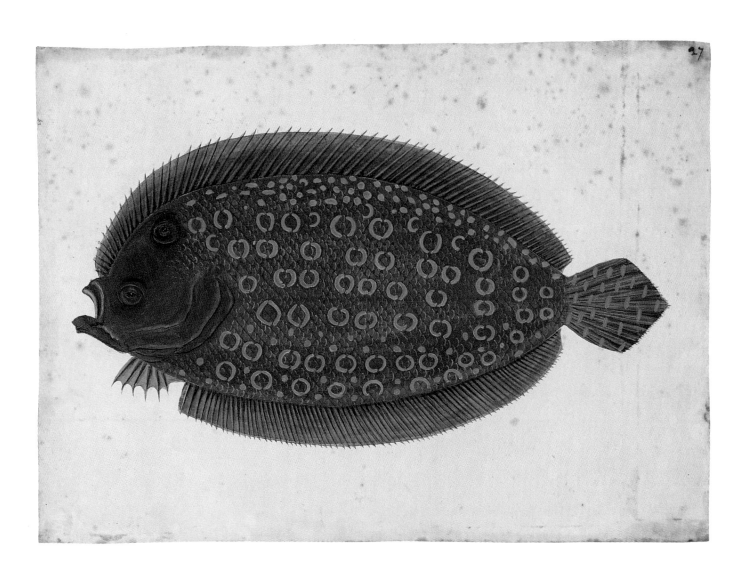

23 The Globe Fish, *Phaseolus minor* and *Cornus, foliis salicis*

[Red milk-pea *Galactia rudolphioides* (Griseb.)
Bentham and Hooker, and bastard torch or black
torch *Nectandra coriacea* (Sw.) Griseb.;
Pufferfish *Sphoeroides testudineus* (L.)]
RL 25972, 25973 (II, p. 28)

Watercolor and gouache, over pen and brown ink and graphite
Inscribed in pen and brown ink in Catesby's hand, lower left: *Cornus
foliis salicis laurea accuminatis, / floribus albis, fructu Sassafras*; lower
right: *An Phaseolus minor lactescens flore / purpureo – Hist. Jam:*; in
graphite, to right of right-hand stem: *57*; to right of left-hand stem: *58*
Verso: sketch of plant in brush and green watercolor over graphite
14¹⁄₁₆ × 10¹¹⁄₁₆ in.; 357 × 271 mm
Watercolor over graphite
5⅛ × 10⁹⁄₁₆ in.; 130 × 268 mm
LITERATURE: Hulton and Quinn 1964, pp. 129–30, no. 100, under 'D:
Catesby copy,' plate III (b)

These two watercolors were mounted together in the
Windsor albums, and the studies were combined in the
etching. The reason for Catesby's putting the 'Globe
Fish' together with his study of the '*Cornus*' and the
climbing '*Phaseolus*' is unclear; the resulting composi-
tion is somewhat incongruous.

Catesby's drawing of the 'Globe Fish' is based on a
watercolor in one of Hans Sloane's natural history al-
bums (see p. 33 above). Two versions of the 'Globe
Fish' exist: one in Sloane's so called John White album
(II.2) and a copy of that in his album 'Drawings of
Fish in Colour' (II.3). The latter is inscribed *Tanborel*,
after the inscription in the earlier drawing; Catesby,
however, does not use this name for the fish.

Catesby notes that 'Globe Fish' are "found in *Vir-
ginia* and many other Parts of *America*." He says of its
unusual shape: "This Fish (no doubt of it) has re-
ceived its Name from the Form, which is almost glob-
ular, except that the Tail extends beyond the spherical
Form."

He appears not to have seen the fish himself as he
follows the Sloane drawings in their inaccurate depic-
tion of the tail (the tail of the pufferfish is not forked).

He writes of the '*Cornus*' tree: "On the Tops of the
Branches are placed many small white hexapetalous
flowers, which are succeeded by green Berries in a
reddish Calix, growing to red Foot-stalks of an Inch
long, resembling much the Berries of *Sassafras*."

The '*Phaseolus*' plant "creeps up, and is supported
by Trees and Shrubs near which it grows." The verso
of the sheet bearing the plant studies (RL 25973) has a
sketch in brush and green watercolor of an unidenti-
fied plant, possibly a magnolia.

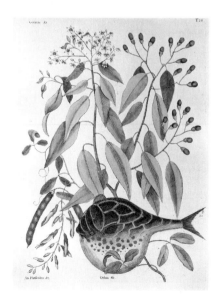

23.1 *Natural History*, II, Plate 28

84

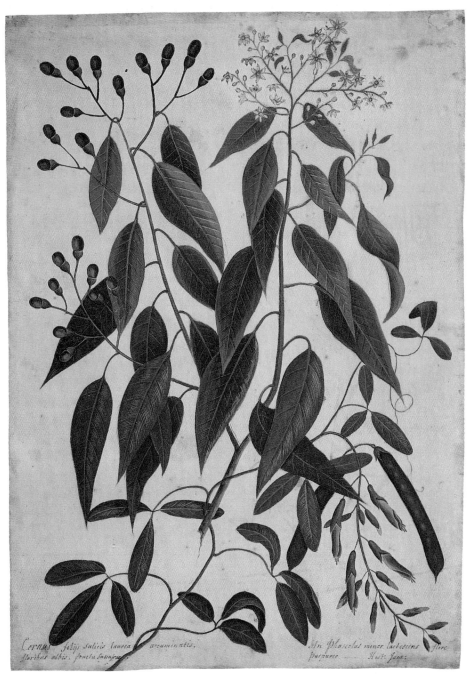

Cornus folijs salicis laurea acuminatis,
floribus albis, fructu luteofusco

An Phaseolus minor lactescens flore
purpureo ___ Hist: Jam:

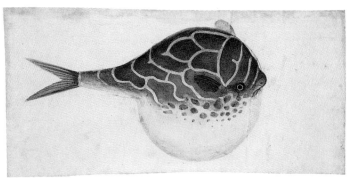

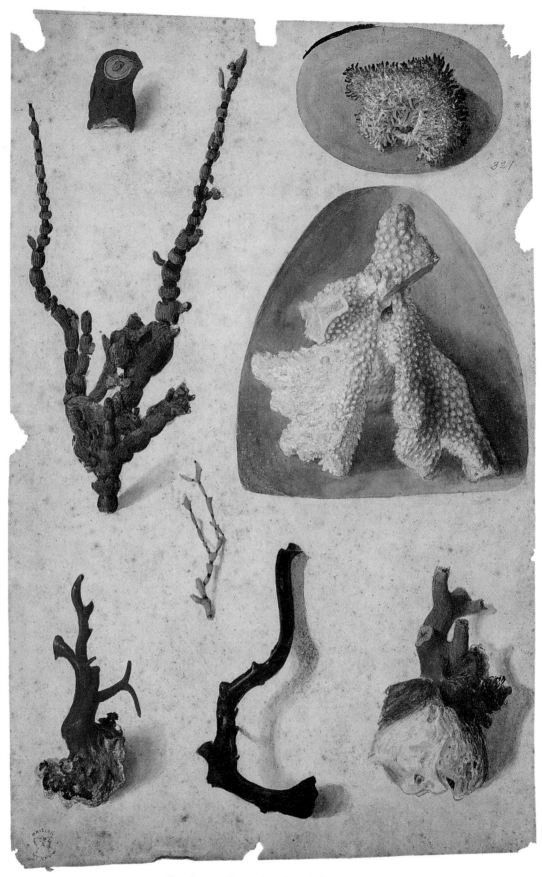

III.1 Attributed to Catesby, Studies of coral (Sloane MS 5271, no. 321)

SECTION III: CRABS, TURTLES AND CORALS
Cat. Nos. 24–26

FOLLOWING his treatment of fishes in Volume II, Catesby devoted the second half of the seventh part of the *Natural History* to crabs and turtles. The majority of these he combined in the final etchings either with sea plants or with corals (which in common with

other naturalists of the day, Catesby considered to be plants); most of the preparatory drawings, however, represent the animals, corals or plants individually before he had determined their final arrangement (see, for example, cat. no. 25).

Catesby found most of the crabs, turtles and corals in the Bahama Islands. However, as with his fishes, he derived a number of his images of crabs and turtles from illustrations in Sloane's collection, specifically Sloane's albums, 'Drawings of Fishes, Crabs, Shells, etc.' (Sloane MS 5262), 'Drawings of Amphibious Animals' (Sloane MS 5272), and the so called John White album (Sloane MS 5270) (see p. 33 above). As with the drawings of fishes Catesby copied from Sloane's collection, the majority of copies in the present category are based closely on their prototypes, with the outlines traced and the media of the earlier drawings reproduced (see cat. no. 26).

Catesby tells us that while he was in the Bahama Islands, "I collected many Submarine productions, as Shells, Corallines, Fruitices Marini, Sponges, Astroites &c. These I imparted to my curious Friends, more particularly (as I had the greatest obligations) to that great Naturalist and promoter of Science Sir *Hans Sloane*, Bar.ᵗ" (Preface, p. x).

Although he illustrates several species of coral in the *Natural History*, he does not include any of the other 'submarine productions' that he collected and gave to Sloane. Sloane's album, 'Drawings of Insects, Corallines, &c. in colours' (Sloane MS 5271), does, however, contain a number of drawings of such 'submarine productions,' and while none of them bears the identification 'Mr Catesby' in Sloane's hand, Catesby is credited in the 1832 manuscript inventory (see p. 33 above) as one of the artists of the album, and may well have executed sheets such as no. 321 (see III.1).

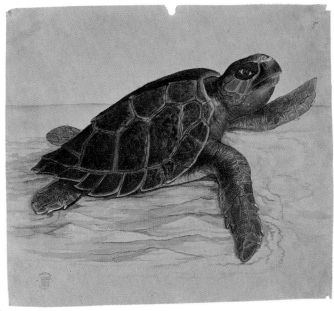

III.2 Unidentified eighteenth-century artist, 'Hawks-bill turtle' (Sloane MS 5272, no. 5)

24 The Red Motled Rock Crab and the Rough-Shelled Crab

[Sally lightfoot or rock crab *Grapsus grapsus* L., and
Calappa flammea Herbst]
RL 25982 (II, p. 36)

Watercolor and gouache heightened with gum arabic, over pen and
brown ink and graphite; some corrections in white
Inscribed in pen and brown ink, upper right corner: *36*
14¹¹⁄₁₆ × 10⅝ in.; 372 × 269 mm

Of the seven species of crab Catesby depicts in his *Natural History*, these two studies are the most spectacular. They are also the only two he did not separate and combine with plants or corals in the etched plates.

This drawing is one of Catesby's most successful in its detailed depiction of coloring and texture. Here, he is not hampered by problems of anatomy or three-dimensionality, and the flatness of his subjects allows him to concentrate wholly on depicting the markings and textures of the animals' shells – which he does with an almost miniaturist technique.

He notes of the 'Red Motled Rock Crab' that "the whole is motled in a beautiful Manner with Red and White" and explains the reason for its epithet 'Rock': "These Crabs so far as I could observe never go to Land, but frequent mostly those Parts of the Promontories and Islands of Rocks, in and near the Sea, where by the continual and violent Agitation of the Waves against the Rocks, they are always wet, continually receiving the Spray of the Sea, which often washes them

into it, but they instantly return to the Rock again, not being able to live under Water, and yet requiring more of that Element than any other of the crustaceous Kinds that are not Fish."

Of the 'Rough-Shelled Crab' he observes that "as the Structure of this Fish is so much better understood by the Figure of it than by the most tedious Description, I shall only observe that the whole Shell is covered with innumerable little Tubercles, resembling Shagrine: The Colour of it is brown variously stained with purple."

24.1 *Natural History*, II, Plate 36

25 *Titanokeratophyton ramocissimum*

[Gorgonian coral, unidentified]
RL 25983 (II, p. 37)

Watercolor and gouache over graphite
Inscribed in pen and brown ink in Catesby's hand, lower right:
Titanokeratophyton Ramocissimum, crusta eleganti / tuberculata; upper
right corner: *37*; in graphite at base of coral: *42*
Verso: preparatory drawing for the 'Black Mangrove' and an
unidentified plant in pen and brown ink over graphite
Inscribed in pen and brown ink in Catesby's hand, lower left: *Frutex
Lauri folio pendulo, fructu tricocco, Semine / Nigro Splendente*; in
graphite at base of stem: *39* [crossed out]; *47*
5¹⁄₁₆ × 14¹¹⁄₁₆ in.; 129 × 372 mm

Catesby includes five species of coral in the *Natural History*, three of which he combined with his illustrations of crabs, and two with his studies of the flamingo. In the published plate this coral was put together with the 'Red Claw Crab,' the preparatory drawing for which is found on the sheet with the 'Hermit Crab' (RL 25978).

He notes of the '*Titanokeratophyton*' coral that it "rises from one to two Feet in Height, covered with a very thick tuberculated Incrustation, which while it is growing in the Water, is covered with a thick Slime or Mucilage. The whole Plant is pliant and very ponderous, both which it retains when dry, the Colour of it is deep yellow, as well while it is growing as when dry."

The sketches of Bahamian plants on the verso of the present drawing show Catesby's devoting a sheet to studies of similar (or what he considered to be similar) subject matter (25.2). One of the plants, the '*Frutex Bahamensis*' (or 'Black Mangrove'), is sketched

again with the oyster catcher – a bird which he saw on the coasts of the Bahama Islands – and is illustrated in the final plate with that bird (RL 25920 and *Natural History*, Plate 85); the other plant, the '*Frutex Lauri folio*,' does not appear to have been reproduced in the *Natural History*.

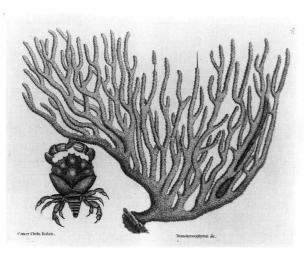

25.1 *Natural History*, II, Plate 37

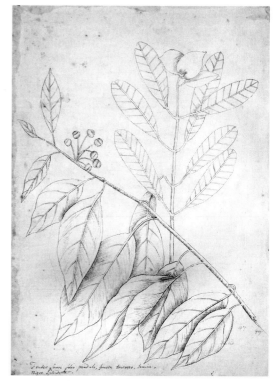

25.2 Verso of cat. 25

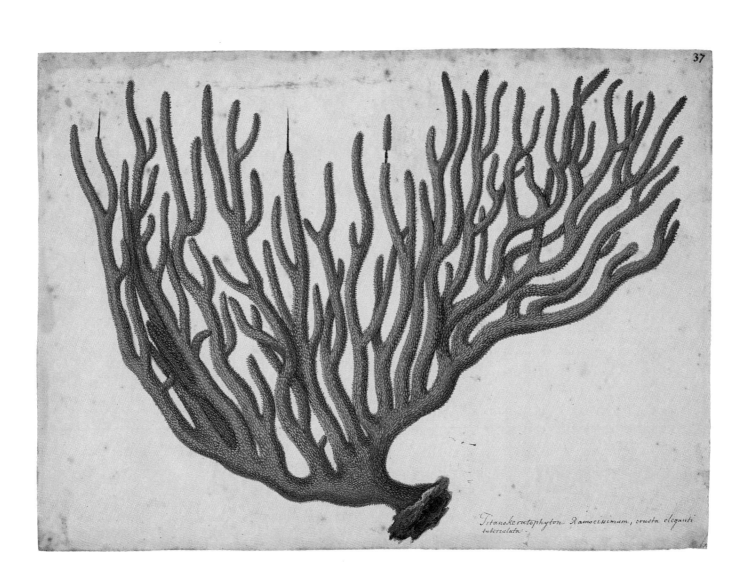

Titanokeratophyton Ramocissimum, crusta eleganti tuberculata.

26 The Hawks-Bill Turtle

[Hawks-bill turtle *Eretmochelys imbricata* L.]
RL 25985 (II, p. 39)

Watercolor with touches of gouache, over graphite
Inscribed in pen and brown ink, upper right: *39*
Verso: outline of 'Hawks-Bill Turtle' in graphite; inscribed in pen and
brown ink in Catesby's hand, upper center: *The Hawksbil Turtle*
10⅝ × 14⅞ in.; 270 × 378 mm

The hawks-bill is one of three species of turtle depicted by Catesby. He notes that "The Strength and Beauty of the Shell is sufficient to distinguish it from the other Kinds of Turtle," the shell, apparently, being "in Esteem for [its] usefulness, so well known in Mechanick Uses." He also comments: "This Kind of Turtle receives its Name from the Form of its Mouth, resembling that of an Hawk's beak; the upper Jaw hanging more over the under Jaw than in the other Kinds."

The present drawing is copied from one by an anonymous artist in Sloane's album, 'Drawings of Amphibious Animals,' where the turtle is shown sitting in the shallow sea water (III.2). The outlines of the two drawings accord exactly, indicating that Catesby traced his image from the Sloane version. Catesby also replicates the rather thin use of watercolor in the Sloane drawing.

The verso of the sheet bears an outline in graphite of the turtle; a tracing made of this outline fits exactly over the outlines of the finished drawing on the recto and the Sloane drawing, possibly indicating that the unfinished outline represents a stage in the process of transferring the image from the Sloane album.

In the etching Catesby places his turtle on what is presumably a sandy shore next to its nest full of eggs.

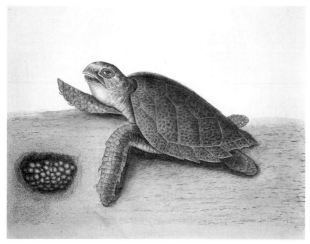

26.1 *Natural History*, II, Plate 39

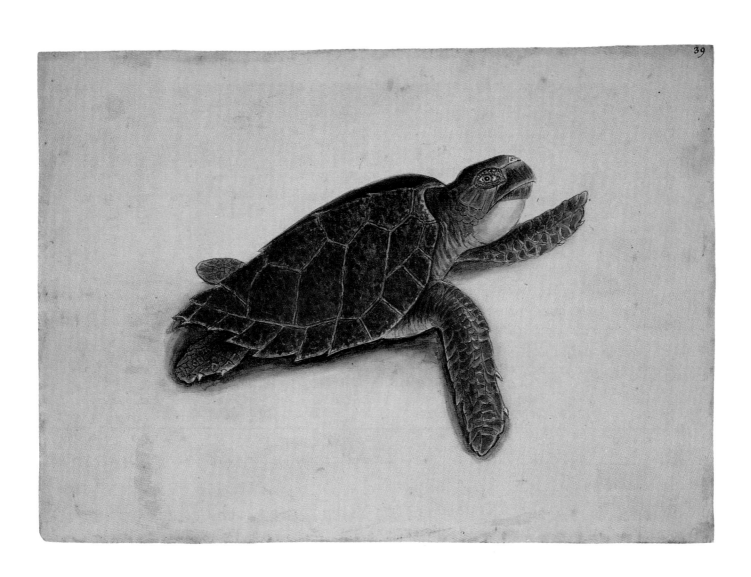

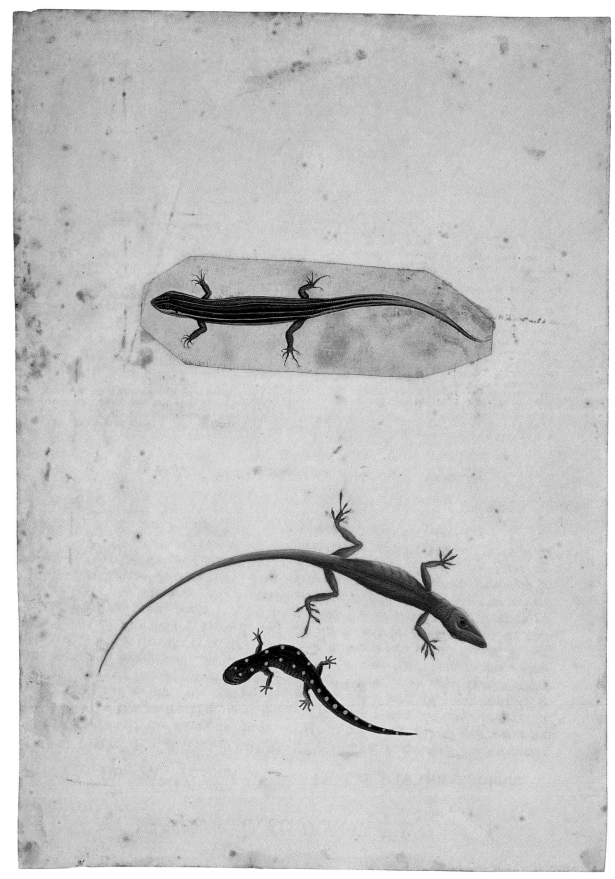

IV.1 Catesby, Studies of lizards (RL 26018)

SECTION IV:
SNAKES, LIZARDS AND FROGS
Cat. Nos. 27–35

CATESBY devotes the eighth part of the *Natural History* to snakes, representing twenty species. All but one of these are illustrated together with plants, combined in some cases to reflect a particular relationship between snake and plant (cat. no. 28), and in other cases for aesthetic reasons (cat. no. 30).

Catesby's images of frogs and lizards are included with his mammals in the ninth part of the *Natural History*. He illustrates five species of lizard, one alligator and four frogs. All, apart from one illustration of the iguana (taken from Sloane's so called John White volume: see p. 33 above), appear to have been drawn from actual specimens of the animals. In the case of both the lizards and the frogs Catesby's earlier drawings consist of specimen pages (IV.1 and cat. no. 34) which he later rearranged into compositions with plants (cat. nos. 31, 32 and 35). Of all Catesby's illustrations of animals, his frogs are unusually accurate, with details such as the eardrums carefully depicted. Possibly the reason for this greater accuracy was the ease in obtaining and drawing specimens from life.

27 The Brown Viper

[Unidentified snake]
RL 25992 (II, p. 45)

Watercolor and gouache, over pen and brown ink and touches of
graphite (snake); pen and ink over graphite (ox)
Inscribed in pen and brown ink in Catesby's hand, upper right corner:
The brown Truntion S; upper left edge: *45*
Verso: inscribed in pen and brown ink in Catesby's hand, right-hand
edge: *The Brown Viper*
10⅝ × 15 in.; 270 × 380 mm

The present sheet represents an informal moment in
Catesby's working out his compositions, the head of
the ox in the right-hand corner appearing more as a
doodle than as an element of the final composition
which Catesby might have been contemplating. In
the etching the snake is illustrated together with the
'*Arum maximum Aegyptiacum*' (*Colocasia esculenta* (L.)
Schott) on a floating island of vegetation; no drawing
for this lily appears in the Windsor *Natural History* set.

Catesby says of the 'Brown Viper': "It is ... a very
slow moving and sluggish Reptile, advancing deliber-
ately, even to escape Danger; yet will defend himself
with much Fierceness when attacked, and its Bite is
said to be as venomous as any: They retain their brown
Colour in all Stages of Life."

He notes that it is found in Virginia and Carolina
and is known as the 'Trunchion Snake,' the name he
inscribes on the upper right-hand edge of the sheet. He
adds a postscript to his text accompanying this illustra-
tion: "The Subject of this Plate is as it appeared to me
at a great Inundation, where by the Violence of the
Current, Fish, Reptiles, with other Animals and In-
sects, were dislodged from their Holes, &c. floating
upon Heaps of Vegetable Refuse, where the voracious
and larger Serpents were continually preying upon the
smaller, as well those of their own Kind, as others,
which in that Confusion were more easily surprized."

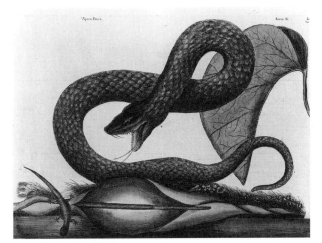

27.1 *Natural History*, II, Plate 45

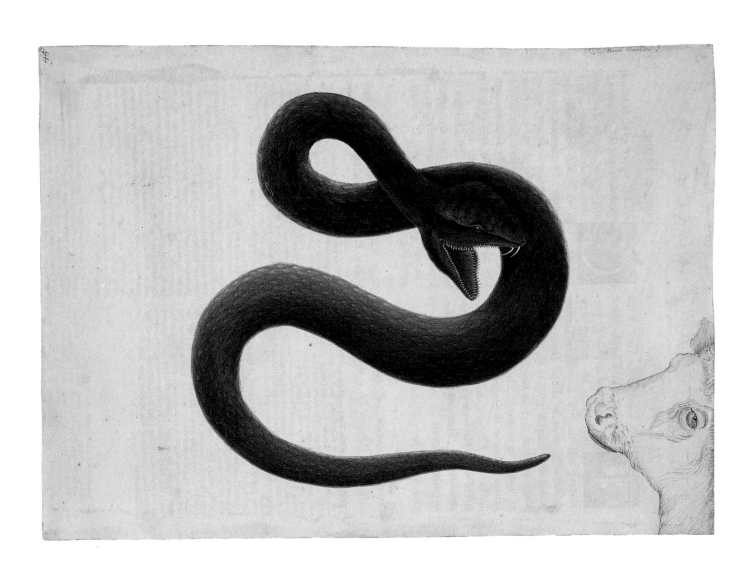

28 The Little Brown Bead Snake and *Corallodendron humile*

[Unidentified snake, and coral bush *Erythrina herbacea* L.]
RL 25997 (II, p. 49)

Watercolor and gouache heightened with gum arabic, over outlines in brush and green watercolor and touches of graphite
Inscribed in pen and brown ink in Catesby's hand, lower right:
Corallodendron humile, Spica florum longissima / coccinea, radice crassissima; upper right corner: *49*
Verso: sketch of waterlily in graphite with parts gone over in pen and grey-brown ink
14¾ × 10⅝ in.; 375 × 269 mm

Unlike cat. no. 27, the snake in the present drawing is harmless. It is shown twisting around the root of the coral bush, illustrating Catesby's statement that "These [snakes] seldom appear above Ground, but are dug up and found twisting about the Roots of shrubs and other Plants." He explains the reason for its name: "All the Back and upper Part of the Body, have transverse Spots of brown and white, so disposed, as to make some Resemblance of a String of Beads, which seems to have given its *English* Name."

Catesby arranges the composition ingeniously so that the seed pods of the coral bush, with their 'bead-like' seeds, and the curving lines of the root complement the curves of the snake.

The stem of the coral bush, bearing its distinctive coral-colored flowers, is shown bent over in the manner of a herbarium specimen (see p. 131 below).

Catesby notes: "In Winter the whole Plant dies to the Ground, leaving as a Monument of fading Glory its withered Stalks, which remain standing the whole Winter, and are towards their Bottoms as big as the largest walking Cane ... The Root of this Plant resembles that of Briony, being large at Top, running down into the Earth four or five Feet, white within, and covered with a brown Rind; some of them so large, that they weigh upwards of twenty Pounds."

The verso of this sheet bears a sketch of waterlily leaves and a flower, a plant which does not appear among either the finished watercolors or the etchings.

Ehret's illustration of the '*Corallodendron*' (28.2), reproduced in Plate LVIII of Trew's *Plantae Selectae*, appears to have been influenced by the present drawing.

28.1 *Natural History*, II, Plate 49

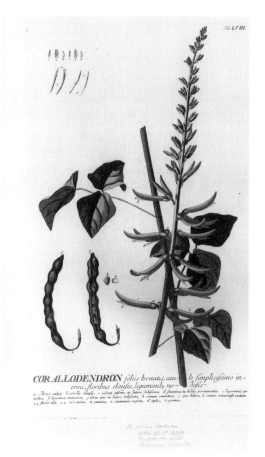

28.2 G.D. Ehret, '*Corallodendron*' (Trew 1750–53, Plate LVIII)

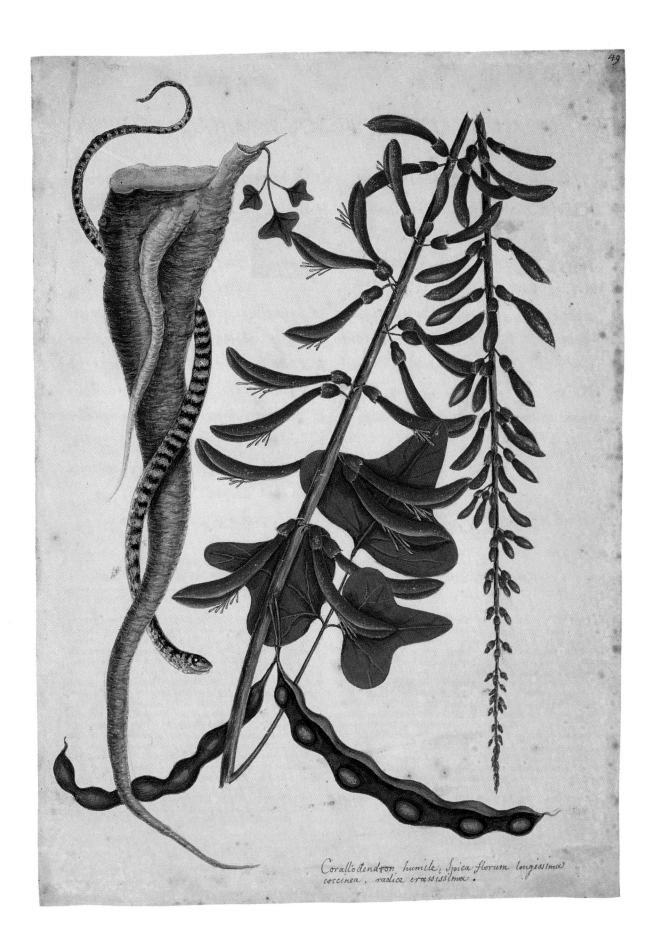

Corallodendron humile, Spica florum longissima coccinea, radice crassissima.

29 The Ribbon-Snake and Winter's Bark

[Ribbon snake *Thamnophis sauritus* L., and cinnamon bark *Canella winterana* (L.) Gaert.]

RL 25998 (II, p. 50)

Watercolor and gouache heightened with gum arabic, over touches of graphite
Inscribed in pen and brown ink in Catesby's hand, lower left, beneath flap: *Arbor baccifera, Lauri folia, aromatica, / fructu viridi calyculato racemoso Hist: Jam:*; in pen and ink upper right corner: *50*; in graphite beneath stem of plant: *55*
14⅝ × 10¾ in.; 371 × 273 mm (with flap of paper attached lower left edge: 5⁵⁄₁₆ × 4⅞ in.; 134 × 123 mm)

The drawing of the snake is on a separate piece of paper, silhouetted around its upper edge. It appears that during the process of Catesby's arranging his compositions and his decision to combine this particular snake and plant, he cut the snake out of another sheet and pasted it over the lower stem of the plant and the inscription, in the position in which he intended to etch it. Before pasting it down, however, he erased the part of the stem that the image of the snake was to cover (29.2). In the etching this lower branch is omitted altogether.

Catesby notes that the ribbon snake is "a slender Snake, usually not much bigger than the Figure. The Upper Part of the Body dark brown, with three parallel white Lines, extending the whole Length of the Body; the Belly white. They are very nimble and inoffensive."

He found the cinnamon bark growing in "the thick Woods of most of the *Bahama* Islands The whole Plant is very Aromatick, the Bark particularly being more used in Distilling, and in greater esteem in the more Northern Parts of the World than in *England*."

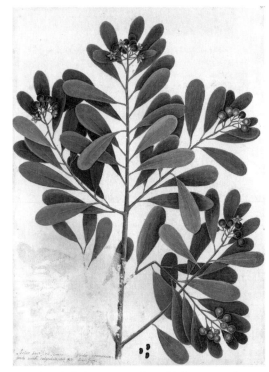

29.1 *Natural History*, II, Plate 50

29.2 Cat. 29 during conservation, with flap removed

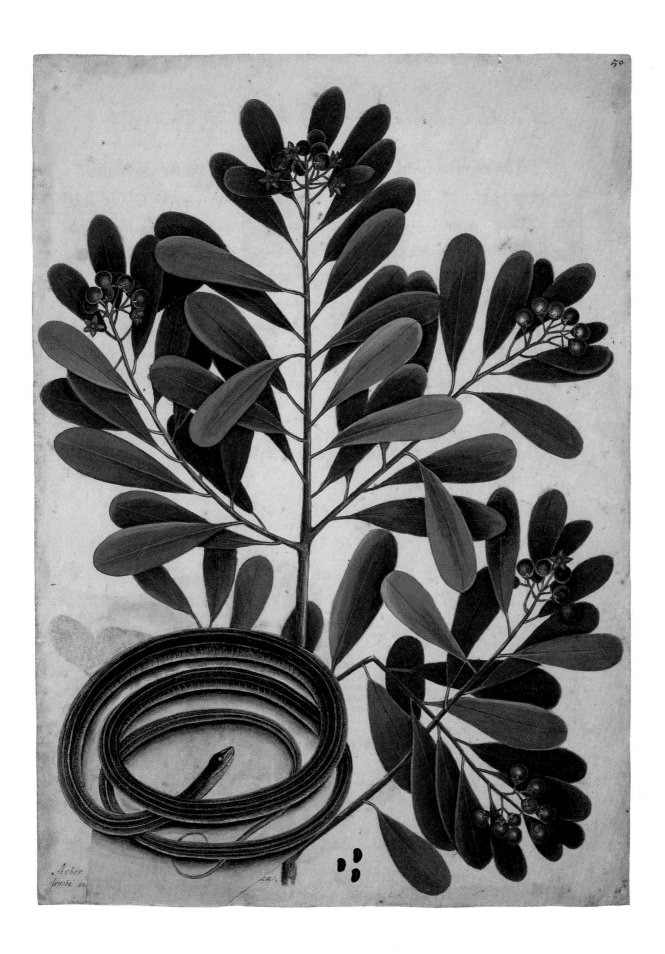

Arbor
fructu ...

2a.

30 The Wampum Snake and the Red Lily

[Wampum snake *Nerodia fasciata* L., and Catesby's
lily *Lilium catesbaei* Walt.]
RL 26008 (II, p. 58)

Watercolor and gouache, over pen and brown ink and touches of
graphite (snake); outlines in brush and watercolor, over graphite (plant)
Inscribed in pen and brown ink in Catesby's hand, upper right corner:
Wampum S; upper left: *58* and *11*
Verso: inscribed in pen and brown ink in Catesby's hand, right edge:
The Wampum Snake and *Lilium Carol:*
10⅝ × 15 in.; 270 × 380 mm

Catesby notes that this snake "receives its name from
the Resemblance it has to *Indian* Money called
Wampum, which is made of Shells cut into regular
Pieces, and strung with a Mixture of Blue and White
…. The Back of this Serpent was dark Blue, the Belly
finely clouded with brighter Blue, the Head small in
Proportion to its Body. They seem to retain their
Colour and Marks at every Change of their *Exuviae*.
They are found in *Virginia* and *Carolina*."

He also tells us that although it is not poisonous, "as
all the largest Snakes are voracious, so will they devour
what Animals they are able to overcome."

The drawing represents an early stage in the evolu-
tion of the composition. The 'Red Lily' is sketched in
outline only, a study of it having been completed
already on a separate sheet together with the '*Marta-
gon Canadense*' (see cat. no. 41). The cut-off stalk
emerging from the bulb, shown in both the present
sheet and the fully worked-up watercolor, is length-
ened in the etching to match the height of the upper
part of the plant shown on the other side of the sheet.

The 'Red Lily' was renamed 'Catesby's Lily' in
1788 by the botanist Thomas Walter. It is one of a
number of plants named in Catesby's honor (see
p. 131).

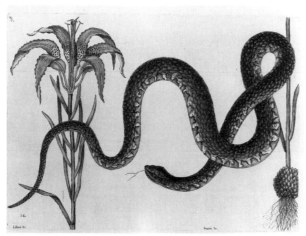

30.1 *Natural History*, II, Plate 58

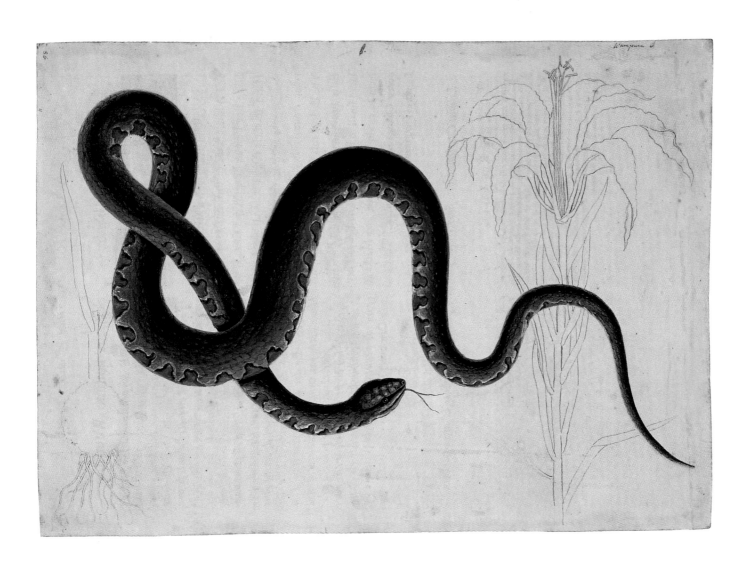

31 The Green Lizard of Jamaica and the Sweet Gum-Tree

[Jamaican chameleon *Anolis garmani* Stejneger, and sweet gum *Liquidambar styraciflua* L.]
RL 26016 (II, p. 65)

Watercolor and gouache, over pen and brown ink and graphite
Inscribed in pen and brown ink in Catesby's hand: *Liquid-Ambari arbor Stiraciflua – aceris folio / fructu tribuloide (ie) pericarpio Obientari – ex quam / plurimis apicibus coagmentato Semen recondens – / Phytogr. Pluk: Alma. Umbrella Tree* [crossed out]; in pen and brown ink, top right: *65*; in graphite beneath lower fruit: *9*
Verso: inscribed in pen and brown ink: *85*
15¹¹⁄₁₆ × 10⅝ in.; 382 × 270 mm

Catesby's preparatory drawing for this composition appears on the verso of an unrelated botanical drawing of the '*Viscum Cariophilloides*' (31.2). It is clear from this sketch that Catesby added the lizard to what was primarily a study of the sweet gum, a study probably executed directly from a specimen. In the etched version of the composition (II, Plate 65) Catesby depicts a different species of lizard – his 'Green Lizard of Carolina' (green anole *Anolis carolinensis* Voigt), which is shown without the red throat fan or dewlap – placing the 'Green Lizard of Jamaica' instead with his illustration of the 'Logwood' (Plate 66 and RL 26017). Here, however, the combination of plant and animal emphasizes the chameleon-like qualities of the lizard, its red throat fan (used for display) and green skin appearing as a perfect camouflage against the foliage and red flower-heads of the sweet gum. Catesby notes of the lizard's changing colors: "[They] change their Colour in some Measure, like the Camelion, for in a hot Day their Colour has been a bright Green, the next Day changing Cold, the same Lizard appeared brown."

Although Catesby uses his preliminary sketch of the sweet gum for his final watercolor, the earlier version is altered in several ways. It is also reduced in scale to allow for a separate stem with flower-heads to be added to the upper part of the watercolor. A detailed description of the flower-heads accompanies the illustration, followed by a brief discussion of gum, the most notable characteristic of this tree: "From between the Wood and the Bark of this Tree issues a fragrant Gum, which trickles from the wounded Trees, and by the Heat of the Sun congeals into transparent resinous Drops, which the *Indians* chew, esteeming it a Preservative of their Teeth."

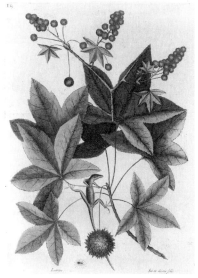

31.1 *Natural History*, II, Plate 65

31.2 Preparatory study for cat. no. 31 (RL 26030 verso)

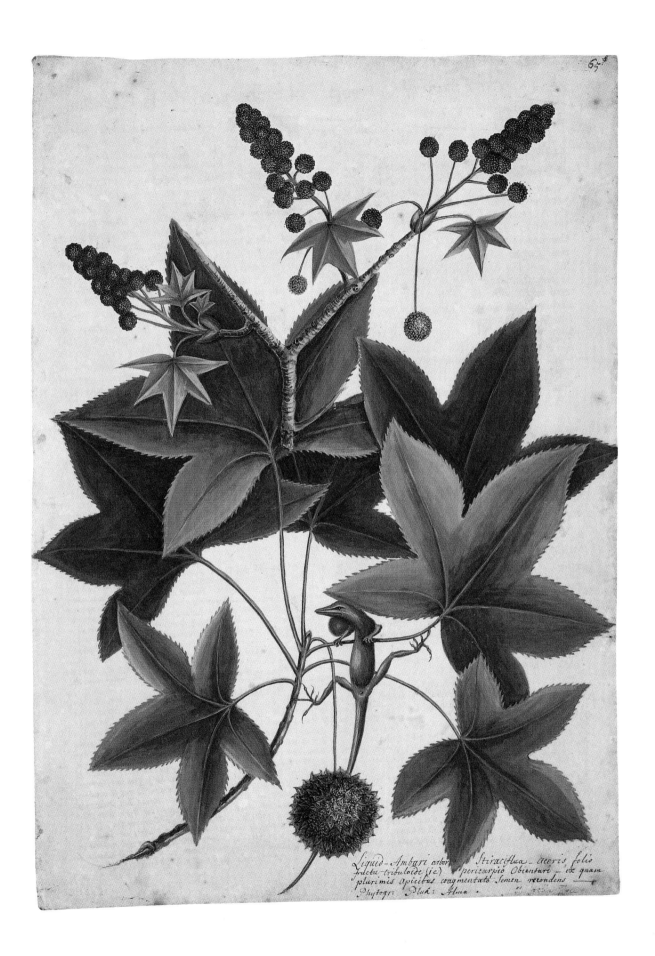

*Liquid-Ambari arbor Stiraciflua aceris folio
fructu tribuloide (si e) pericarpio Orientari ex quam
plurimis apicibus congmentato semen recondens*
Phytogr: Pluk: Alma.

32 The Land Frog, Fire-Fly, and *Sarracena, foliis longioribus et angustioribus*

[Southern toad *Bufo terrestris* Bonaterre, a click beetle *Deilelater atlanticus* Hyslop, Catesby's pitcher plant *Sarracenia catesbaei* (Ell.) Bell, and hooded pitcher plant *Sarracenia minor* Walt.]

RL 26020 (II, p. 69)

Watercolor and gouache heightened with gum arabic, over graphite
Inscribed in pen and brown ink, upper right corner: *69*
Verso: inscribed in pen and brown ink in Catesby's hand, upper left:
Sarracena foliis longioribus & angustioribus / Bucanephyllon elatius Virginianum &c / Pluk. Alm. p. 27. T. 152. f. 3 & T. 376. f. 5
14⅞ × 10⁹⁄₁₆ in.; 371 × 268 mm

Catesby creates a striking composition by combining his 'Land Frog,' one of the insects off which it feeds, and a plant which grows "in Bogs and watery Places in *Carolina, Virginia, Maryland* and *Pensylvania*" – the forms of the animals being paralleled in the unusual shapes of the plant (two species of *Sarracenia* are in fact depicted, although Catesby considered them to represent the different stages of growth of a single species). Another watercolor of the southern toad appears on a sheet with two species of frog (cat. no. 34), representing the stage before Catesby had worked out this composition.

He explains his reason for believing the southern toad to be a frog: "Their Bodies are large, resembling more a Toad than a Frog, yet they do not crawl as Toads do, but leap." In discussing the feeding habits of the toad he recounts an intriguing anecdote: "They feed on Insects, particularly of one Kind, which the following Accident seems to confirm. As I was sitting in a sultry evening with some Company without Doors, one of us let fall from a Pipe of Tobacco some light burning Ashes, which was immediately catched up and swallowed by a Frog of this Kind. This put us upon tempting him with a red hot Wood Coal, not less than the End of ones Finger, which he also swallowed greedily; thus afterwards I always found one or other of them easily deceived in this Manner, as I imagine, by taking it to be a *Cicindela*, or *Fire-Fly*, which in hot Nights are very numerous in *Virginia* and *Carolina*, where also these Frogs abound."

Catesby was clearly fascinated by the strange anatomy of the pitcher plant family, executing three studies of different species of the plant (see cat. no. 33). He gives a detailed description of the various parts characteristic of the different species, noting of the leaf of the hooded pitcher plant that "when near its full Growth [it] arches over the Mouth of the Tube, in Form of a Fryar's Cowl." A specimen of this species Catesby sent to William Sherard is preserved in the Sherard Herbarium in Oxford (32.2): the leaf with its hood, or "Fryar's Cowl," is close to the view he depicted in the present watercolor.

32.1 *Natural History*, II, Plate 69

32.2 Catesby's specimen of the hooded pitcher plant, detail (Sher. Herb., spec. no. 1086.3)

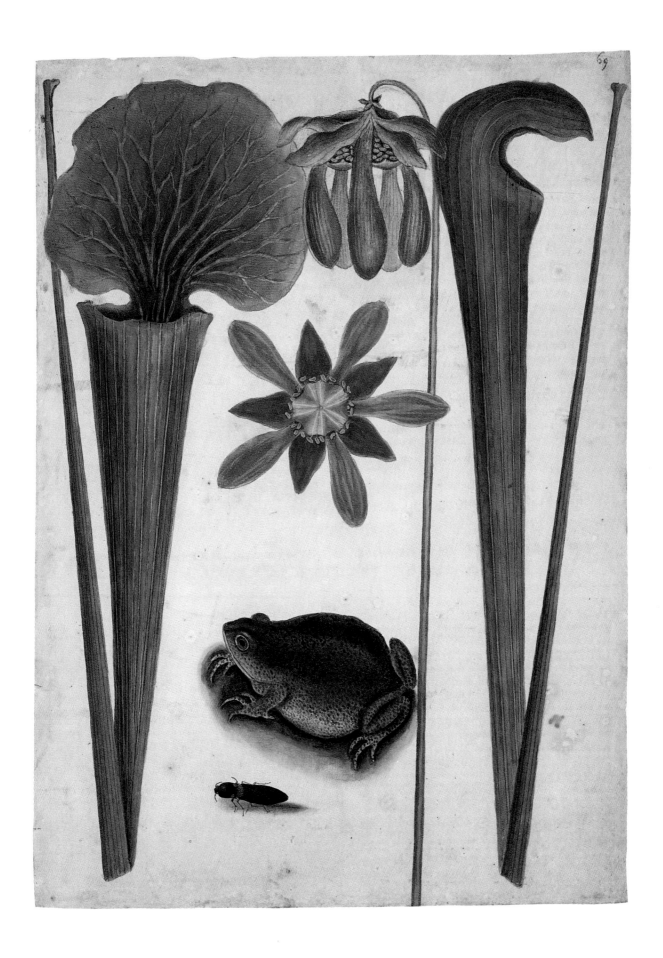

33 *Sarracena, foliis brevioribus* or *Sarracena Canadensis* [and *Sarracenia flava* L.]

[Sidesaddle plant or northern pitcher plant *Sarracenia purpurea* L., and yellow trumpet *Sarracenia flava* L.]
RL 26022 (II, p. 70a)

Watercolor and gouache heightened with gum arabic, over outlines in brush and watercolor and graphite; ruled lines in graphite, lower edge
Inscribed in pen and brown ink in Catesby's hand, upper edge: *Bucanephyllon Americanum Limonio congener dictum Pluk. Almag / bot. p. 71. Plant. alt. / Sarracena Canadensis foliis cavis & auritis Tournef. Inst. 657*; in graphite, lower left, center (possibly in Edwards's hand): *Vol 2 – P 70*
Verso: outline in graphite of plant leaf traced through from recto
14⁵⁄₁₆ × 10¾ in.; 363 × 273 mm

Here, Catesby depicts two further species of *Sarracenia* (see also cat. no. 32). That on the left – the purple-flowered sidesaddle plant or northern pitcher plant – he illustrated again in a third watercolor together with his 'Water Frog' (33.2; see also cat. no. 34), a composition which was reproduced as Plate 70 in Volume II of the *Natural History*. In this latter composition the flower-head is shown at a later stage to that illustrated in the present sheet. The yellow trumpet is not included in the final plate of either composition.

An outline in graphite of the plant leaf on the verso of the present sheet is traced through from the recto, possibly indicating a stage in Catesby's transferring the image from this sheet to the later composition in which he included his 'Water Frog.'

Catesby, in common with other naturalists at this date, did not know of the carnivorous nature of *Sarracenia*; William Bartram (see note 43 on p. 26) was one of the first to recognize this characteristic of the plant. In his description, Catesby mistakenly considers the plant's anatomy as providing a "secure Retreat" for insects: "The Leaves of this, like the precedent [*i.e.* cat. no. 32], spring from a fiberous Root, to the Height of six or eight Inches, they are likewise hollow, swelling and more protuberant than the former, and differently shaped, as in the Figure; they are of a yellow green Colour, striped and veined with purple The Hollow of these Leaves, as well as of the other Kind, always retain some Water, and seem to serve as an Asylum or secure Retreat for numerous Insects from Frogs and other Animals, which feed on them."

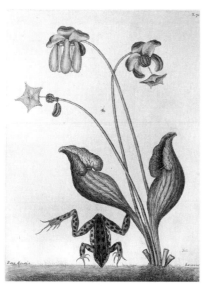

33.1 *Natural History*, II, Plate 70

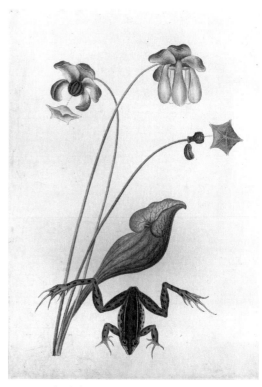

33.2 Catesby, 'The Water Frog and *Sarracena foliis brevioribus*' (RL 26021)

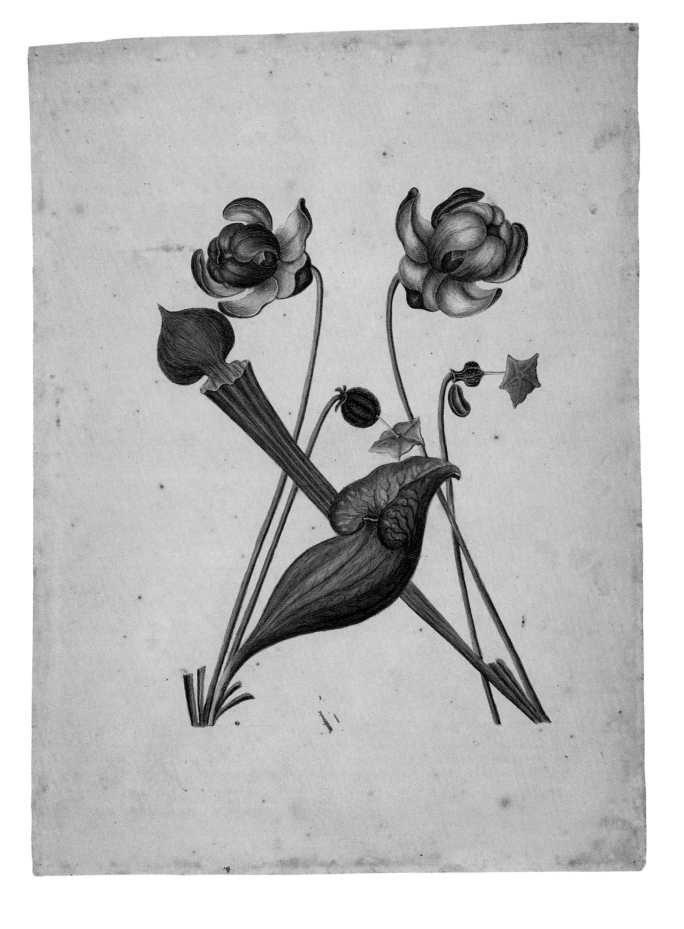

34 The Land Frog, the Water Frog and the Green Tree Frog

[Southern toad *Bufo terrestris* Bonaterre, southern leopard frog *Rana sphenocephala* Cope, and green treefrog *Hyla cinerea cinerea* Schneider]
RL 26023 (II, p. 70b)

Watercolor and gouache heightened with gum arabic, over pen and brown ink and graphite
Inscribed in pen and brown ink, upper right corner: *17*
14¾ × 10⁵⁄₁₆ in.; 374 × 262 mm

On this sheet Catesby depicts three of the four studies of frogs and toads he includes in the *Natural History*. The sheet represents an intermediary stage between his preliminary sketches from life or from specimens (see, for example, 13.2) and his final compositions for which he often extracts and combines elements from several different studies. The three studies were later combined with plants in three separate watercolors: the 'Land Frog' in cat. no. 32; the 'Water Frog' in RL 26021 (see 33.2), and the 'Green Tree Frog' in cat. no. 35.

It would appear from the positioning of the 'Land Frog,' and the fact that it is the only specimen with a background, that Catesby depicted that specimen first, leaving space for the others which he may have added at a later date. The watercolor was mounted upside down in the Windsor volume.

35 The Green Tree Frog and the Skunk Weed

[Tree frog *Hyla cinerea cinerea* Schneider, and skunk cabbage *Symplocarpus foetidus* (L.) Nutt.]
RL 26024 (II, p. 71)

Watercolor and gouache over pen and brown ink, brush and watercolor and graphite
Verso: inscribed in pen and brown ink in Catesby's hand, upper center:
Skunk Weed / Aram Americanum Betaefolio
13¹¹⁄₁₆ × 10¹¹⁄₁₆ in.; 348 × 271 mm

The 'Green Tree Frog' was included in an earlier sheet of studies of different species of frog (see cat. no. 34). In the present watercolor Catesby modified slightly the position of the frog in order to indicate its feeding habits; the frog is thus shown with its mouth open and tongue extended toward a spider.

In the text accompanying Plate 71, Catesby describes the distinctive feature of the 'Green Tree Frog,' which enables the frog to adapt to its particular habitat: "what is most remarkable in this Frog are its Feet, which, as in all the other Kinds of Frogs, had four Toes on each of the fore Feet, and five on the hind Feet; but of a different Structure from other Frogs, they being round, fleshy, and concave, somewhat like the Mouth of a Leech. They most commonly are found adhering to the under Sides of green Leaves, which they seem to do for their Security, to conceal themselves from their rapacious Enemies ... which

they could not do without this extraordinary Structure of their Toes, by which they cleave to the Smoothest Leaf by Suction They are numerous in *Virginia* and *Carolina*, frequenting both herbacious Plants, and the loftiest Trees."

The unusual composition of this watercolor is explained by Catesby in his text: "As the Flowers of this Plant were engraven before I had an Opportunity of seeing the Leaves, I was obliged to introduce a Leaf in the Manner as in the Plate."

The strange plant evidently intrigued Catesby and his colleagues. He executed another drawing of it for Sloane (35.2), and noted in his description: "The Introduction of this most curious Plant with innumerable others, is owing to the indefatigable Attachment of Mr. *Collinson*, who in the Year 1735, received it from *Pensilvania*, and in the Spring following it displayed itself in this Manner at *Peckham*."

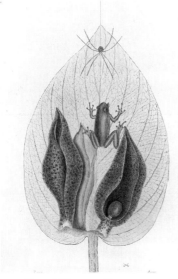

35.1 *Natural History*, II, Plate 71

35.2 Catesby, 'The Skunk Weed' (Sloane MS 5283, no. 46)

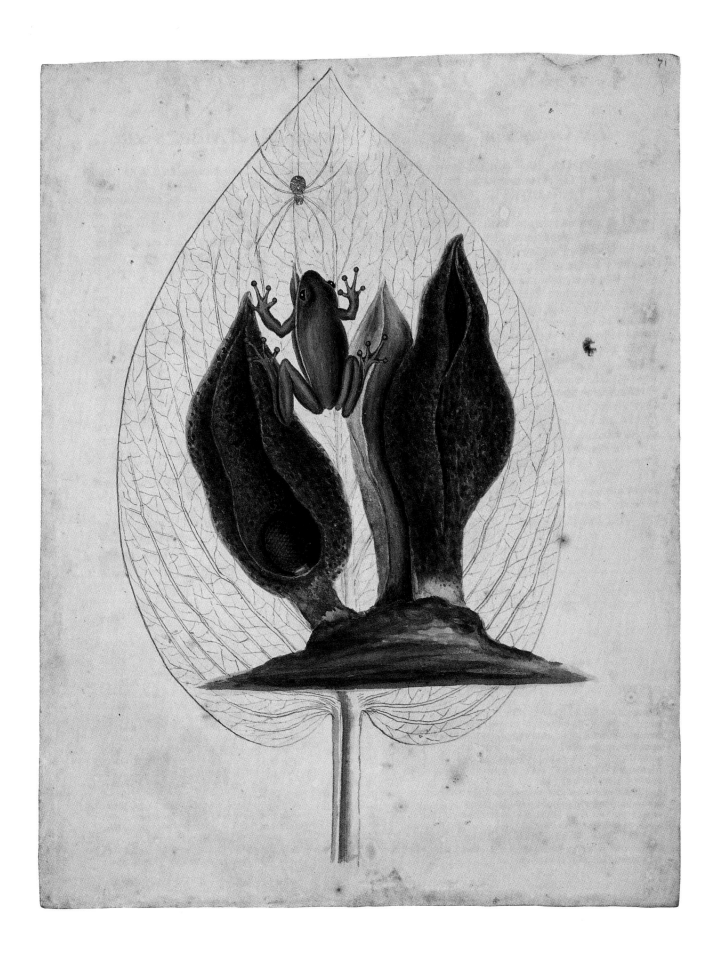

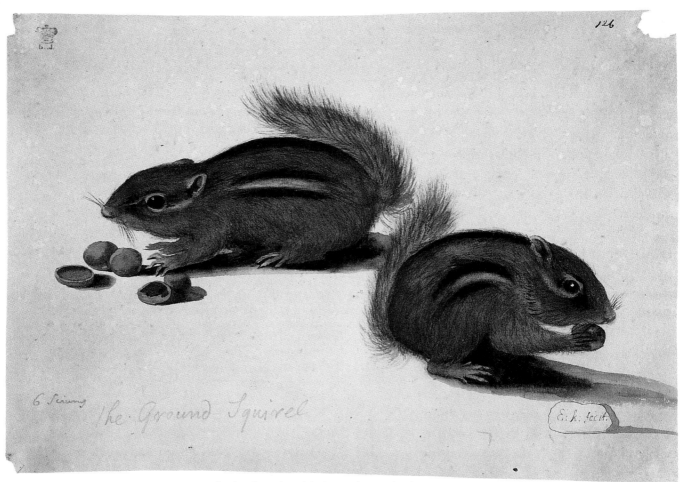

V.1 Everhard Kick, Studies of the 'Ground Squirrel' (Sloane MS 5261, no. 126)

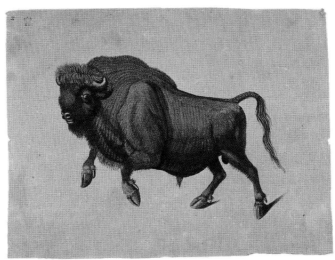

V.2 Everhard Kick, Buffalo (Sloane MS 5261, no. 62)

114

SECTION V: MAMMALS
Cat. Nos. 36–38

CATESBY devotes comparatively few plates in his *Natural History* to mammals: seven in the ninth part in Volume II, and two in the Appendix. As stated in the Preface, Catesby's intention was to "compleat an Account of [Birds] rather than describe promiscuously

Insects and other Animals ... for I had not time to do all." He goes on to say: "Of Beasts there are not many Species different from those in the Old World, most of these I have Figur'd, except those which do not materially differ from the same Species in *Europe*, and those which have been described by other Authors" (Preface, p. ix).

In his Account he organizes "Beasts" into four classes: "Beasts of a different genus from any known in the Old World," "Beasts of the same genus, but different in Species from those of *Europe*, and the Old World," "Beasts of which the same are in the Old World" and "Beasts that were not in *America* 'till they were introduced there from *Europe*." Most of the mammals he illustrates fall into his second category. The exception is his anomalous 'Java Hare', which he depicted not because he had seen it in North America but because the Duke of Richmond was "pleased to think it worth a place in this collection." He does not illustrate the three animals included in the first category – the 'Raccoon,' 'Opossum' and 'Quick-Hatch' – because they had, presumably, all been "described by other Authors" (although he mentions authors for only two of them: see Account, pp. xxix–xxx).

Possibly another and equally important reason for including so few illustrations of mammals was the difficulty in procuring specimens of them. Apart from his own field sketches (see, for instance, cat. no. 38), Catesby would therefore have had to base his drawings either on dried skins of the animals in question or on other people's illustrations. He seems to have resorted to the latter solution most frequently because of the availability of images of American fauna in Sloane's albums (see p. 33). These albums, particularly one titled 'Drawings of Quadrupeds' (Sloane MS 5261), furnished a significant number of prototypes for Catesby's illustrations (see cat. nos. 36 and 38). However, in one instance only did Catesby acknowledge the source of any of his borrowed images (see cat. no. 39), claiming that "the materials of [my work] were collected from the living subjects themselves, and in their native abodes ... for the picture of an Animal, taken from its stuffed skin or case, can afford but a very imperfect idea of the creature, compared with what is done from life" (Appendix, p. 20).

Because very few of Catesby's drawings of mammals were done from life, they tend to be less successful than other categories of his illustrations of fauna, often appearing stiff or unconvincing.

V.3 Unidentified seventeenth-century artist, 'Ground Squirrel' (Sloane MS 5261, no. 121)

36 The Ground Squirrel and the Mastic Tree

[Mastick tree *Mastichodendron foetidissimum* (Jacq.) Cronq.;
Eastern chipmunk *Tamias striatus* L.]
RL 26031, 26032 (III, p. 75)

Watercolor and gouache over pen and brown ink and graphite
Inscribed in pen and brown ink in Catesby's hand, lower center: *Cornus foliis
laurinis, fructu Mastic Tree*; upper right corner: *Mastic* and *75*; in graphite, lower
edge: *5*[*1?*]
Verso: sketch of 'Laughing Gull' in pen and brown ink over graphite
15 × 10¾ in.; 381 × 272 mm
Watercolor and gouache heightened with gum arabic, over graphite
Verso: traced outline of part of 'Tyrant' and 'Sassafras' in graphite
3⅝ × 7¹⁵⁄₁₆ in.; 92 × 201 mm

These two watercolors, mounted together in the Windsor *Natural History* set, were combined by Catesby in a single etching, his Plate 75.

Catesby appears to have derived his image of the 'Ground Squirrel' from two different drawings in Hans Sloane's album 'Drawings of Quadrupeds' (Sloane MS 5261). The features of the animal (for instance, the formation of the ear) and the detailed handling of the markings and fur are closest to an anonymous seventeenth-century drawing on vellum (V.3). However, Catesby's attempt to give the animal a more animated pose seems to be based on studies of the squirrel by Everhard Kick, one of which shows the animal holding a nut in its front paws while standing on its hind legs (V.1).

Possibly still following his seventeenth-century prototype, Catesby does not attempt to illustrate the squirrel life-size, its actual size being, he notes, "about half the Size of an *English* Squirrel." He says they "abide in the Woods of *Carolina*, *Virginia*, &c. Their Food is Nuts, Acorns, and such like as other Squirrels feed on. They being brought up tame, are very familiar and active."

His etching is close to the drawing. In the etching, however, he illustrates a different species of nut, of which he observes: "The Fruit which the Squirrel is feeding on, belongs to a Tree or Shrub which General *Oglethorp* brought from *Georgia* by the Name of the Wild Nutmeg; from its being aromatic, and other Circumstances, induces me to think it is the Fruit of the Plant I have described, p. 46. Vol. 1. which Description is imperfect, because the Fruit was not then formed."

Of the mastic tree Catesby says that the yellow flowers "are succeeded by yellow oval Fruit, in Size and Shape of small Plums, inclosing an oval brown Stone [an example of which he illustrates]. The Fruit is eat, and is sweet and luscious, but serves chiefly for the Sustenance of Birds and other Animals."

Both sheets bear drawings on the verso: the verso of the upper sheet has Catesby's preparatory sketch for the 'Laughing Gull' (RL 25924); the verso of the lower sheet has a tracing of part of the composition of the 'Tyrant' and 'Sassafras' (RL 25890).

36.1 *Natural History*, II, Plate 75

Cornus folijs laurinis, fructu Majore luteo Mastic Tree

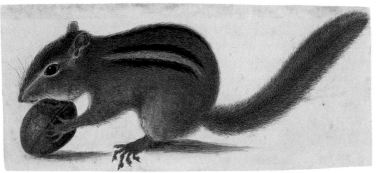

37 The Bahama Coney

[possibly dwarf Cuban hutia *Capromys nana* Allen]
RL 26039 (III, p. 79)

Watercolor and gouache over touches of graphite
10⅝ × 14⅞ in.; 270 × 378 mm

The identification of Catesby's 'Bahama Coney' presents several problems. The stiff and unconvincing pose of the animal would seem to imply that Catesby did not draw it from life, although no prototype for the image has been found among Sloane's natural history albums. Catesby describes the animal as follows: "This Creature is a little less than the common Wild Rabbit, and of a brown Colour, without a mixture of gray Hairs. Its Ears, Feet and Tail resemble those of a Rat, in other Parts it is somewhat like a Rabbit. They feed wholly on wild Fruit and other Vegetables: When surpriz'd by Hunters they retreat to Holes in Rocks. Their Flesh is esteemed very good, it has more the Taste of a Pig than that of a Rabbit. I take it to be nearly of the Kind of the *Mus Alpinus*, or *Marmot*. Raii Syn. Quad. p. 221."

His reference to a 'Marmot' is, however, misleading, as he describes (on p. xxviii of the Account) what was clearly a separate species – 'The Monax' or '*Marmota Americana*.' Although Ewan identified the present animal as a woodchuck *Marmota monax* (L.), he noted that Catesby's 'Bahama Coney' is referred to on p. 115 of Glover M. Allen's *Extinct and Vanishing Mammals of the Western Hemisphere* (1942) as one of the species belonging to the genus *Capromys* from Cuba (Ewan and Frick 1974, pp. 98 and 100). The most recent opinion given is that the drawing may represent either a dwarf Cuban hutia or a species which has become extinct since Catesby's time.

In Plate 79 Catesby combines the animal with a stem of the 'Strong Back' (strong back *Bourreria ovata* Miers.), noting that "Coneys, Guana's and Birds are great Lovers of the Berries." He further observes of the shrub: "[it] grows on many of the *Bahama* Islands, and is called there *Strong Back*. The Inhabitants there make Decorations of its Bark, of which they make much Use, attributing to it great Virtues, as strengthening the Stomach, restoring lost Appetite, and other like Virtues, as the *Cassena* is said to have on the Continent."

His drawing of the strong back is found on a sheet together with the '*Frutex Rubo Similis*' (RL 25996), a plant which was added to the illustration of the 'Black Snake' (II, Plate 48).

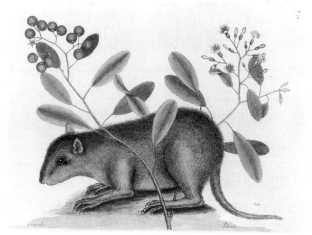

37.1 *Natural History*, II, Plate 79

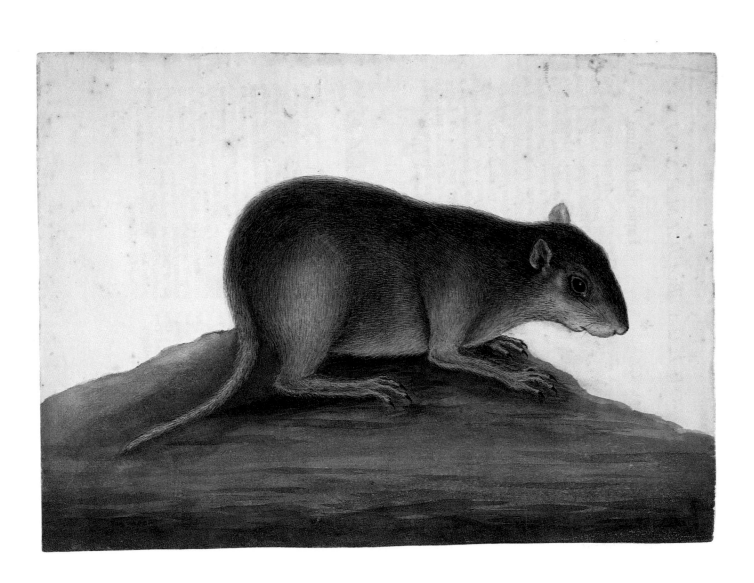

[Buffalo or American bison *Bison bison bison* L., and bristly locust *Robinia hispida* L.]
RL 26092 (III, Appendix, p. 20b)

Watercolor and gouache heightened with gum arabic, over graphite; plant outlines in brush and watercolor over graphite
Verso: inscribed in pen and brown ink in Catesby's hand, upper right: *Pseudo Acacia hispida, floribus roseis. – Red fl. Acacia*
10⅝ × 14¹¹⁄₁₆ in.; 269 × 372 mm

In a letter to William Sherard in 1723, Catesby mentioned that he had been "out a Buffello hunting" in the Carolina Piedmont (Sher. Lett., no. 171: Charles City, May 10). He did not, however, include an illustration of the buffalo until the very end of his publication, where he illustrated it as the last plate of the Appendix. He explains in the accompanying text that the reason he did not depict it earlier in the book is that he had considered his field sketch of the animal to be inadequate – presumably he had not been able to get close to his subject: "This Beast I have already described in the Account of Beasts, p. 27. but having then by me only a sketch of the Animal, which I thought not sufficient to make a true figure from, I have since been enabled to exhibit a perfect likeness of this awful creature."

He does not say that what had later "enabled [him] to exhibit a perfect likeness" was a drawing of the buffalo by Everhard Kick in Hans Sloane's album 'Drawings of Quadrupeds' (V.2). Catesby based his own drawing on Kick's, changing the three-quarters' profile of Kick's version slightly so that the face is seen in a more frontal pose. Still following his model, however, he portrays the creature with only one eye, a feature which adds a slightly comic element to his image. He adapted the present drawing – possibly with the help of his field sketch – to produce an illustration of the buffalo in a different pose (38.2); it was this version that he used for the final plate (38.1).

The outline sketch of the acacia which Catesby arranged around the image of the buffalo appears to have been based on an earlier study of the plant (38.3). He says that he collected specimens of the leaves and flower (later giving samples to Sloane and Dillenius; see fig. 5), but when "I visited [the trees] again at the proper time to get some seeds ... the ravaging *Indians* had burned the woods many miles round, and totally destroyed them, to my great disappointment." However, he notes that later he was "informed, that a plant of this tree [had] been introduced from *America*, by Sir *John Colliton*, Bart. to his gardens at *Exmouth* in *Devonshire*."

Catesby observes: "I never saw any of these trees but at one place near where the Buffelos had left their dung; and some of the trees had their branches pulled down, from which I conjecture they had been browsing on the leaves."

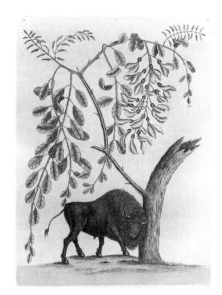

38.1 *Natural History*, II, Appendix, Plate 20

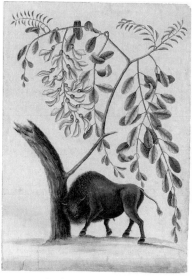

38.2 Catesby, '*Bison Americanus* and *Pseudo Acacia*' (RL 26090)

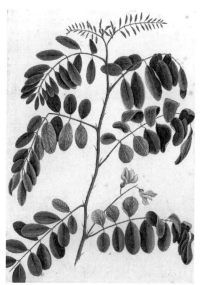

38.3 Catesby, '*Pseudo Acacia*' (RL 26091)

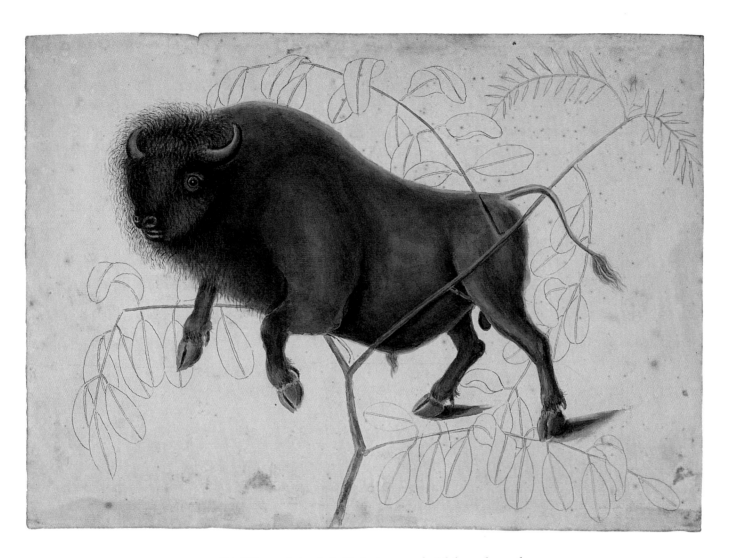

"In Winter their whole Body is covered with long shagged Hair, which in Summer falls off, and the Skin appears black, and wrinkled, except the Head which retains the Hair all the Year. On the Forehead of a Bull the Hair is a Foot long, thick, frizled, of a dusky black Colour; the Length of this Hair hanging over their Eyes, impedes their Flight, and is frequently the Cause of their Destruction ... when wounded they are very furious, which cautions the Indians *how they attack them in open* Savanas, *where no Trees are to skreen themselves from their Fury. Their Hooves more than their Horns are their offensive Weapons, and whatever opposes them are in no small Danger of being trampled into the Earth ..."*
(Account, p. xxvii).

VI.1 Attributed to Catesby, Page of insect studies (Sloane MS 5271, no. 174)

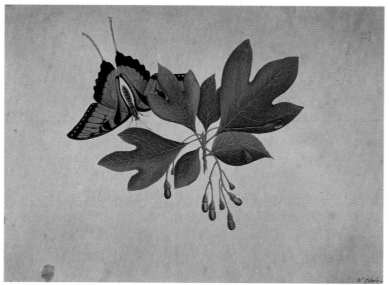

VI.2 Catesby, 'Papilio caudatus maximus and Sassafras' (Sloane MS 5289, no. 167)

SECTION VI: INSECTS

Cat. Nos. 39–40

ALTHOUGH Catesby did not devote a separate section of the *Natural History* to insects, he depicted a fairly large number, mostly as appendages to his botanical studies. The tenth part of the publication is devoted to plant studies and near the beginning of this part he notes: "In the following Plates are interspersed some remarkable Butterflies, whose Colours are so various and intricately blended, that their Figures and / Descriptions would give but a faint Idea of their Beauty, without being illuminated; which alone answers the Purpose" (*Natural History*, II, p. 82).

In common with other natural history illustrators of the day, Catesby appears to have executed pages of insect studies in which the different specimens were arranged in rows, devoid of context; many were, no doubt, from his own collection boxes (we know, for example, that Catesby had a specimen of the '*Blatta maxima fusca peltata*' in his own collection which came into Edwards's possession after Catesby's death: see under cat. no. 40). Hans Sloane's album 'Drawings of Insects' (Sloane MS 5271), for instance, contains many such pages of studies by different artists, one of which is attributed to Catesby (VI.1).

When he came to assemble his drawings for publication, individual studies were cut out of these specimen sheets and pasted on to the sheets bearing botanical studies. The butterfly in one such drawing (cat. no. 39, lower sheet) was copied by Catesby for Sloane and arranged in a composition with a totally different plant study (VI.2); this watercolor is in Sloane's album 'Drawings of Plants, Flowers and Fruits' (Sloane MS 5289). In one instance Catesby did not cut up his specimen page but published it as it was (VI.3; frontispiece); in another instance, in the etched plate, he combined his insects with an ornithological rather than a botanical study (40.1).

On the whole the pairing of insect and botanical studies was done for aesthetic reasons – an insect being used to fill up a space in a composition, or to complement the shape or colors of a plant – rather than because of any environmental connection.

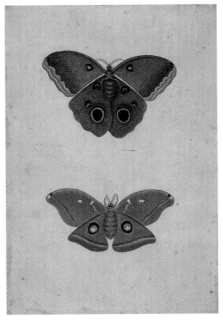

VI.3 Catesby, 'The Great Moth and *Phalaena Fusca*' (RL 26053)

[Tiger swallowtail *Papilio glaucus* L.;
Tiger swallowtail *Papilio glaucus* L. and wafer-ash
Ptelea trifoliata L.]
RL 26044, 26045 (III, p. 83)

Watercolor with touches of gouache, over graphite
Inscribed in graphite: *2*
4⁷⁄₁₆ × 8 in.; 113 × 203 mm
Watercolor and gouache, over outlines in pen and brown ink, brush
and watercolor and graphite
Inscribed in pen and brown ink in Catesby's hand, lower right: *Frutex
Virginianus trifolius ulmi Samarris. Ban: Pluk: Alma: 159.*; in graphite,
upside down, above butterfly: *10*
14⅞ × 10⅝ in.; 377 × 270 mm
LITERATURE: Hulton and Quinn 1964, pp. 133–35, no. 108, under 'E:
Catesby copy,' plate 117 (b)

These drawings were mounted one above the other in
the Windsor *Natural History* set, although in Catesby's
publication he placed the upper study of the tiger swal-
lowtail butterfly with his illustration of the 'Cat's-
Claw' (39.2). The mounting of the present drawings
together in the Windsor albums could thus indicate
either an earlier stage in Catesby's working out of his
compositions, or an inaccuracy on the part of whoever
was responsible for assembling the albums (see p. 00).

It is likely that both drawings of butterflies were cut
from a sheet of studies such as that on which Catesby
depicts his '*Phalaena Fusca*' and 'Great Moth' (VI.2).
While the upper drawing of the butterfly is still on the
(trimmed) sheet on which it was drawn, the lower

drawing of the butterfly has been cut out from its ori-
ginal sheet, affixed to another sheet on which its anten-
nae and legs are drawn in pen and ink, cut out again
and pasted to the sheet bearing the drawing of the
wafer-ash. When Catesby etched the lower butterfly,
in order to place it more satisfactorily on the page, he
had to omit the upper left-hand stem of the plant.

Catesby derived the upper illustration of the but-
terfly from a watercolor (II.2) in Hans Sloane's so
called John White volume (Sloane MS 5270), where the
insect is identified as *Mamankanois*. He clearly believed
that that illustration (the source of which he acknow-
ledges unusually in his text in the *Natural History*, II, p.
97: see p. 33 above), which is shown without its 'tail,'
represents a different species from the lower specimen
that he drew from life.

Catesby executed a duplicate watercolor of his own
image of the tiger swallowtail for Sloane, arranging it
in a composition with leaves and berries of the sassa-
fras tree (VI.3). Catesby notes that tiger swallowtails
"are inhabitants of *Virginia* and *Carolina*." He found
the '*Frutex Virginianus*' growing "on the upper Parts
of the *Savannah* River in *Carolina*, and no where
that ever I saw in the lower inhabited Parts of the
Country."

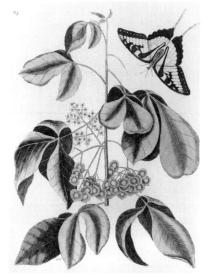

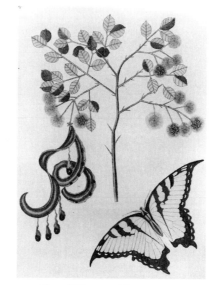

39.1 *Natural History*, II, Plate 83 39.2 *Natural History*, II, Plate 97

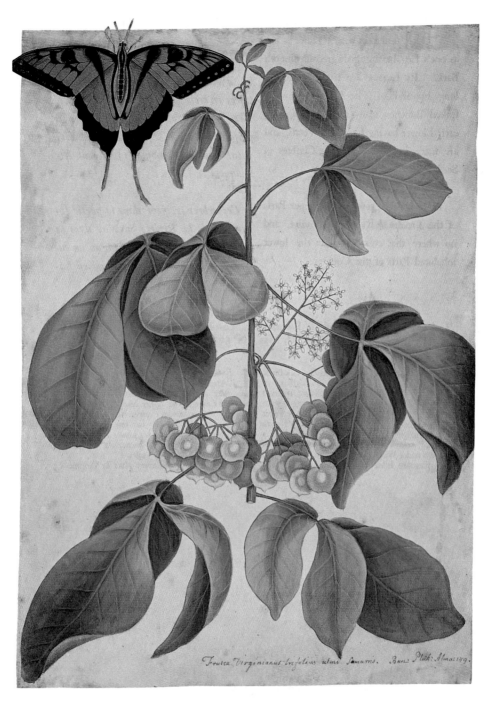

Frutex Virginianus trifolius ulmi famamis. Bau: Plik: Alma: 179.

40 *Blatta maxima fusca peltata,*
The Cockroach,
Scarabaeus peltatus,
The Velvet Ant,
Vespa Ichneumon,
The Chego,
The King Tumble-Turd,
Vespa Ichneumon coerulea,
Scarabaeus capricornus,
The Tumble-Turd and
[moth]

[Greater cockroach from South America *Blaptica dubia* (Serville)
American cockroach *Periplaneta americana* L.
a carrion beetle *Necrophila americana* L.
velvet ant *Dasymutilla occidentalis* L.
a wasp *Sceliphron* sp. ?
jigger *Tunga penetrans* L.
a scarab beetle *Phanaeus vindex* McLeay
a sthecid wasp *Chalybion* sp.
a ground beetle, possibly of the *Carabidae* family
a dung beetle *Canthon* sp.
giant leopard moth *Ecpantheria scribonia* Stoll]
RL 26077 (III, Appendix, p. 10)

Watercolor and gouache heightened with gum arabic and touches of gold, over pen and brown
ink and graphite; grey wash over pen and brown ink and graphite (jigger and ground beetle)
9⁹⁄₁₆ × 9⁷⁄₁₆ in.; 243 × 240 mm

A Greater cockroach from South
America *Blaptica dubia* (Serville)

B American cockroach *Periplaneta
americana* L.

C carrion beetle *Necrophila americana* L.

D velvet ant *Dasymutilla occidentalis* L.

E a wasp *Sceliphron* sp. ?

F jigger *Tunga penetrans* L.

G a scarab beetle *Phanaeus vindex*
McLeay

H a sthecid wasp *Chalybion* sp.

I a ground beetle, possibly of the
Carabidae family

J a dung beetle *Canthon* sp.

K giant leopard moth *Ecpantheria
scribonia* Stoll

40.1 Diagram of RL 26077

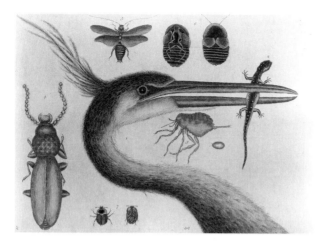

40.2 *Natural History*, II, Appendix, Plate 10

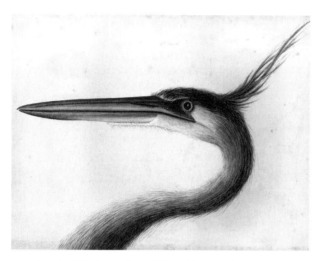

40.3 Catesby, 'The Large Crested Heron' (RL 26078)

This is an example of a 'specimen' page of insect studies, three of which (the 'Chego,' '*Scarabeus capricornus*' and moth) Catesby had already cut out of an earlier sheet or sheets of studies and pasted on to this page. In the etched plate (40.2), Catesby arranged the majority of these insects around his illustration of the 'Large Crested Heron' (40.3), creating a composition in which he consciously retained the character of the present specimen page. Apart from the moth which was not published, Catesby incorporated the remaining insects into compositions with plant studies (see, for example, 50.1 and 51.1); some of the insects he redrew on the sheets with the plants, while others were added only in the etchings.

Both the 'Chego' and '*Scarabeus capricornus*' were drawn under the microscope. Catesby says that the 'Chego' "in its natural size, is not above a fourth part so big as the common Flea, but magnified by a microscope it appeared of the size of the figure here represented." He illustrates one of the eggs of the 'Chego,' observing: "They penetrate the skin, under which they lay a bunch or bag of eggs, which swell to the bigness of a small pea or tare, and give pain till it is taken out; to perform which, great care is required for fear of breaking the bag, which endangers a mortification, and the loss of a leg, and sometimes life itself."

In the accompanying text to the '*Scarabeus*' he writes: "In the Year 1725, I being at the house of his Excellency Mr. *Phinney*, then Governor of the *Bahama Islands*, who, as he was searching of his feet for Chegoes, at the time we were viewing them through a microscope, produced an odd Insect on the point of his needle, as at Fig. 4. [*i.e.* in Catesby's Appendix, Plate 10] which he then picked out of his foot. I showed it to Negroes and others, and none of them had seen the like. The natural size of this Insect was that of the spot over its head; but magnified, it appeared of the size and form here exhibited. I think it may be called as above [*i.e.* '*Scarabeus capricornus minimus cutem penetrans*']."

In his *Gleanings of Natural History* Edwards tells us that he was in possession of Catesby's specimen of the '*Blatta maxima fusca peltata*'; he identified it as the 'Greater Cockroach,' and reproduced an 'amended' image of it (40.4): "The Greater Cockroach was brought from Carolina by the late Mr. Catesby, who in the Appendix to his History of Carolina, page 10, calls it *Blatta maxima fusca peltata*. The reason why I have refigured it is, because it is very rare, and Mr. Catesby has a little miscarried in his drawing, which I have endeavoured to amend. This insect fell into my hands after the death of Mr. Catesby" (Edwards, 1758–64, II, p. 285).

When Peter Collinson wrote to William Bartram to thank him for his account of the 'Tumble Bug,' which he found "very curious and entertaining," he added: "Mr Catesby says they have another sort that they call so, in Virginia. Pray send us two or three more specimens; for I presume they are not scarce. One or two for Sir Hans [Sloane], with thy account, will wonderfully please him" (Ewan 1967, p. 152).

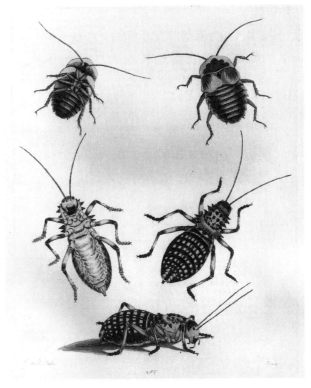

40.4 G. Edwards, 'The Greater Cockroach'
(Edwards 1758–64, II, Fig. 285)

VII.1 Catesby's specimen of 'Red Oak' (Sher. Herb., spec. no. 2136)

SECTION VII: PLANTS

Cat. Nos. 41–52

CATESBY'S primary interest as a naturalist was in plants. In his Preface he speaks of his "early Inclination to search after Plants," an interest encouraged by the botanist William Sherard, "one of the most celebrated Botanists of this Age who favoured me with his

Friendship on my return to England in ... 1719 [that is, from the first trip to America] and by his Advice ... I first resolved on this undertaking [the compiling of the *Natural History*] so agreeable to my Inclination" (Preface, pp. v–vi).

Plants are featured in the majority of the plates in the *Natural History* (apart from those of fishes and a few of birds), and in the words of Frick and Stearns, the illustrations of plants bind "the diverse fauna pictured in the two volumes into a coherent whole" (Frick and Stearns 1961, p. 64). On the whole, however, Catesby does not organize his plants systematically, arranging them rather as suitable background for his zoological subjects, or, increasingly toward the end of the publication, including them where convenient.

Catesby speaks in the Preface of collecting plants and seeds – "Both in *Carolina* and on [the Bahama] Islands, I made successive Collections of dry'd Plants and seeds" – most of which he sent to his patrons and "curious Friends" in England. On the advice of Sherard he numbered his specimens so that he could identify them later, applying equivalent numbers to any duplicate specimens he kept himself; many of the botanical drawings likewise bear these numbers (inscribed in graphite, normally at the base of the plant stem). Catesby claimed that his illustrations of plants were not, however, done from dried specimens, but were "taken from living Plants," "fresh and just gather'd." Even if this was true, his technique of collecting and preserving plant specimens (see, for example, VII.1) – especially his habit of bending a stem over in order to show the whole specimen – appears to have influenced the arrangement on the page of a number of his botanical illustrations (see cat. nos. 6, 32 and 52).

Catesby also claimed that he depicted plants "in a Flat tho' exact manner, [as they] may serve the Purpose of Natural History better in some Measure than in a more bold and Painter like Way." Despite this claim, the drawings themselves demonstrate that his approach to botanical illustration changed, largely through his contact with Ehret from 1735. He learned something of the art of portraying plants in a rounded, three-dimensional way, and his fundamentally pictorial approach became more scientific with the inclusion of details such as seeds, individual buds or flower-heads, and occasionally root structures (cat. nos. 41 and 46). Sometimes, as in Ehret's illustrations, a still-life element was introduced into the depiction of seeds and fruits, which are shown as existing in their own space with a shadow (see cat. no. 3).

Many of the shrubs and trees which Catesby illustrates and describes in the *Natural History* are included in his later work, the *Hortus Britanno-Americanus; or a Curious Collection of Trees and Shrubs, the Produce of the British Colonies in North America; adapted to the Soil and Climate of England*, a publication on which he appears to have been working during the last years of his life but which was not published until some time after his death, in 1763. It was as an experimental horticulturalist that Catesby worked after his return from America, and he was, indeed, responsible for the introduction to England of a significant number of plants from the New World.

Catesby's importance as a botanist was recognized in the naming of several plant species after him, for example, Catesby's lily (cat. nos. 30 and 41) and Catesby's pitcher plant (cat. no. 32).

41 The Red Lily and the *Martagon Canadense*

[Catesby's lily *Lilium catesbaei* Walt., and turk's cap
lily *Lilium superbum* L.]
RL 26009 (II, p. 58a)

Watercolor and gouache heightened with gum arabic, over graphite;
pen and brown ink over graphite (bulb in right-hand plant)
Inscribed in pen and brown ink in Catesby's hand, lower left: *Lilium
Carolinianum fl crocco punctato, – / petalis lonjoribus* [sic] &
angustioribus; and lower right: *Lilium sive Martagon Canidense / flore
luteo punctato Acad: R. Par:*
14⅞ × 10½ in.; 377 × 267 mm

This is one of four sheets of studies of lilies in the
Windsor *Natural History* set, three of which were exe-
cuted by Catesby and one (cat. no. 50) by Ehret. The
present sheet clearly shows Catesby emulating Ehret.
The German artist's influence is evident in Catesby's
three-dimensional treatment of the flower petals and
his attempt to show the rounded form of the stalk. The
arrangement on the page of the 'Red Lily,' with the
technique of breaking the stem in order to display the
bulb and root, is also reminiscent of the botanical con-
cern characteristic of many of Ehret's illustrations,
and is unlike the majority of Catesby's botanical stud-
ies where the root structure is not shown.

Catesby did not use this study of the '*Martagon
Canadense*' in his publication, instead combining the
two different species of lily depicted in RL 26005 and RL
26006 in one plate (Plate 56), where he "exhibits the
Flowers of two Kinds, because I conceive their Differ-
ence being little." His 'Red Lily,' however, was pub-
lished together with the 'Wampum Snake' in Plate 58

(30.1) and an outline of it appears with the watercolor
of that snake (cat. no. 30).

Catesby writes of the 'Red Lily,' which was later
named after him: "This Lilly grows from a single bul-
bous scaly Root about the Size of a Walnut, rising with
a single Stalk to the Height of about two Feet One
Flower only is produced on the Top of the Stalk, con-
sisting of six Petals From the Bottom of the Flower
rises six very long *Stamina* with their *Apices*, sur-
rounding a *Pistillum*; the whole Flower is variously
shaded with Red, Orange and Lemmon Colours.
They grow on open moist *Savannas* in many Parts of
Carolina."

Specimens of the 'Red Lily' which Catesby sent
Sherard are now preserved in the Sherard Herbarium
in Oxford.

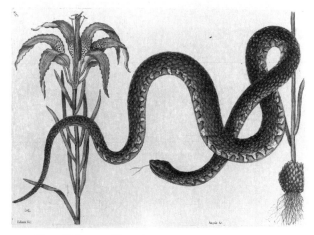

41.1 *Natural History*, II, Plate 58

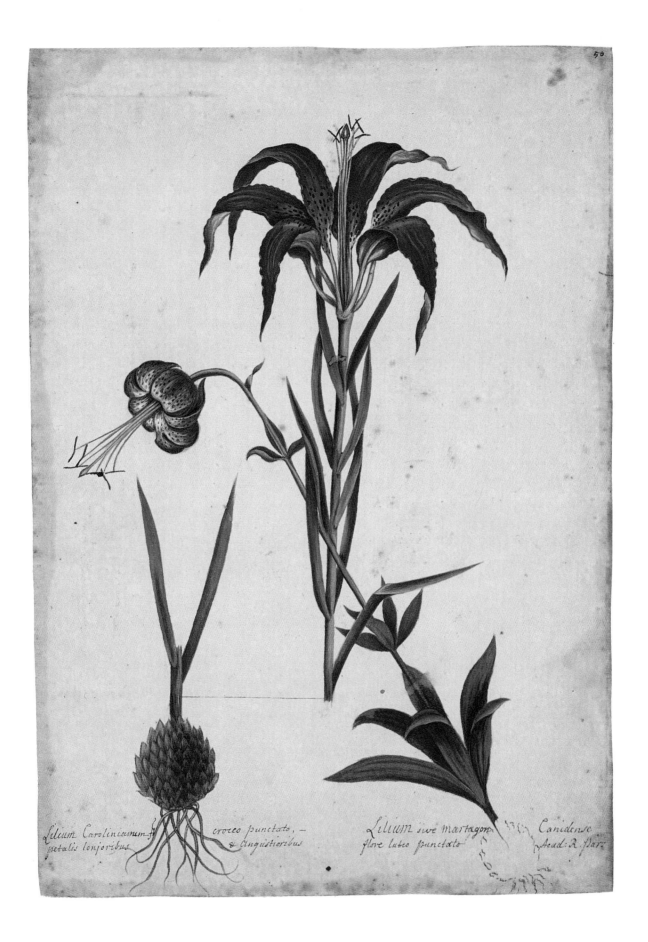

Lilium Carolinianum
petalis longioribus

croceo punctato,
& angustioribus

Lilium sive Martagon
flore luteo punctato

Canidense
Acad: R. Par.

42 *Bignonia Americana*

[Cross-vine *Bignonia capreolata* L.]
RL 26043 (III, p. 82)

Watercolor and touches of gouache heightened with gum arabic, over outlines in brush and watercolor and graphite; outline of seedpod in brush and watercolor
Inscribed in pen and brown ink, upper right corner: *2*
14¹¹/₁₆ × 10⁷/₁₆ in.; 372 × 265 mm

The cross-vine was another of the shrubs which Catesby had introduced successfully to England. He notes that "This elegant Plant is a Native of both *Virginia* and *Carolina*, and blows there in *May*, but in *England* not before *August*."

He includes an illustration of it in his *Hortus Britanno-Americanus* (42.2) with specific instructions on how to grow the seeds: "These seeds should be brought over in their pods, and being at their arrival sown in a hot bed, moderately warm, will not lay long before they appear above ground; they require some care and protection till they have passed the second winter, but are able afterwards to abide our open air" (*Hortus Britanno-Americanus*, p. 25).

In this elegant watercolor Catesby depicts the vine growing up a stake, with an outline only of the seedpod. The details of the half-open pod, possibly done directly from a seedpod in his collection, were completed when he etched the composition.

42.1 *Natural History*, II, Plate 82 42.2 *Hortus Britanno-Americanus*, Figure 48

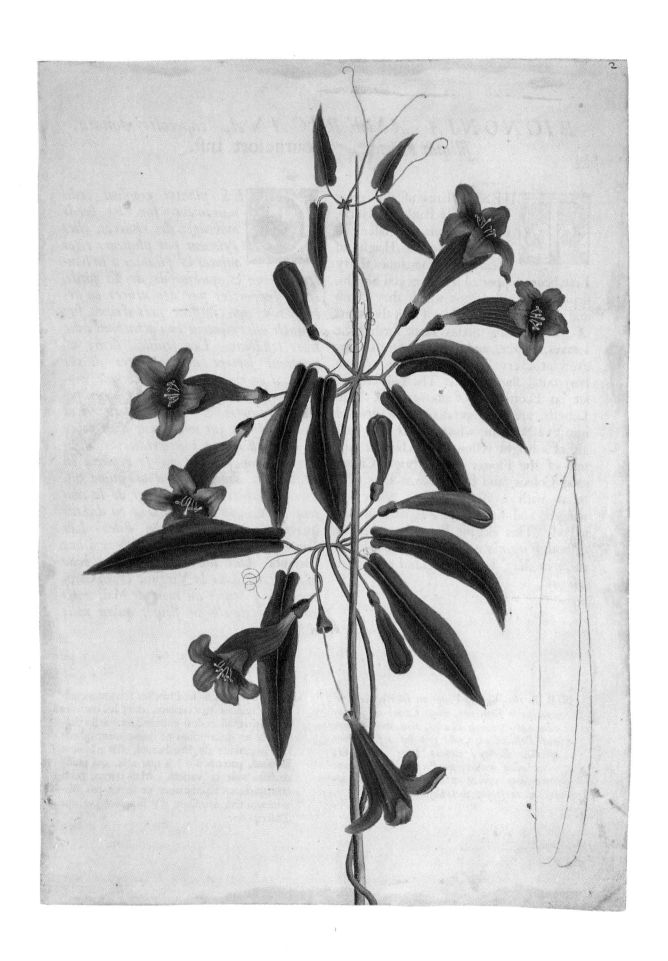

43 *Anona fruƈtu lutescente*

[Pawpaw *Asimina triloba* (L.) Dun.]
RL 26047 (III, p. 85)

Watercolor and gouache heightened with gum arabic, over graphite;
ruled lines in graphite marking plate lines
Inscribed in pen and brown ink, upper right corner: *85*
15¾ × 11⅛ in.; 399 × 282 mm

From correspondence between Peter Collinson and
John Bartram, it appears that Catesby did not see the
pawpaw while he was in America. On January 26,
1739, Collinson wrote on Catesby's behalf to Bartram,
asking him to send a specimen of the fruit, saying that
Catesby would "thank thee very kindly for the fruit;
and come they either dry, or in spirits, they will lose
their color; so pray describe it as well as thee can, that
he may be qualified to paint it." On April 12 of that
year, Collinson wrote again to report that "the jar with
the pawpaws came safe, and my friend Catesby thanks
thee very much" (Ewan 1967, pp. 124 and 129).

It is likely that Ehret, who knew Collinson at this
date, also did his illustration from Bartram's specimen.
Catesby's drawing has not survived; it is perhaps not
surprising that he rejected his own illustration in favor
of the present magnificent drawing by Ehret. The fact
that this drawing was clearly done for publication (the
leaf on the right is cut off and the whole drawing is
framed for a particular plate size) implies that Ehret
may have intended to publish it himself: it is interest-

ing to note that when Catesby etched the composition
he altered the cut-off leaf to show it bent over. How-
ever, Ehret used another drawing of the fruit, flower,
and cross-section of the fruit (43.2) as the basis of the
print he published later as Plate V in Trew's *Plantae
Selectae*, 1750. In the caption to this plate Ehret refers
to Volume II, Plate 85 of the *Natural History* and to
Catesby's description of the fruit as "light yellow,
smooth, resembling a ram's scrotum" (see Ewan 1974,
p. 98).

The pawpaw was later grown successfully in Eng-
land, and Ehret depicted an example of a purple (as
opposed to white) flower for Peter Collinson. Ehret's
drawing, mounted into Collinson's copy of the *Natu-
ral History* now at Knowsley, is annotated by Collin-
son, "My Fr[ien]d Mr Ehret has most curiously painted
the/ Blossom of the Anona as it flower'd in England –
/ by the Different colour of the Flowers, it is/ proba-
ble there is some, with white, and with/ purple Flow-
ers, – for Mr Catesby drew his on the spott./ P. Col-
linson/ May 22/ 1754."

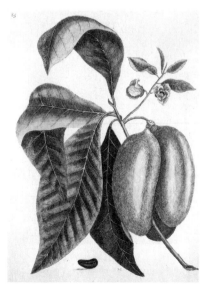

43.1 *Natural History*, II, Plate 85

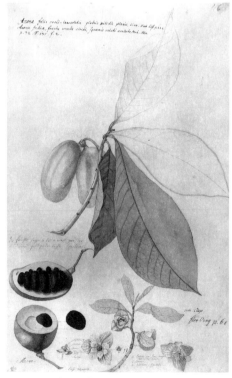

43.2 G.D. Ehret, The pawpaw
(BM: NHM, Ehret sketch no. 137)

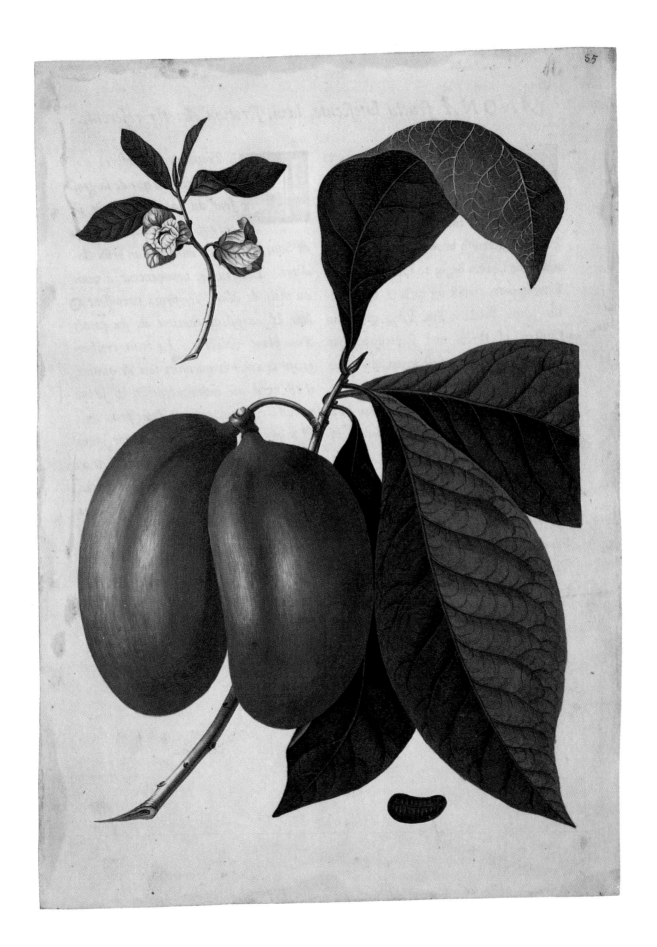

44 The Sapadillo Tree and *Convolvulus*

[Wild dilly *Manilkara bahamensis* (Baker) Lam &
Meeuse, and wild potato *Ipomoea microdactyla*
Griseb.]
RL 26049 (III, p. 87)

Watercolor and gouache over graphite
Inscribed in pen and brown ink in Catesby's hand, upper edge: *Anona,
foliis Laurinis in Summitate incisis fructu compresso Scabro fusco, medio
acumine longo. Sapadillo*; lower right corner: *Convolo: foliis variis
inferioribus / trifarium divisis superioribus sagi – tatis, floribus ex rubro
purpureis.*; upper right corner: *87*
Verso: inscribed in graphite, upper edge in Catesby's hand: *Sappodilla*
14⁹⁄₁₆ × 10½ in.; 369 × 267 mm

Catesby saw both these plants growing in the Bahama
Islands, and depicted them together because, he ob-
serves, he "found [the 'Convolvulus'] with the *Anona*
[his Latin name for the 'Sapadillo Tree'] joined in the
Manner exhibited."

By contrast with his representation of the cross-
vine (cat. no. 42), he creates a dense composition,
filling as much of the lower half of the sheet as pos-
sible with the trailing stems of the 'Convolvulus.'

In his accompanying text he explains the reason for
his not providing an adequate illustration of the
flowers of the 'Sapadillo Tree': "The Flowers seemed
to be monopetalous, but as I had not an Opportunity
of seeing them in Blossom, I am necessitated to refer
to this Plate [44.1], which shews at Fig. 1. the Frag-
ments of the decayed Flowers, and Fig. 2. the Buds of
the Blossoms hanging pendant."

Of the fruits he writes: "[They] generally grow
erect to Footstalks of above an Inch long, and are usu-
ally of the Size of a large Walnut, round, but com-
pressed, having a very rough russet Coat of a brown
Colour, with a sharp brittle Spine growing out of it;
under this Coat is a spongy Pulp, full of milky Juice of
a pleasant Sweetness when the Fruit is perfectly ripe;
but if not, very astringent and disagreeable. Several
hard Seeds are contain'd within the Fruit, of the Form
here exhibited."

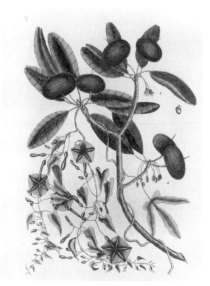

44.1 *Natural History*, II, Plate 87

Anona, folijs Laurinis in Summitate incisis fructu compresso scabro fusco, medio acumine longo. Sapadillo

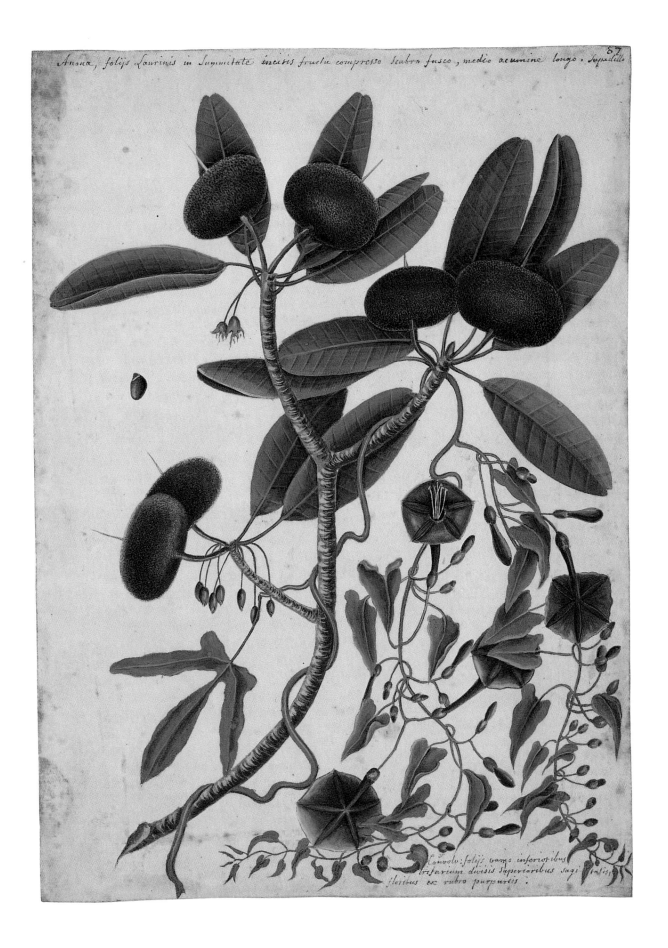

Convolv: folijs ramis inferioribus
trifariam divisis Superioribus sagittalibus,
floribus ex rubro purpureis.

Anona, folijs Laurinis in Summitate incisis fructu compresso scabro fusco, medio acumine longo. Sapadillo

45 *Plumeria flore niveo* and *Grandilla*

[White frangipanni *Plumeria obtusa* L., and smooth
passion flower *Passiflora cupraea* L.]
RL 26056 (III, p. 93)

Watercolor and gouache heightened with gum arabic, over outlines in
brush and watercolor and graphite
Inscribed in pen and brown ink in Catesby's hand, lower left:
*Granadilla foliis Sarsaparillae trinerviis flore / purpureo fructu Olivae
formi Caeruleo*; lower right: *Plumeria flore foliis brevioribus / et obtusis –
Plum: Cat.*; in graphite (beneath passion flower): *70*; to right of stem of
frangipanni: *60*
14⁷⁄₁₆ × 10⅜ in.; 367 × 263 mm

As with cat. no. 44, Catesby depicts the climbing plant
on the tree on which he observed it growing in the
Bahamas. He writes: "These Plants [the 'Grandilla'],
as likewise the Plant on which this is supported, grow
plentifully on many of the *Bahama* Islands, where I
painted them in the natural Appearance as is here
represented."

He creates an elegant composition of the two plants
adding an outline only of the seedpod, the details of
which are completed in the etching (compare cat. no.
42). He observes of the seedpod: "The Seed-vessel is
a double Pod, seven Inches long, curved at the Insides,
and both Ends meeting: At their Time of Maturity the
curved Side of each Pod splits open, and displays the
Seeds, which are disposed in like Manner as the Scales
of Fish."

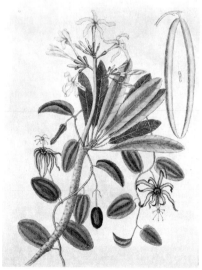

45.1 *Natural History*, II, Plate 93

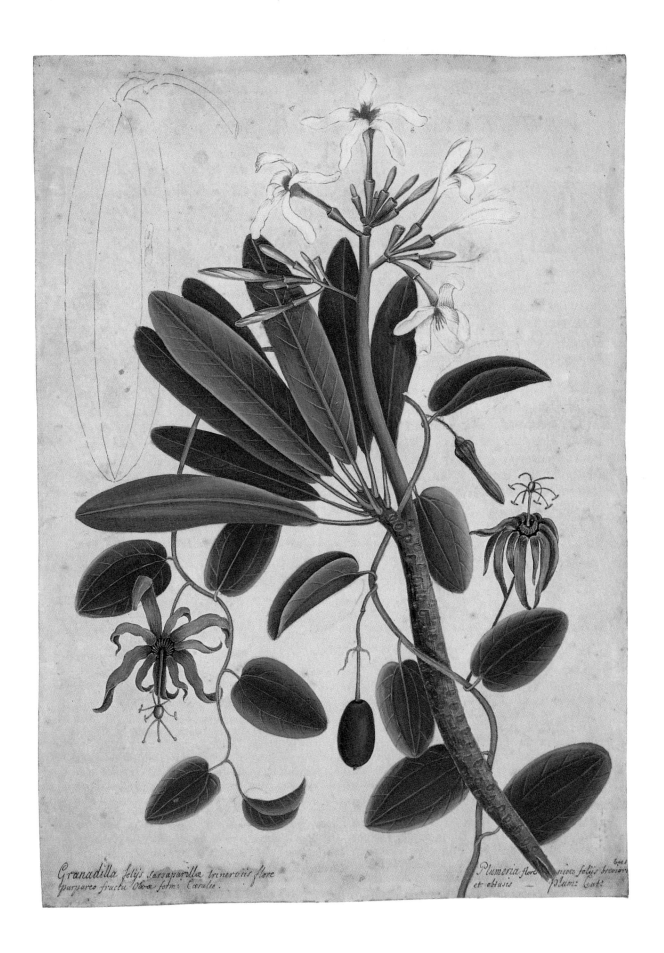

Granadilla folijs sarsaparilla trinerviis flore
purpureo fructu Olivæ form: Cærulee.

Plumeria flore niveo folijs brevior:
et obtusis — Plum: Cat:

46 *Chamaedaphne foliis Tini*

[Mountain laurel *Kalmia latifolia* L.]
RL 26061 (III, p. 98)

Watercolor and gouache heightened with gum arabic, over outlines in
brush and watercolor and graphite
Inscribed in pen and brown ink, upper right corner: *98*
14¾ × 10⁹⁄₁₆ in.; 375 × 268 mm

The present watercolor and that reproduced as cat. no.
47 show Catesby and Ehret working together. In these,
they not only each depicted the same plant but drew
the same specimen. The differences between the art-
ists' techniques are demonstrated clearly, and so is the
extent to which Catesby appears consciously to have
emulated Ehret.

The shrub itself was highly prized by Catesby's fel-
low horticulturalists, and several attempts (at first un-
successful) were made to propagate it in England.
Catesby writes in the text accompanying Plate 98: "As
all Plants have their peculiar Beauties, 'tis difficult to
assign to any one an Elegance excelling all others, yet
considering the curious Structure of the Flower, and
beautiful Appearance of this whole Plant; I know of
no Shrub that has a better Claim to it.

"After several unsuccessful Attempts to propagate
it from Seeds, I procured Plants of it at several Times
from *America*, but with little better Success, for they
gradually diminished, and produced no Blossoms; 'till
my curious Friend Mr. Peter *Collinson*, excited by a
View of its dried Specimens, and Description of it,
procured some Plants of it from *Pensilvania*, which
Climate being nearer to that of *England*, than from
whence mine came, some Bunches of Blossoms were
produced in *July* 1740, and in 1741, in my Garden at
Fulham."

The stem depicted by Catesby and Ehret is likely to
have been taken from the plant Catesby reared "in my
Garden at Fulham." The differences between the two
illustrations suggest that both artists were looking
at the specimen rather than one copying the other.
Catesby depicts rather more flowers, and in a less tight
bunch than Ehret; he also illustrates a stem with fruits,
which Ehret does not include. It is interesting to note

that Catesby decided to etch his own version rather
than Ehret's, presumably because his included more
botanical details than that of his colleague.

Despite Catesby's attempt at emulating the three-
dimensionality of Ehret's subjects, especially his tech-
nique of bending over leaves to convey their form, the
superior qualities of the younger artist are evident.
Above all, the meticulous realism and crispness of
Ehret's drawing stand out by comparison.

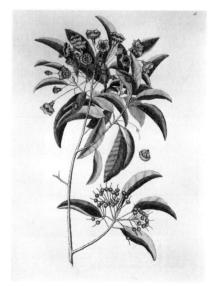

46.1 *Natural History*, II, Plate 98

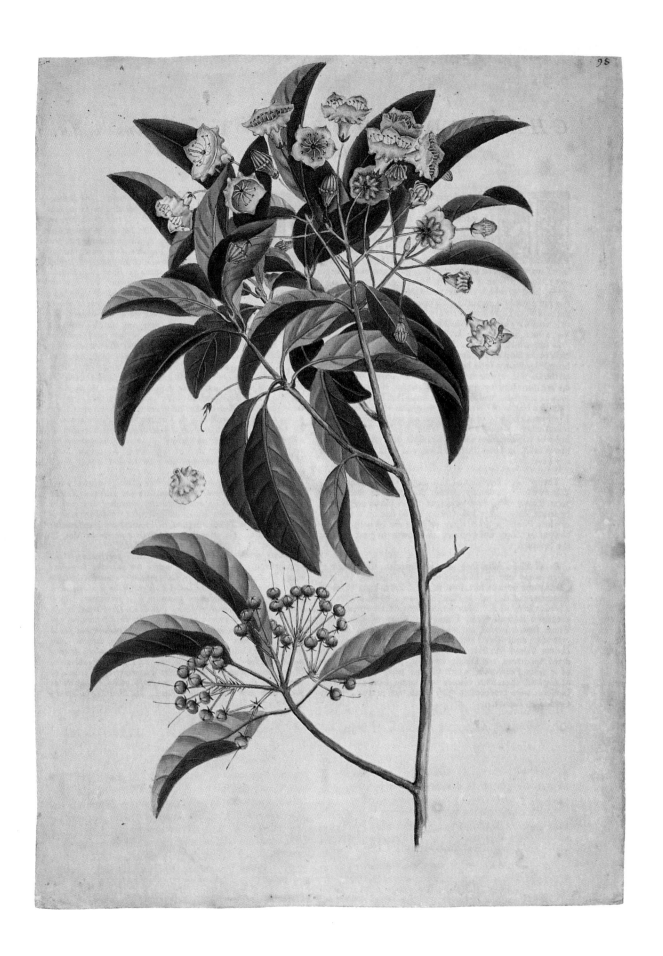

47 *Chamaedaphne foliis Tini*

[Mountain laurel *Kalmia latifolia* L.]
RL 26062 (III, p. 98a)

Watercolor and gouache heightened with gum arabic, over graphite
Inscribed in graphite (possibly in Edwards's hand), lower, left: *Vol 2
P 90*
14⁵⁄₁₆ × 10⁷⁄₁₆ in.; 364 × 265 mm

For a discussion of this drawing, see cat. no. 46.

Ehret executed a second, almost identical, drawing of the plant which is now in the Natural History Museum, London (47.1). He adapted the image slightly (by adding flowers and leaves to the broken-off stem on the right) for the print he included in Trew's *Plantae Selectae* (47.2); the latter print also includes Ehret's image of the narrow-leaved laurel (see 52.4).

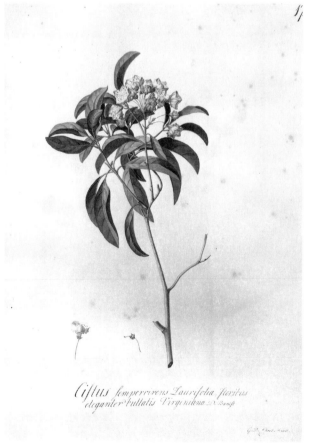

47.1 G.D. Ehret, '*Chamaedaphne*' (BM: NHM, Banks MS, f. 17)

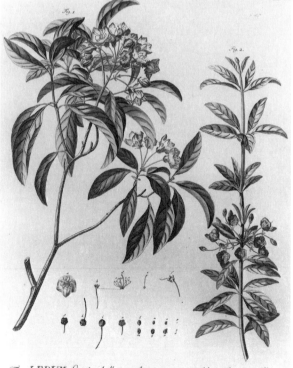

47.2 G.D. Ehret, '*Ledum*' (Trew 1750–53, I, Plate XXXVIII)

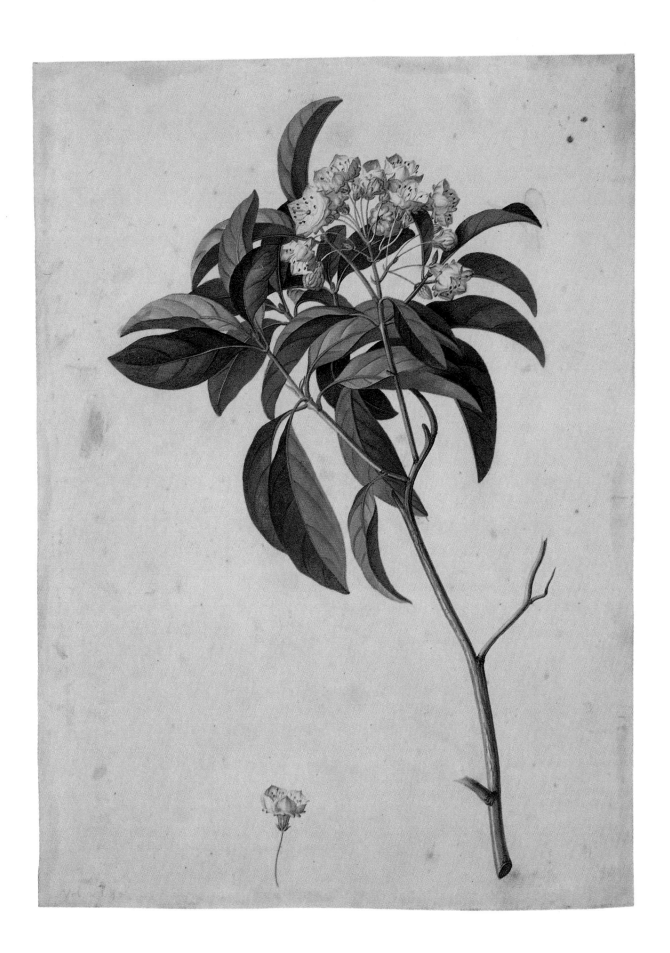

48 The Cacao Tree

[Chocolate *Theobroma cacao* L.]
RL 26072 (III, Appendix, p. 6)

Watercolor and gouache heightened with gum arabic, over graphite;
on vellum
9⅛ × 14 in.; 231 × 355 mm

The watercolor is one of a group of four (including
cat. no. 49) in the Windsor *Natural History* set executed
on vellum. The artist of these drawings has not been
identified but may have been a pupil or follower of
Ehret. There is a hardness, almost a metallic quality
about the forms, especially noticeable in the treatment
of the leaves, where the use of light and shade is more
exaggerated than in Catesby's drawings. Particularly
reminiscent of Ehret is the way of presenting cross-
sections of the solid forms, especially the stylized
treatment of the cut-off branch (compare, for exam-
ple, the stems in cat. nos. 47 and 52). Ehret himself
executed a rather more ambitious illustration of the
cocoa plant in which he shows how the fruit grow
along the trunk (48.2). The cross-section of the fruit
should also be compared with that in the present
drawing.

Catesby decided to include the 'Cacao Tree' in his
Appendix even though it is native to the Caribbean
rather than North America. He had seen it when he

visited Jamaica in 1714 and he notes that "the places of
its growth are in the Bay of *Campeachy*, on *Costa Rica*
between *Portabel* and *Nicaragua*, the Coast of *Carac-
cos, Guaiaquil,* and *Colima.*" He includes an account
from Captain William Dampier's *New Voyage Round
the World* (1697) of how the "cods" (fruits) are gath-
ered; Catesby then observes: "The fruit hangs pen-
dant, and, when ripe, has a shell of a purple colour, in
substance somewhat like that of a pomegranate, and
furrowed from end to end; containing in the middle
many kernels of the size of acorns, inclosed in a
mucilaginous substance, and which are known
amongst us by the name of *Cacao Nuts*, of which is
made chocolate."

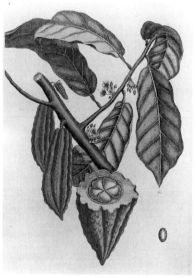

48.1 *Natural History*, II, Appendix, Plate 6

48.2 G.D. Ehret, Cocoa tree (BM: NHM, Ehret sketch no.
176)

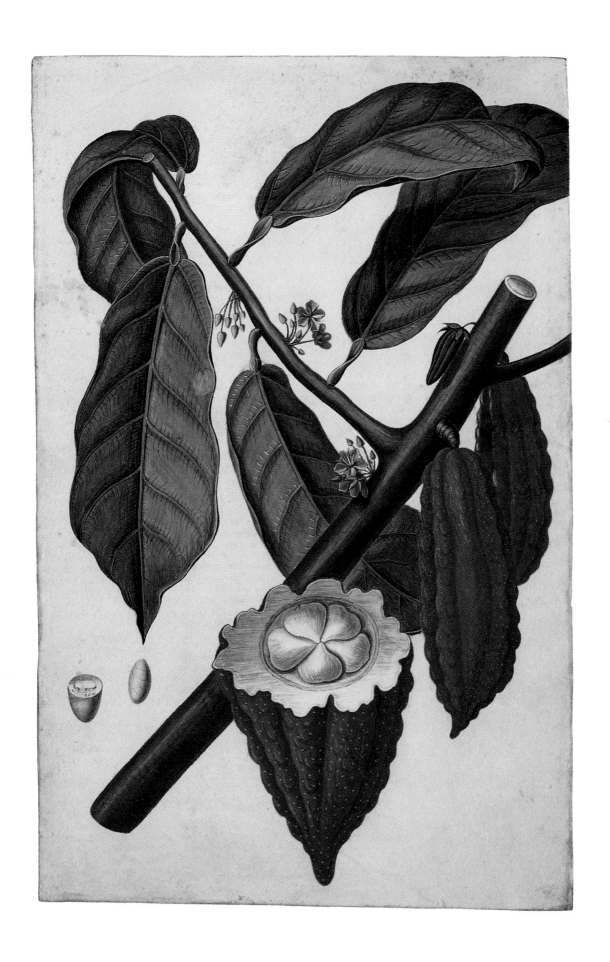

49 The Vanelloe

[Vanilla *Vanilla planifolia* Andrews]
RL 26073 (III, Appendix, p. 7)

Watercolor and gouache heightened with gum arabic, over graphite;
on vellum
13⁹⁄₁₆ × 9¼ in.; 344 × 235 mm

This is another of the group of drawings on vellum,
possibly by a follower of Ehret (see cat. no. 48). Like
the cocoa, the vanilla plant was native to South rather
than North America, and appears to have been includ-
ed by Catesby purely for its exotic interest. He writes:
"With this fruit the *Spaniards* perfume their chocolate,
and employ *Indians* to cure the pods, which they do, by
laying them in the sun to dry; then dipping them in an
oil drawn from the kernel of the *Acajou* nut. This per-
fume is so little agreeable to an *English* palate, that it is
rarely made use of any more in our *American* Planta-
tions than at home, and therefore not cultivated by us.

"They grow naturally in many places between the
Tropicks, particularly at *Boccatoro*, lying in ten degrees
north latitude."

Catesby notes that the seeds of the vanilla plant "are
very small, and black, and are contained in a long pod,
which, when ripe, splits open, and discharges them."
In this watercolor, the artist includes a detail of the
seeds scattering.

49.1 *Natural History*, II, Appendix, Plate 7

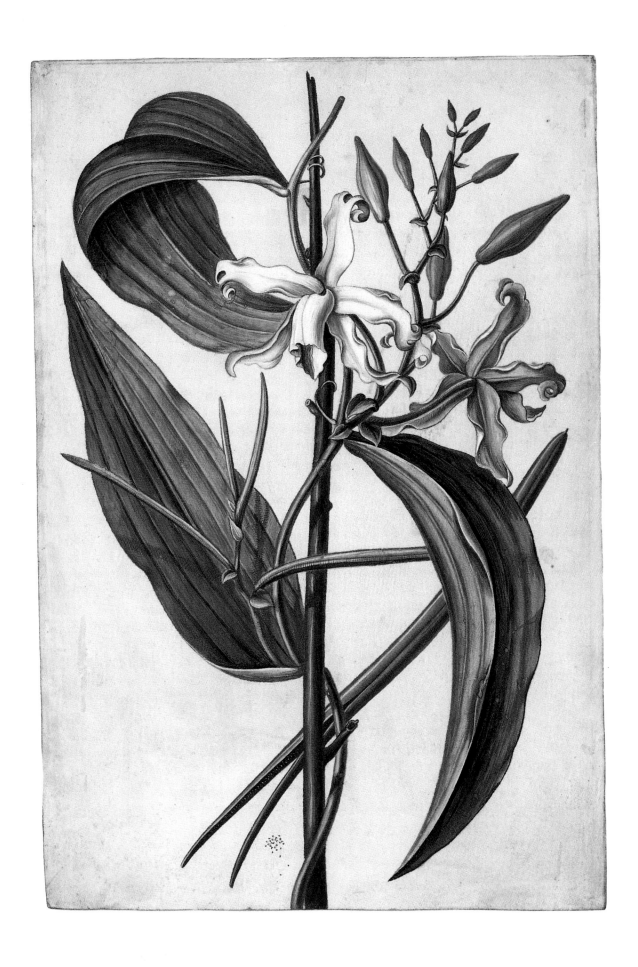

50 *Lilium sive Martagon Canadense*

[Canada lily *Lilium canadense* L.]
RL 26079 (III, Appendix, p. 11)

Watercolor and gouache heightened with gum arabic, over graphite
15⅞ × 11⅞ in.; 403 × 301 mm

The Canada lily, like other plants included by Catesby in his Appendix, was apparently one he did not see while he was in America. He notes that "These Plants were produced from scaly roots sent from *Pensylvania*, and have flowered several years in Mr. *Collinson*'s garden at *Peckham*."

We know from Ehret's preparatory drawing that he executed the present watercolor from a specimen of the lily which flowered in Collinson's garden in August 1744 (50.2). In that drawing, which bears the annotation "floruit in Horto Dni P. Collinson / 1744. Augusti," Ehret depicts the whole stem of the plant, which Catesby notes "rises to the height of almost four feet." However, in his finished drawing Ehret omits the extra length of the stem. As with his other plant drawings first published by Catesby, Ehret included this lily later in one of his own publications, describing it as the "Martagon Virginianum" in Plate 27, Volume I, of Trew's *Hortus Nitidissimus*, 1758 (50.3).

Catesby writes further of "this singular kind of *Martagon*": "On the summit of the stem are set altogether about twelve pedicles, to which are fixed its reclining flowers. The difference between this and other *Martagons* consists principally in this particular, that whereas the petals of the other kinds of *Martagons* are reflected with a twirl, in this kind they reflect very little, not more than those of the common white Lily."

The images of the insects which Catesby added in the etching are taken from his sheet of insect studies, cat. no. 40.

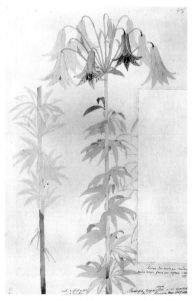

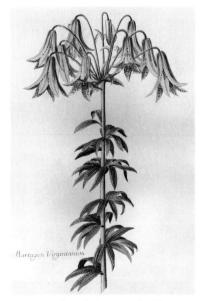

50.1 *Natural History*, II, Appendix, Plate 11

50.2 G.D. Ehret, '*Martagon Canadense*' (BM: NHM, Ehret sketch no. 73)

50.3 G.D. Ehret, '*Martagon Virginianum*' (Trew 1758–92, I, Plate XXVII)

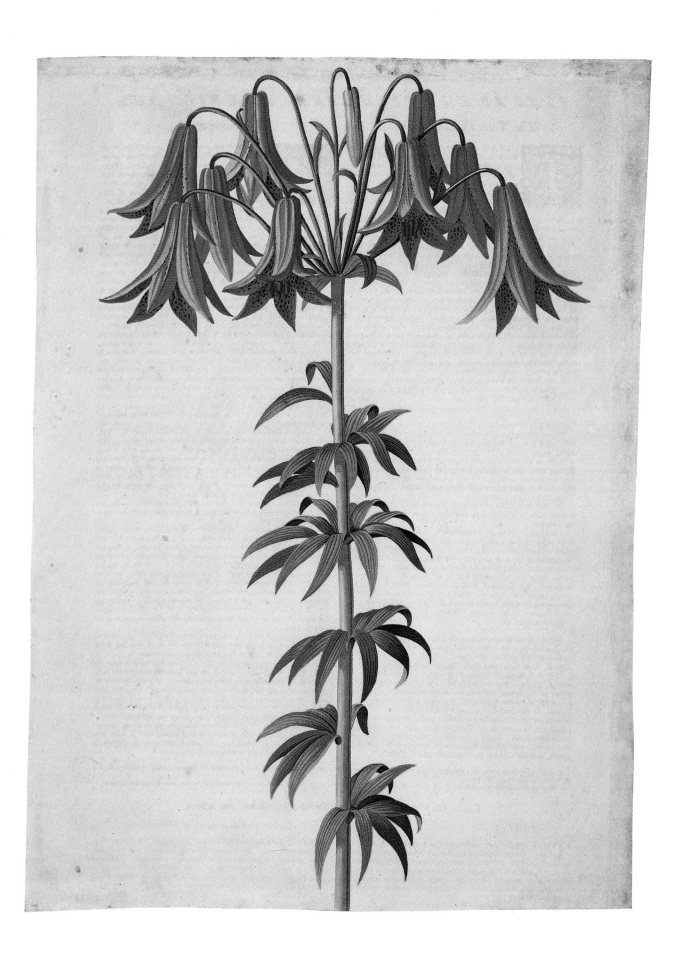

51 *Magnolia flore albo*

[Sweet bay *Magnolia virginiana* L. (flower), and
cucumber tree *Magnolia acuminata* L. (leaves)]
RL 26084 (III, Appendix, p. 15)

Watercolor and gouache heightened with gum arabic, over graphite
16 × 11⁹⁄₁₆ in.; 405 × 293 mm

Catesby includes several species of magnolia in the
Natural History (see also cat. nos. 7 and 9), at least one
of which he encountered only after his return from
America. In the text accompanying Plate 15 of the Ap-
pendix, he writes: "Specimens of this Tree were first
sent me in the year 1736, by my worthy friend *John
Clayton*, Esq; of *Virginia*, and from the only Tree
known in that country. Since which, Mr. *Bartram* of
Pennsylvania has discovered many of them in that
province, from the seeds of which I am in hopes of
raising some. Mr. *Bartram* saw them growing on the
north branch of *Susquehannah* River: some of them
were above an hundred feet in height."

It would seem that the specimens of leaf and flower
that Catesby was sent by John Clayton became sepa-
rated from each other at some stage, as Ehret depicts
here the leaves of the cucumber tree with the flower of
the sweet bay. We know that Ehret made this drawing
from specimens given him by Catesby (rather than
from a tree reared later in England), because of an in-

scription in Catesby's hand in Collinson's copy of the
Natural History at Knowsley. This inscription, on Plate
15 of the Appendix, reads: *G.D. Ehret del. / from a
dried Specimen / given him from the Author*. It is likely,
therefore, that Catesby gave Ehret the Clayton speci-
mens sent for the purposes of making this drawing.

Catesby was later successful in rearing the cucum-
ber tree in England. In his *Hortus Britanno-Americanus*,
where he calls the tree the 'Magnolia of Pennsylvania'
he observes: "[their] northern situation [on the north
side of the Susquehannah river in Pennsylvania and in
the woods of New York] adapts them to our climate
more than the other kinds [of magnolia]; and from the
vigorous appearance of two or three very young
plants now growing at Fulham, and which I believe are
the only ones growing in England, there is good
reason to hope this majestic tree may easily be natural-
ized to our northern parts." Nonetheless, the illustra-
tion he includes in this later publication (51.2) repro-
duces the incorrect flower as shown in the *Natural
History*.

The image of the velvet ant, which Catesby adds to
Ehret's illustration in Appendix, Plate 15, is derived
from the sheet of insect studies, cat. no. 40.

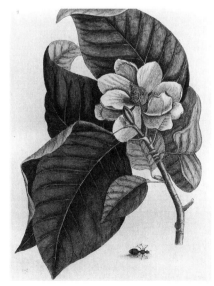

51.1 *Natural History*, II, Appendix, Plate 15

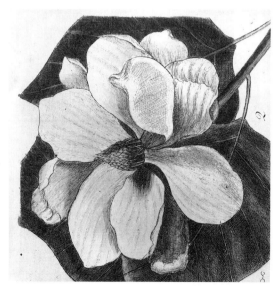

51.2 *Hortus Britanno-Americanus*, Figure 2

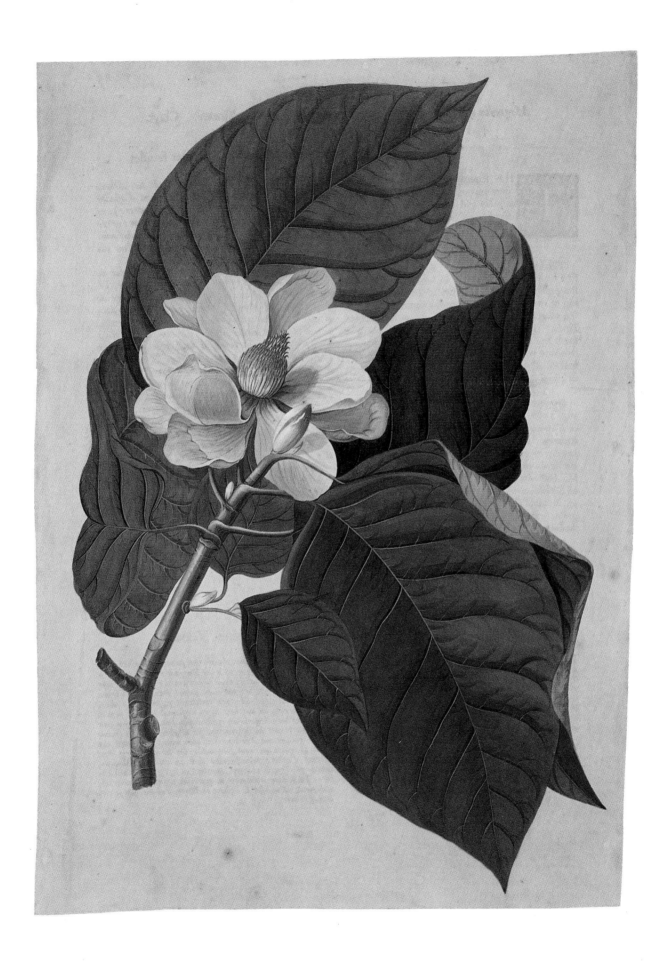

52 *Chamaerhododendros lauri-folio* and *Chamaedaphne semper virens*

[Rosebay or great laurel *Rhododendron catawbiense*
Michx., and narrow-leaved laurel or sheepkill *Kalmia
angustifolia* L.]
RL 26086 (III, Appendix, p. 17)

Watercolor and gouache heightened with gum arabic, over graphite
Inscribed in pen and brown ink in Catesby's hand, along upper edge:
Camaerhododendron
14¾ × 10⅝ in.; 375 × 270 mm

These two laurels are further examples of shrubs
which were sent to Catesby after he returned to Eng-
land, and which he attempted to cultivate. Although he
included illustrations and descriptions of both in his
Hortus Britanno-Americanus (Figures 35–36), he was
successful only in rearing the narrow-leaved laurel
which, he notes, "produced its blossoms at *Peckham* [in
Collinson's garden], in *September*, 1743, and several
succeeding years." He says of the great laurel: "Sever-
al of these young trees have been sent from *Pensylva-
nia* by Mr. *Bartram*, who first discovered them there;
but they have not yet produced any blossoms here: and
though they have been planted some years, they make
but slow progress in their growth, and seem to be one
of those *American* Plants that do not affect our soil and
climate."

Ehret therefore had to base his illustration of the
great laurel on a dried specimen and on the description
of its colors sent to Catesby by Bartram: "these

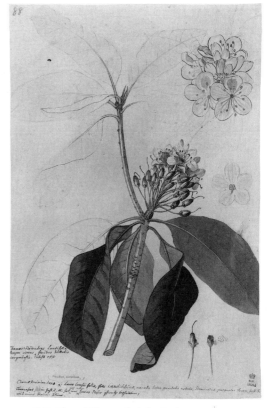

52.2 G.D. Ehret, '*Chamaerhododendron*'
(BM: NHM, Ehret sketch no. 104)

52.3 G.D. Ehret, Notes and studies for the
'*Chamaerhododendron*' (BM: NHM, Ehret sketch no. 105)

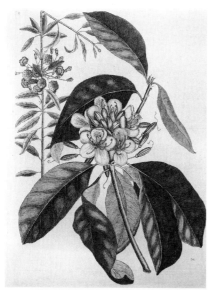

52.1 *Natural History*, II, Appendix, Plate 17

154

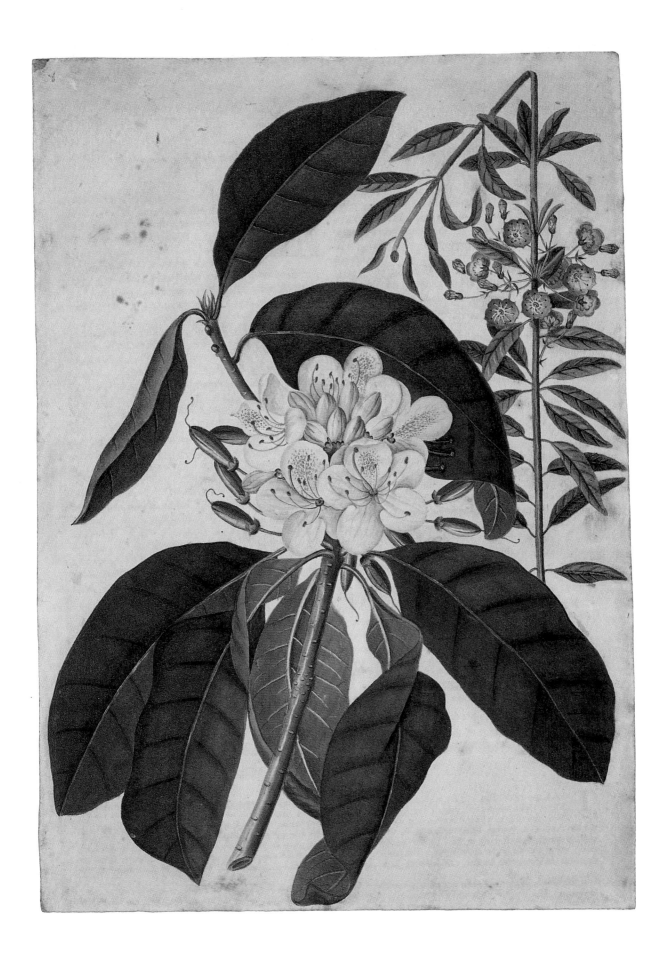

flowers when blown, appear white; but on a near view are of a faint blush colour, which as the flower decays grows paler." Ehret's preparatory drawing done from the dried specimen shows that the blossoms had mostly died (52.2); his trial arrangement of the open flowers can be seen in the upper right corner of that drawing. A companion sheet (52.3) includes a detailed study of the blossoms that Ehret was able to execute many years later from a plant raised successfully by Mr Gordon. On this sheet he notes that "The Chamae-rhododendron Figured in Catesby, and Miller[']s Plants, was taken from a dried Specimen. This Flow-ered in June 21, 1758 on a Seedling Plant raised by Mr Gordon." In his finished drawing Ehret employs an arrangement on the page similar to that used for cat. no. 51.

The drawing of the narrow-leaved laurel was added to the sheet by Catesby. He copied the image from a drawing that Ehret made of the plant (presumably drawn directly from the shrub in Collin-son's garden); Ehret's drawing is now in the Pierpont Morgan Library in New York (52.4). In order to fit the image on to the sheet, Catesby bent the stem over – a technique he often employed when preserving plant specimens (see p. 131). His etching of the two plants together follows this somewhat cramped composition. However, in Ehret's own prints of the plants published later, he shows the great laurel on its own (52.5) while placing the narrow-leaved laurel together with his mountain laurel, a species to which it is more similar, and with which, indeed, it fits more happily on the page (47.1).

52.4 G.D. Ehret, '*Chamae-rhododendron ... foliis oblongis*' (Pierpont Morgan Library 1961. 6:4)

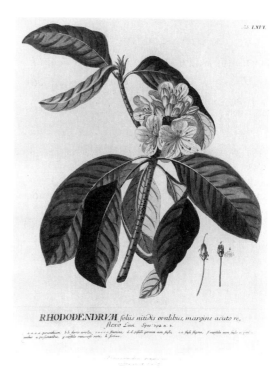

52.5 G.D. Ehret, '*Rhododendrum*' (Trew 1750–53, Plate LXVI)

BIBLIOGRAPHICAL ABBREVIATIONS

ACCOUNT
Natural History, II, pp. i–xliv

APPENDIX
Appendix, added to *Natural History* in 1747

BERKELEY AND BERKELEY 1982
Edmund Berkeley and Dorothy Berkeley, *The Life and Travels of John Bartram from Lake Ontario to the River St John*, Tallahassee FL 1982

BERKELEY AND BERKELEY 1992
Edmund Berkeley and Dorothy Berkeley, edd., *The Correspondence of John Bartram: 1734–1777*, Gainesville FL 1992

BILLINGTON AND RIDGE 1982
Ray Allen Billington and Martin Ridge, *Westward Expansion: A History of the American Frontier*, 5th edn., New York 1982

BL
British Library, London

BL (MSS)
Department of Manuscripts, British Library, London

BM: NHM
British Museum (Natural History Museum), London

BM (P&D)
Department of Prints and Drawings, British Museum, London

CALMANN 1977
Gerta Calmann, *Ehret, Flower Painter Extraordinary*, Boston 1977

CHAMBERS 1993
Douglas Chambers, *The Planters of the English Landscape Garden: Botany, Trees, and the 'Georgics'*, New Haven CT 1993

CLOKIE 1964
Hermia Newman Clokie, *An Account of the Herbaria of the Department of Botany in the University of Oxford*, Oxford 1964

CROFT-MURRAY AND HULTON 1960
Edward Croft-Murray and Paul Hulton, *Catalogue of British Drawings in the British Museum: XVI and XVII Centuries*, London 1960

DAVIS 1995
Natalie Zemon Davis, *Woman on the Margins: Three Seventeenth-Century Lives*, Cambridge MA 1995

DESMOND 1977
Ray Desmond, *Dictionary of British and Irish and Horticulturalists, including Plant Collectors and Botanical Artists*, London 1977

DESMOND 1995
Ray Desmond, *Kew: The History of the Royal Botanic Gardens*, London 1995

DNB
Dictionary of National Biography

EDWARDS 1743–51
George Edwards, *A Natural History of Uncommon Birds, and of some other rare and undescribed Animals, Quadrupeds, Reptiles, Fishes, Insects, etc.*, 4 parts in 2 vols., London 1743–51

EDWARDS 1758–64
George Edwards, *Gleanings of Natural History, exhibiting figures of quadrupeds, birds, insects, plants, etc. With descriptions in French and English.*, 3 vols., London 1758–64

EHRET MEMOIR
'A Memoir of Georg Dionysius Ehret ... written by himself', trans. E.S. Barton, *Proceedings of the Linnean Society of London*, 1894–95, pp. 41–58

EWAN 1967

Joseph Ewan, Introduction to William Darlington, *Memorials of John Bartram and Humphry Marshall* (Philadelphia 1849), New York 1967

EWAN AND FRICK 1974

Joseph Ewan and George Frick, Introduction and Notes to *Facsimile Edition of Mark Catesby's Natural History of Carolina* (3rd edn., 1774), Savannah 1974

FEDUCCIA 1985

Alan Feduccia, *Catesby's Birds of Colonial America*, Chapel Hill NC 1985

FRICK AND STEARNS 1961

George Frederick Frick and Raymond Phineas Stearns, *Mark Catesby: The Colonial Audubon*, Urbana IL 1961

GENT. MAG.

The Gentleman's Magazine

HEDRICK 1950

Ulysses Prentiss Hedrick, *A History of Horticulture in America to 1860*, Oxford 1950; rpt. Portland OR 1988

HENREY 1986

Blanche Henrey, *No ordinary gardener: Thomas Knowlton, 1691–1781*, ed. A.O. Chater, London 1986

HORTUS BRITANNO-AMERICANUS

Mark Catesby, *Hortus Britanno-Americanus: or, a Curious Collection of Trees and Shrubs, the Produce of the British Colonies in North America; adapted to the Soil and Climate of England*, London 1763

HOWARD AND STAPLES 1983

Richard A. Howard and George W. Staples, 'The Modern Names for Catesby's Plants', *Journal of the Arnold Arboretum*, LXIV, October 1983, pp. 511-46

HULTON AND QUINN 1964

Paul Hulton and David Beers Quinn, *The American Drawings of John White, 1577–1590*, 2 vols., London and Chapel Hill NC 1964

MCCRADY 1901

Edward McCrady, *The History of South Carolina Under the Proprietary Government, 1670–1719*, New York 1901

MACGREGOR 1994

Arthur MacGregor, ed., *Sir Hans Sloane, Collector, Scientist, Antiquary, Founding Father of the British Museum*, London 1994

MATTLEY 1754

Dr. Mattley, 'Some Account of the Life and Writings of the Late Dr. Richard Mead', *Gent. Mag.*, 24 [November 1754], pp. 510–15

MAYR 1982

Ernst Mayr, *The Growth of Biological Thought: Diversity, Evolution and Inheritance*, Cambridge MA 1982

MEINIG 1986

Donald William Meinig, *Atlantic America*, vol. 1 of *The Shaping of America: A Geographical Perspective on 500 Years of History*, New Haven CT 1986

MERIAN 1679–83

Maria Sibylla Merian, *Der Raupen wunderbare Verwandelung*, 2 vols.: I, Nuremberg 1679; II, Frankfurt 1683

MORTIMER 1748

Cromwell Mortimer, 'A Continuation of an Account of Mr. Mark Catesby's Essay towards the Natural History of Carolina and the Bahama Islands, with some Extracts out of the Appendix', *Phil. Trans.*, XXXXV, no. 486, 1748, pp. 157–73. For Mortimer's earlier articles in this series see *Phil. Trans.* XXXVI, no. 415, pp. 425–34; XXXVII, nos. 420, pp. 174–78 and 426, pp. 447–50; XXXVIII, no. 432, pp. 315–18; XXXIX, nos. 438, pp. 112–17 and 441, pp. 251–58; XL, no. 449, pp. 343–50; XLIV, no. 484, pp. 599–608

NATURAL HISTORY

Mark Catesby, *The Natural History of Carolina, Florida, and the Bahama Islands*, 2 vols., London 1731–43 [1729–47]

NICHOLS 1812–15

John Nichols, *Literary Anecdotes of the Eighteenth Century*, 9 vols., London 1812–15

O'MALLEY 1997

Therese O'Malley, Elizabeth Kryder-Reid and Anne Helmreich, *Keywords in American Landscape Design*, Washington DC, forthcoming 1997

PHIL. TRANS.
Philosophical Transactions of the Royal Society of London

PLOMER 1932
H.R. Plomer *et al.*, *A Dictionary of the Printers and Booksellers who were at work in England, Scotland and Ireland from 1726 to 1775*, Oxford 1932

PREFACE
Natural History, I, pp. v–xii

PRITCHARD AND SITES 1993
Margaret Beck Pritchard and Virginia Lascara Sites, *William Byrd II and his Lost History: Engravings of the Americas*, Williamsburg VA 1993

PROPOSALS
Mark Catesby, *Proposals, for Printing an Essay towards a Natural History of Florida, Carolina and the Bahama Islands: Containing Figures of Birds, Beasts, Fishes, Serpents, Insects and Plants; Particularly, the Forest-Trees, Shrubs, and other Plants, not hitherto described, remarkable for their Rarity, Virtues, &c.,* London 1729

RAVEN 1950
Charles Earle Raven, *John Ray, Naturalist: His Life and Works*, 2nd edn., Cambridge 1950; rpt., Cambridge 1986

RAY 1678
John Ray, *The Ornithology of Francis Willughby of Middleton in the County of Warwick Esq.*, London 1678

RL
Royal Library, Windsor Castle

ROBERTSON 1988
Bruce Robertson, 'Joseph Goupy and the Art of the Copy', *The Bulletin of The Cleveland Museum of Art*, LXXV, 1988, pp. 354–82

RS
The Royal Society, London

RS: SH
Sherard Letters in the RS; MS 253 contains Catesby's letters to Sherard

RÜCKER AND STEARN 1982
Elizabeth Rücker and William T. Stearn, *Maria Sibylla Merian in Surinam: Commentary to the Facsimile Edition of* Metamorphosis Insectorum Surinamensium (*Amsterdam, 1705*); *Based on Watercolours in the Royal Library, Windsor Castle*, London 1982

RUSSELL 1997
Francis Russell, *John, 3rd Earl of Bute, and his Collections*, forthcoming 1997

SH. HERB.
The Sherard Herbarium, Oxford University Herbaria, Department of Plant Sciences

SLOANE MS
Sir Hans Sloane's correspondence and albums of drawings, now divided between the BL (MSS) and BM (P & D)

SPONGBERG 1990
Stephen Spongberg, *A Reunion of Trees: The Discovery of Exotic Plants and their Introduction into North American and European Landscapes*, Cambridge MA 1990

STEARN 1978
William T. Stearn, Introduction to M.S. Merian, *The Wondrous Transformation of Caterpillars 1718*; Selections from *Erucarum Ortus*, London 1978

STEARNS 1970
Raymond Phineas Stearns, *Science in the British Colonies of America*, Urbana IL 1970

STUART MASON 1992
A. Stuart Mason, *George Edwards: The Bedell and his Birds*, London 1992

SWEM 1948
Earl Swem, ed., *Brothers of the Spade: Correspondence of Peter Collinson, of London, and of John Custis, of Williamsburg, Virginia, 1734–1746*, 1948; rpt., Worcester MA 1949

TREW 1750–53
C.J. Trew, *Plantae Selectae*, Nuremberg 1750–73

TREW 1758–92
C.J. Trew, *Hortus Nitidissimus*, Nuremberg 1758–92

TURNER 1835
Dawson Turner, ed., *Extracts from the Literary and Scientific Correspondence of Richard Richardson ...*, 2 vols., Yarmouth 1835

Concordance between
Royal Library Inventory Numbers and Catalogue Numbers

RL NO.	CAT NO.	RL NO.	CAT NO.	RL NO.	CAT NO.	RL NO.	CAT NO.
24814	1	25919	14	25998	29	26049	44
24818	2	25932	15	26008	30	26056	45
24822	3	25940	18	26009	41	26061	46
24828	4	25947–49	19	26039	37	26062	47
24829	5	25957–58	20	26016	31	26068	16
24836	6	25963	21	26020	32	26072	48
24853	7	25971	22	26022	33	26073	49
24847	8	25972–73	23	26023	34	26077	40
25875	9	25982	24	26024	35	26079	50
25879.	10	25983	25	26031–32	36	26084	51
25892	11	25985	26	26043	42	26085	17
25902	12	25992	27	26044–45	39	26086	52
25911	13	25997	28	26047	43	26092	38

Photographic Acknowledgments

Reproductions of all Royal Collection items are the copyright of the Royal Collection © 1997 Her Majesty The Queen. Sam Whitbread kindly gave permission to reproduce the plates in his copy of Catesby's *Natural History*. Reproduction permission was also given by the following: Department of Manuscripts, British Library, London (I.1, I.2, I.3, II.1, II.3, III.1, III.2, VI.1, VI.2); Department of Prints and Drawings, British Museum, London: © British Museum (fig. 10, II.2, 35.2, V.1, V.2, V.3); British Museum (Natural History Museum), London (3.2, 4.2, 5.2, 7.2, 42.2, 43.2, 47.1, 48.2, 50.2, 50.3, 51.2, 52.2, 52.3); Chelsea Physic Garden Company, London (fig. 5: this print is bound into the copy of the *Natural History*, Vol. 1, in the library of the Chelsea Physic Garden); Sotheby's, London (10.3); Pierpont Morgan Library, New York (52.4); Department of Plant Sciences, University of Oxford (fig. 4, 10.2, 32.2, VII.1).